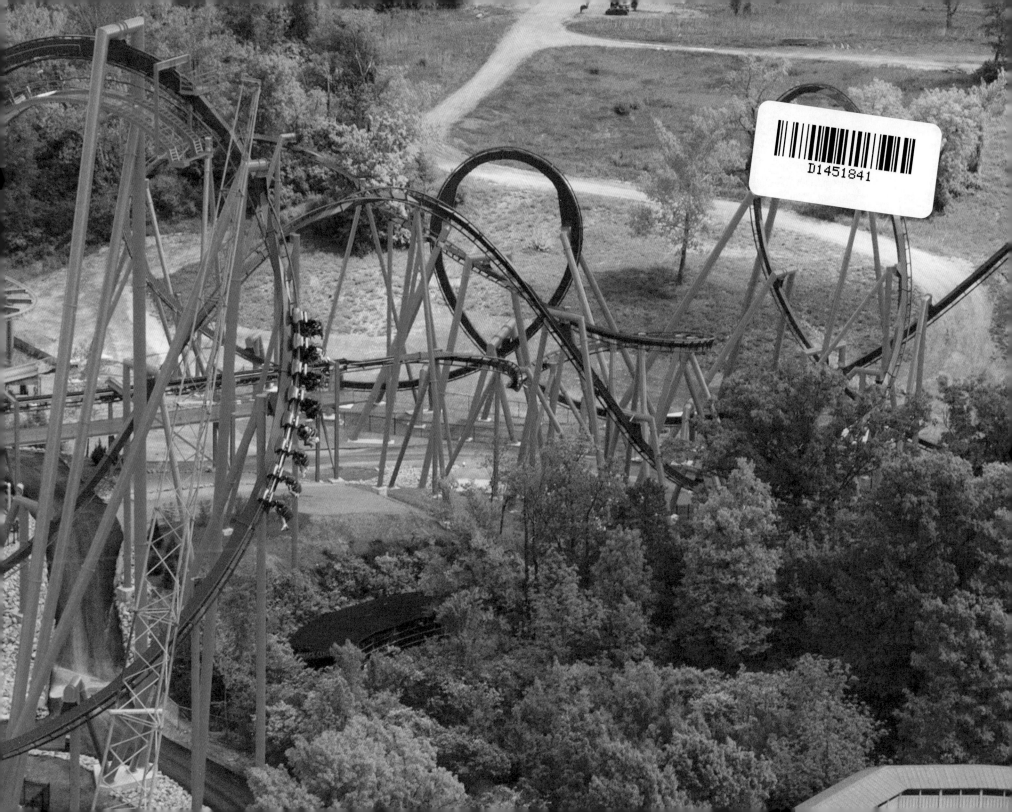
D1451841

AMERICAN COASTERS 2

Coast to Coast　　　Thomas Crymes

Schiffer Publishing Ltd

4880 Lower Valley Road • Atglen, PA 19310

Other Schiffer Books by Thomas Crymes:
American Coasters, ISBN 978-0-7643-4158-8

Other Schiffer Books on Related Subjects:
California Theme Parks, by Alex Miller and Bryce Walker, ISBN 978-0-7643-3478-8

Copyright © 2016 by Thomas Crymes

Library of Congress Control Number: 2012947661

All rights reserved. No part of this work may be reproduced or used in any form or by any means—graphic, electronic, or mechanical, including photocopying or information storage and retrieval systems—without written permission from the publisher.

The scanning, uploading, and distribution of this book or any part thereof via the Internet or any other means without the permission of the publisher is illegal and punishable by law. Please purchase only authorized editions and do not participate in or encourage the electronic piracy of copyrighted materials.

Most of the items and products in this book may be covered by various copyrights, trademarks, and logotypes. Their use herein is for identification purposes only. All rights are reserved by their respective owners.

This book is not sponsored, endorsed, or otherwise affiliated with any of the companies whose products are represented herein. They include Six Flags, Cedar Fair LP, and others. This book is based on the author's independent research.

"Schiffer," "Schiffer Publishing, Ltd.," and the pen and inkwell logo are registered trademarks of Schiffer Publishing, Ltd.

Designed by Justin Watkinson
Type set in Eurostile LT Std/Zurich BT
ISBN: 978-0-7643-5114-3
Printed in China

Published by Schiffer Publishing, Ltd.
4880 Lower Valley Road
Atglen, PA 19310
Phone: (610) 593-1777; Fax: (610) 593-2002
E-mail: Info@schifferbooks.com
Web: www.schifferbooks.com

For our complete selection of fine books on this and related subjects, please visit our website at www.schifferbooks.com. You may also write for a free catalog.

Schiffer Publishing's titles are available at special discounts for bulk purchases for sales promotions or premiums. Special editions, including personalized covers, corporate imprints, and excerpts, can be created in large quantities for special needs. For more information, contact the publisher.

We are always looking for people to write books on new and related subjects. If you have an idea for a book, please contact us at proposals@schifferbooks.com.

This book is dedicated to everyone who gets a thrill as the train crests the hill.

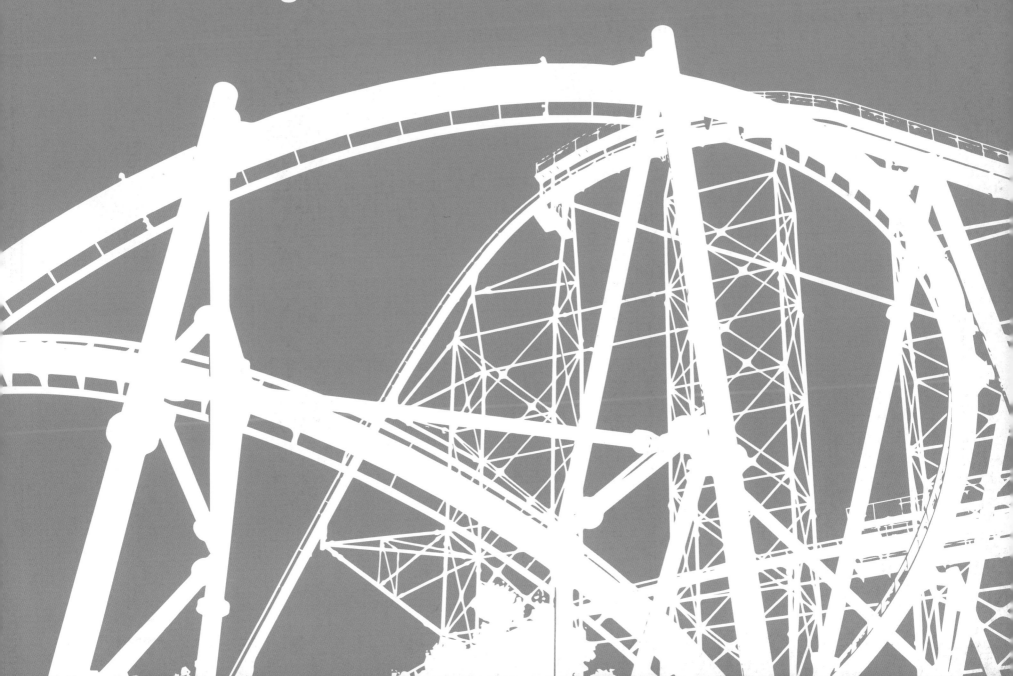

Contents

Acknowledgments

Many thanks to my wife, Beth, for putting up with my trips around the country to take photos for this book. I'd also like to thank Brett Strouse for accompanying me on many of those trips and being patient while I tried to capture the right image. Mark Miles was also instrumental in helping make my photos look their best.

Introduction

With any book such as this, there are always pictures left untaken and areas uncovered, so when I was given the opportunity for a follow-up book, I set out to continue where the first one left off, with the goal of representing nearly every corner of the country. I've visited parks as far north as Maine, as far south as Florida, and as far west as California. I've visited the great north of Minnesota and the vast state of Texas, not to mention the vast heartland of the Midwest. I've taken pictures of the oldest coaster in the world as well as some of the newest coasters. While this book is far from comprehensive, I hope I've captured the heart and beauty of roller coasters from coast to coast.

Enjoy.

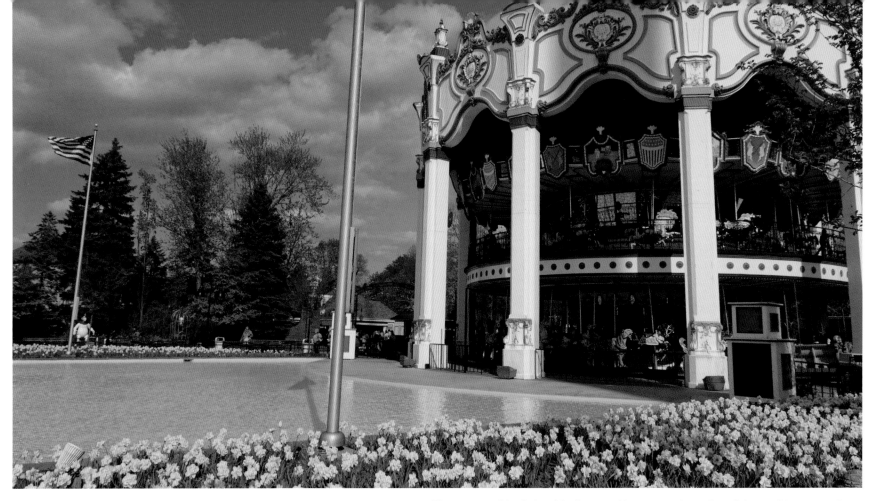

The memorable Columbia Carousel is two stories tall and the park's centerpiece.

Six Flags Great America

Gurnee, Illinois

Great America is Six Flags's premier park of the Midwest. The park was purchased from Marriot in 1984. Three of the coasters built by Marriot are still in operation today: The Whizzer, Demon, and American Eagle. This park also claims a number of industry firsts. Batman: The Ride was the first inverted coaster in the world. Iron Wolf was Bolliger and Mabillard's first roller coaster ever. Raging Bull was Six Flags's first hypercoaster (a non-launched, full-circuit coaster over 200 feet tall and without inversions). With cutting-edge roller coasters like Goliath and X-Flight, Great America continues to drive innovation.

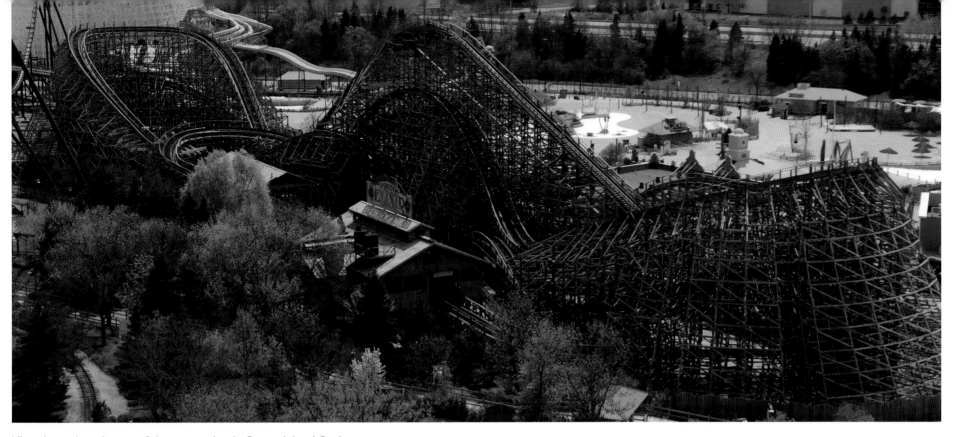

Viper is a mirror image of the one and only Coney Island Cyclone.

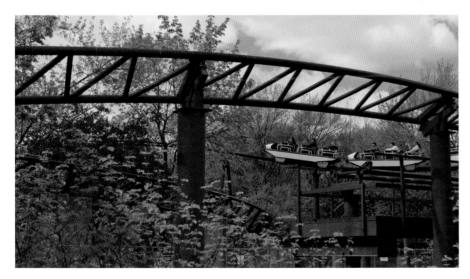

The Whizzer was originally named Willard's Whizzer after the park's first owner.

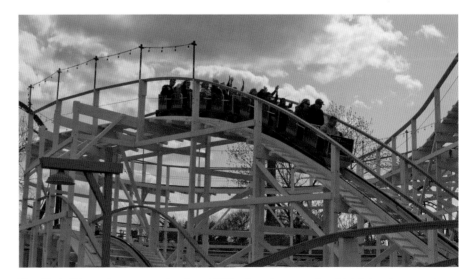

The Little Dipper's roots go back to 1950 when it opened at Kiddieland.

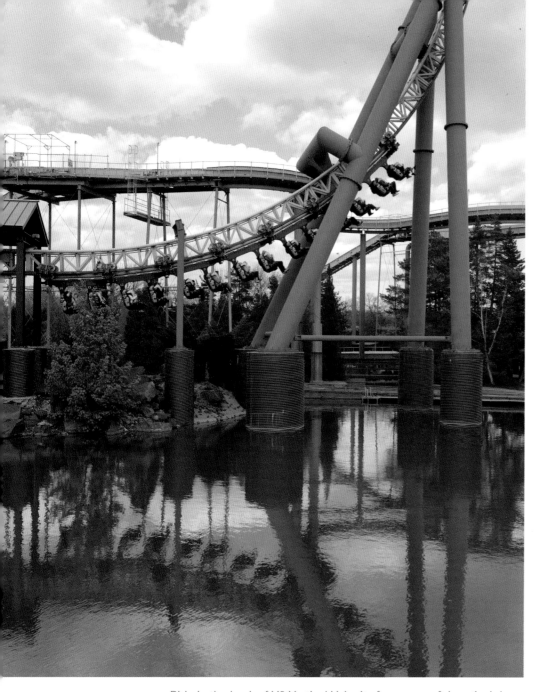

Ride in the back of V2 Vertical Velocity for a powerful vertical drop.

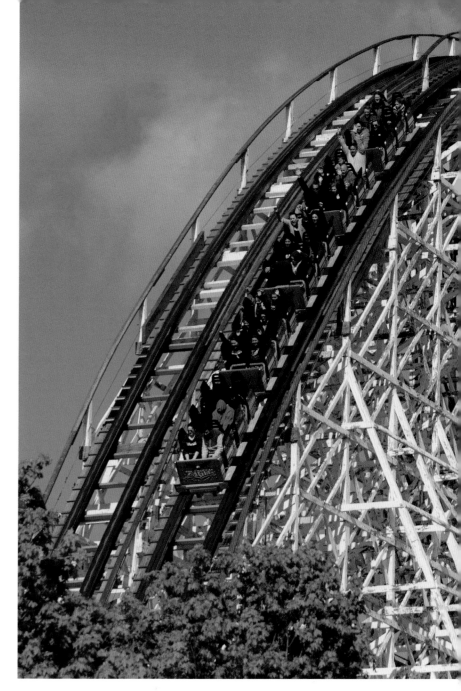

American Eagle is a classic white woodie with an exhaustingly long queue.

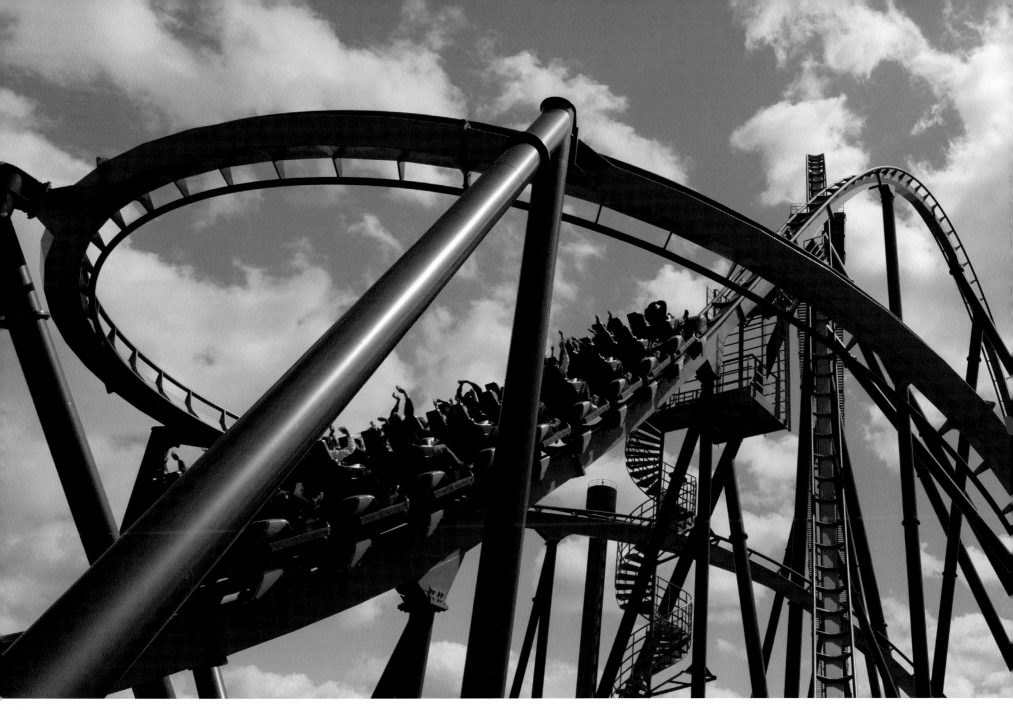

Raging Bull is B&M's second hypercoaster and is the longest roller coaster at Six Flags Great America.

X Flight

OPENING DATE	May 16, 2012
MAKE	Bolliger & Mabillard
MAX HEIGHT	120 feet
LENGTH	3,000 feet
MAX SPEED	55 mph
DURATION	1:45
INVERSIONS	5

This coaster was one of the first wing coasters to open in the United States, along with Dollywood's Wild Eagle, which opened a few months earlier. These coasters allow the rider to sit alongside the track with nothing above or below them. The biggest difference between the two coasters is X Flight's keyhole elements. The feeling of flying through a narrow opening is exhilarating and the highlight of the ride.

X Flight is an entertaining ride, to be sure, but be prepared for a long wait followed by a short ride. For much of its existence, the ride has been using only one train. Hopefully that will change, because there is nothing quite like being extended outside of the track with nothing below you but the ground and nothing above you but the sky.

FACING PAGE

TOP: Feel the rush as you blast through the ride's keyhole elements.

BOTTOM LEFT: Riders soar through one of five inversions.

BOTTOM RIGHT: With such a short track, you'll be spending most of your time head over heels. That's a good thing!

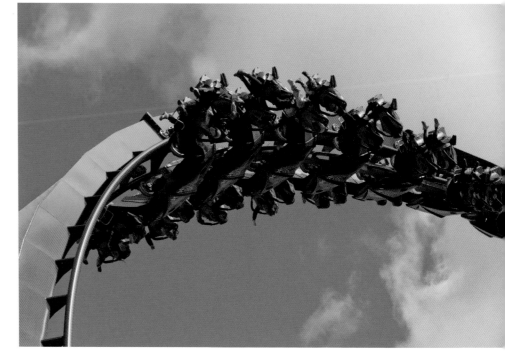

Goliath

OPENING DATE	June 19, 2014
MAKE	Rocky Mountain Construction
DESIGNER	Alan Schilke
MAX HEIGHT	165 feet (180-foot drop)
LENGTH	3,100 feet
MAX SPEED	72 mph
DURATION	1:45
INVERSIONS	2

The 85-degree, 180-foot first drop helps this wood coaster reach a record-breaking 72 miles per hour, but what makes this ride special is its butter-smooth ride and innovative design. Rocky Mountain Construction (RMC) continually redefines what's possible with each coaster it builds. Goliath is only their second wood coaster, and it's magnificent.

This ride explores the idea of the stall—first in the dive loop and then in its signature zero-gravity stall, in which the train slows to a crawl while inverted.

Its only crime is being too short, but RMC did a lot with the small footprint they were allotted. Ride in the back for the maximum stall experience.

FACING PAGE

TOP LEFT: The layout has riders pulling tight turns in tight spaces.

TOP RIGHT: The train races sideways into a tightly banked turn after the first drop.

BOTTOM LEFT: The train slows before being whipped through the dive loop.

BOTTOM RIGHT: The train crests the massive lift hill. The layers of laminated wood under the steel Topper Track classify this as a wooden coaster.

The train seems to hang in the air as it navigates the stall section of track.

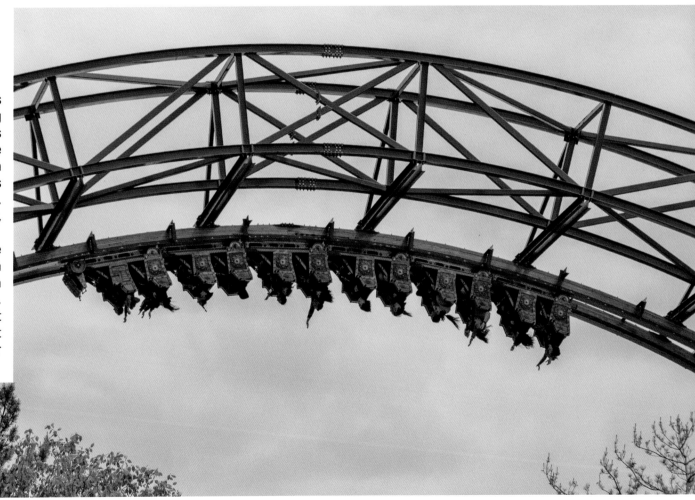

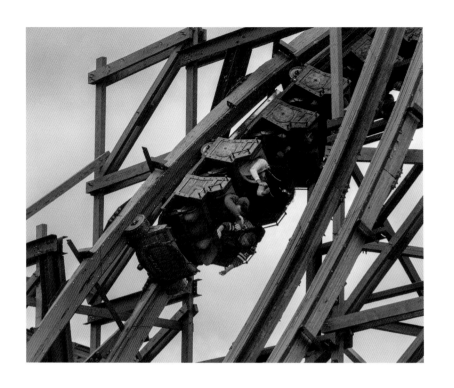
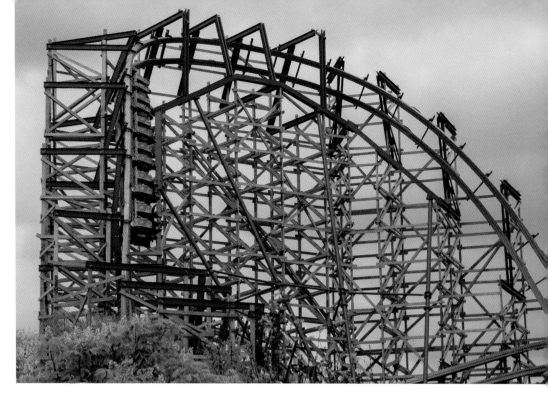

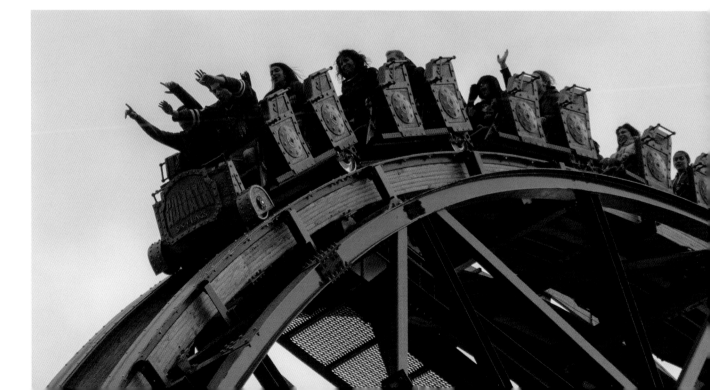

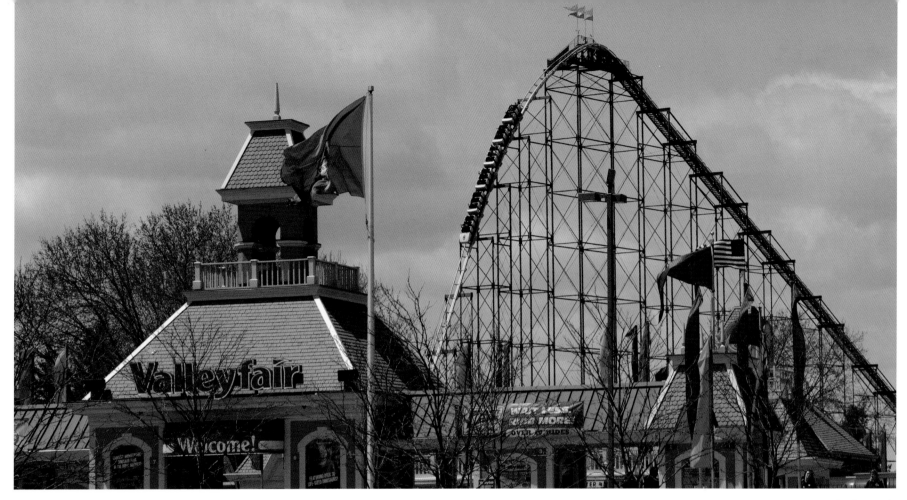

Wild Thing is the most visible ride in the park.

Valleyfair
Shakopee, Minnesota

Along a bank of the Minnesota River is the biggest amusement park in the Upper Midwest. The dream of two local businessmen, it opened in 1976 with twenty rides and attractions featuring the thrilling wood coaster High Roller. A mere two years later, the Cedar Point Pleasure Company acquired the park. The company name was then changed to Cedar Fair (a combination of Cedar Point and Valleyfair) and the company has been the park's steward ever since. Today it features Wild Thing, a dynamite hypercoaster, and Renegade, one of the finest wood coasters in the country.

High Roller opened with the park and is still in operation today. It delivers old-time charm and is perfect for younger riders trying to transition to the more forceful, larger rides. Adults like it because it delivers some airtime thrills.

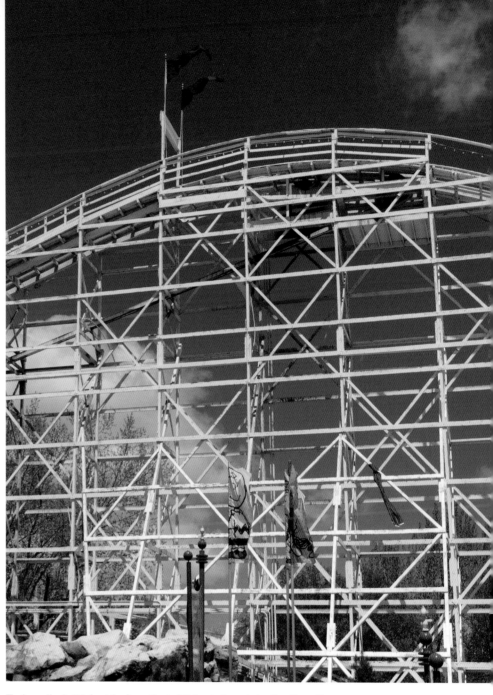

Trains climb 70 feet before their 56-foot drop into the first dip.

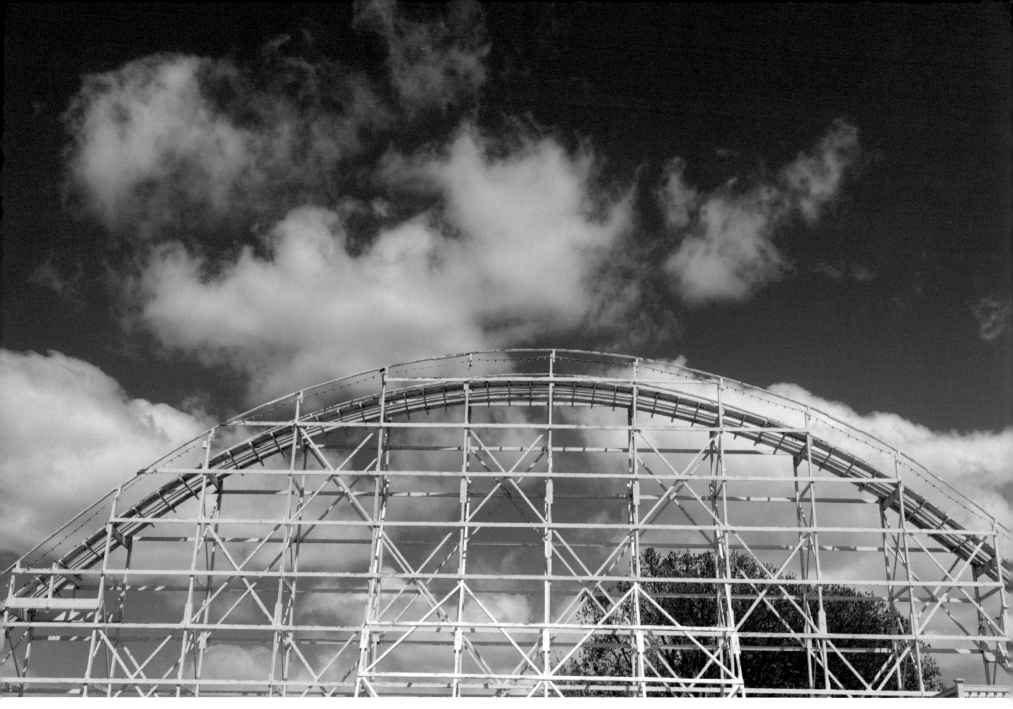

The classic white structure harkens back to its debut in 1976.

Steel Venom launches riders forward and backward.

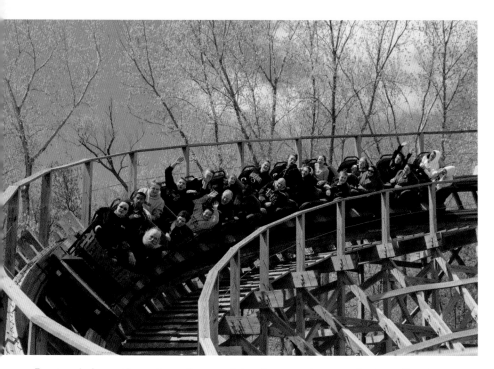

Renegade is another winner from outstanding coaster manufacturer Great Coasters International.

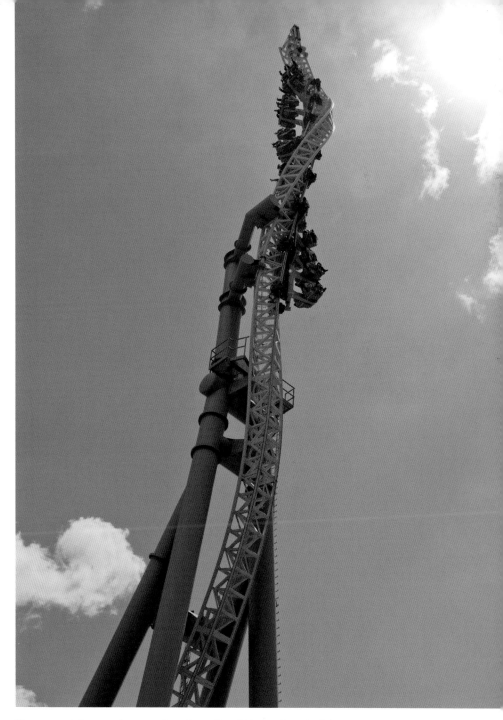

If you want the maximum effect from Steel Venom's spiral, be sure to get a front seat.

FACING PAGE

TOP LEFT: The loop combined with a double corkscrew comprise the coaster's three inversions.

TOP RIGHT: The classic clothoid loop (inverted teardrop-shaped) is still used in today's roller coasters.

BOTTOM LEFT: The small lake provides a scenic backdrop for the ride.

BOTTOM RIGHT: The coaster is tightly integrated into the landscape of the park.

Corkscrew

OPENING DATE	1980
MAKE	Arrow Dynamics
MAX HEIGHT	85 feet
LENGTH	1,950 feet
MAX SPEED	50 mph
DURATION	1:30
INVERSIONS	3

For sixteen years this was the only outdoor all-steel roller coaster in Minnesota, and that spell was broken by Valleyfair's Wild Thing. By the time Corkscrew opened, Arrow Dynamics was comfortably established as the go-to manufacturer of looping steel roller coasters. Variations of Corkscrew dotted the amusement park landscape.

This ride has the distinction of being uncannily smooth for an old Arrow looper. Creatively incorporated into the center of the park, this ride is tame by today's standards and, along with High Roller, is a good stepping stone for junior riders seeking to transition to the fiercer rides.

A double corkscrew never looked so good.

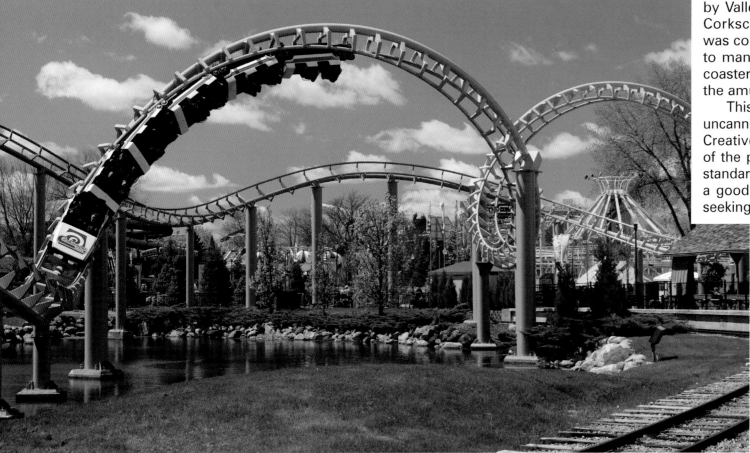

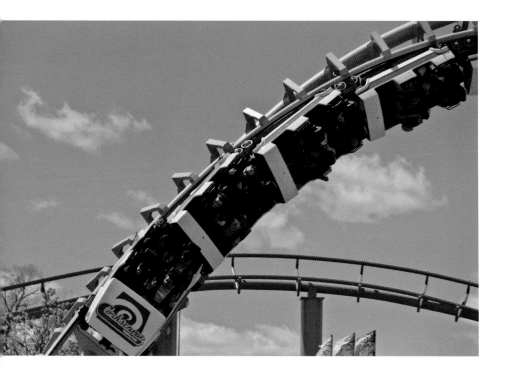
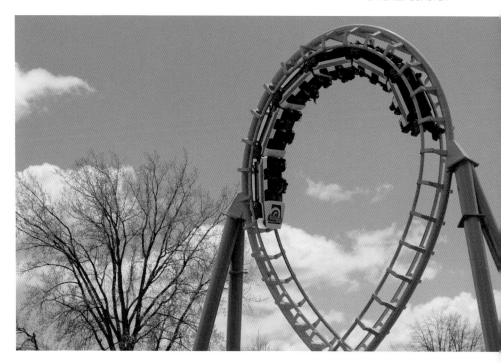
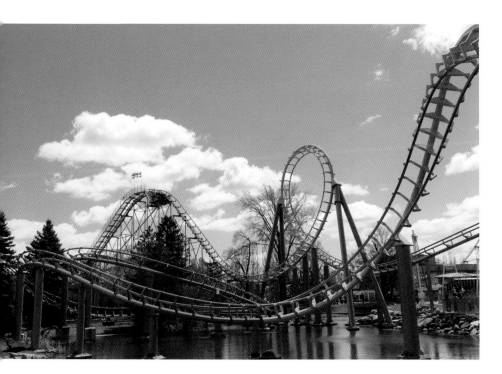
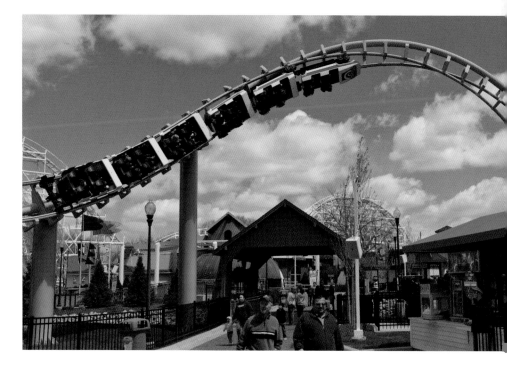

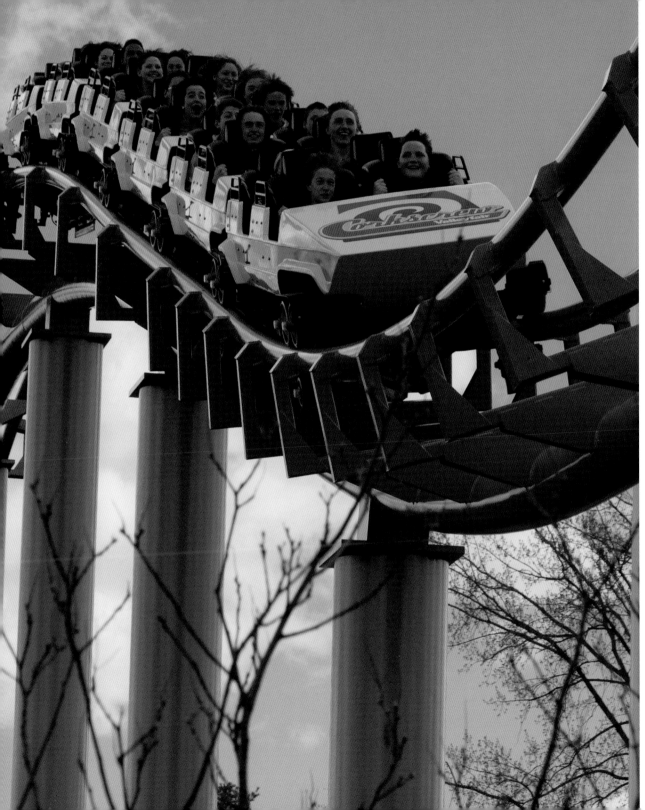

Riders exit the loop and prepare for their double corkscrew finish.

Wild Thing

OPENING DATE	May 11, 1996
MAKE	Morgan
DESIGNER	Steve Okamoto
MAX HEIGHT	207 feet (196-foot drop)
LENGTH	5460 feet
MAX SPEED	74 mph
DURATION	3:00
INVERSIONS	0

This was Morgan's first hypercoaster and the predecessor to Dorney Park's Steel Force and Worlds of Fun's Mamba. It was the fifth-tallest coaster in the world when it opened. The FAA restricted its height because of a nearby airport.

Wild Thing features a long, airtime-filled ride with a nice whip effect on the first drop when riding in the back. It is the tallest and most imposing structure in the park.

FACING PAGE

TOP LEFT: The plentiful supports crisscross in interesting ways when viewed from the right angle.

TOP RIGHT: The train dives toward the ground as it enters the turnaround.

BOTTOM: The turnaround on this coaster is a massive, sweeping figure eight that is as enjoyable to view as it is to ride.

The train thrusts over one of the airtime hills.

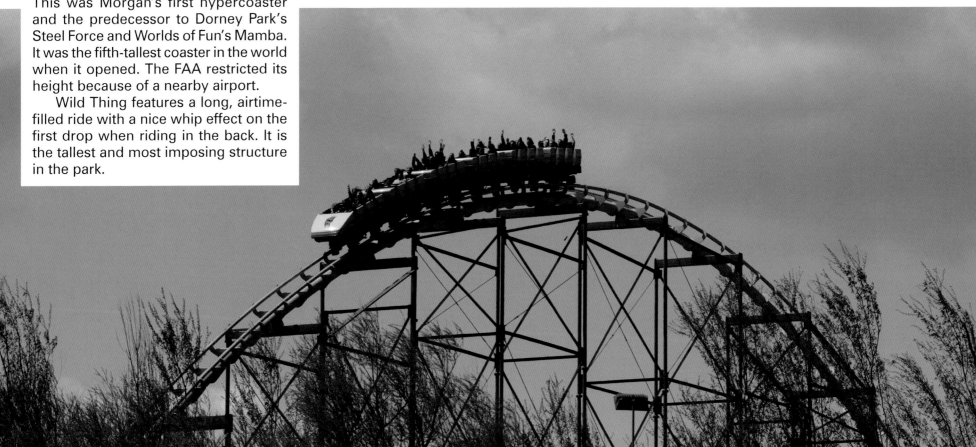

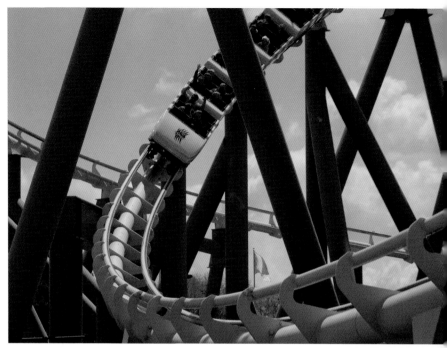
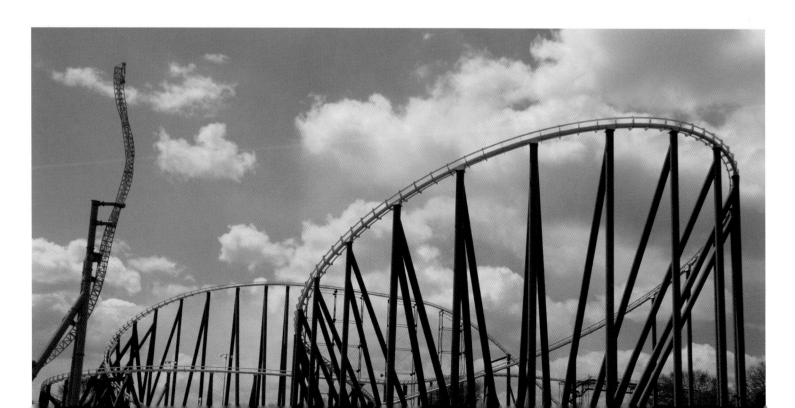

The massive support columns make just about everything else look small.

Be sure to get your picture with Santa when you visit.

Holiday World
Santa Claus, Indiana

This family-owned and operated theme park opened in 1948 as Santa Claus Land. In 1984 the name was changed to Holiday World and the park was expanded to include Halloween and Fourth of July themes. In subsequent years the park opened two roller coasters: The Raven and The Legend. In 2006, a Thanksgiving area was added, along with a brand new roller coaster called The Voyage. Holiday World has a knack for building superb wood coasters. These three wood roller coasters earned top honors in the coaster community.

The station doubles as a spooky-looking house.

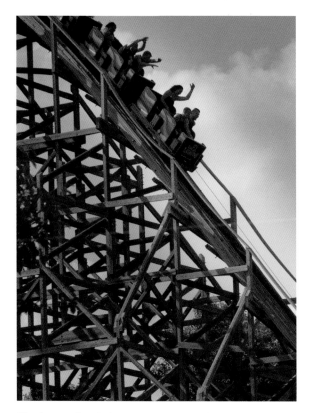

The Legend train barrels down the first drop.

The Raven was inspired by Edgar Allen Poe's poem "The Raven." This furious romp through the woods doesn't let riders come up for air. The Legend coaster is centered on the hair-raising tale of the headless horseman. Riders careen through twists and turns as if chased by the horseman, resulting in an out-of-control, frenetically paced ride. Both coasters were designed and built by the now-defunct Custom Coasters International and earned top honors in the coaster world.

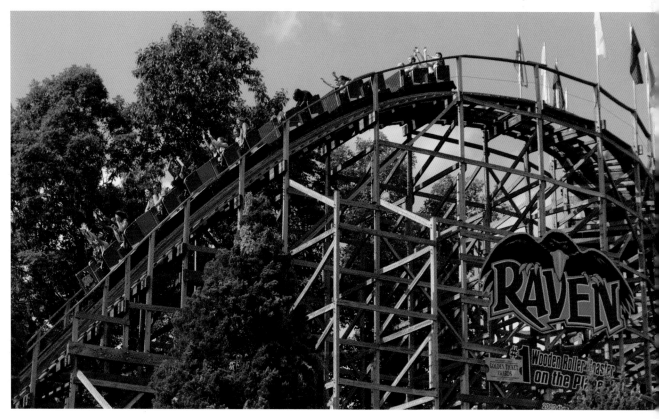

Riders plunge down The Raven's first drop and into a tunnel.

The Voyage

OPENING DATE	May 6, 2006
MAKE	The Gravity Group
MAX HEIGHT	163 feet (154-foot drop)
LENGTH	6,442 feet
MAX SPEED	67 mph
DURATION	2:45
INVERSIONS	0

To follow up The Raven and The Legend, the folks at Holiday World thought a Thanksgiving-themed roller coaster would be a good idea. It turns out they were right. This coaster is not meant to personify the turbulence of a family feast, but to depict the swollen, angry seas the *Mayflower* navigated to reach the New World.

Many wood coasters pack a punch and deliver a breathtaking ride, but what makes The Voyage special is its ability to excel consistently through more than a mile of track.

The Voyage is a turbulent, forceful ride. This is both the coaster's greatest asset and the root of its problems. Due to the high stress the ride puts on the structure, sections of the track needed to be replaced after the first year of operation. A major re-tracking effort was undertaken in 2012, 2013, and 2014. Hopefully, Holiday World's dedication to maintaining the ride will yield positive results and keep The Voyage on the top of many coaster enthusiasts' lists.

FACING PAGE

LEFT: The track is so long that these folks probably got tired of putting their hands up.

RIGHT: The lift hill is colossal. It needs to be for the train to maintain breakneck speed throughout the course.

The train disappears into the woods.

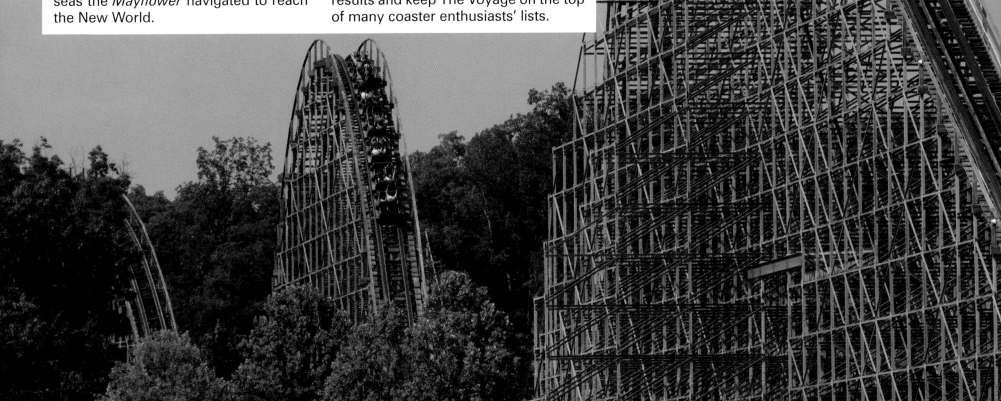

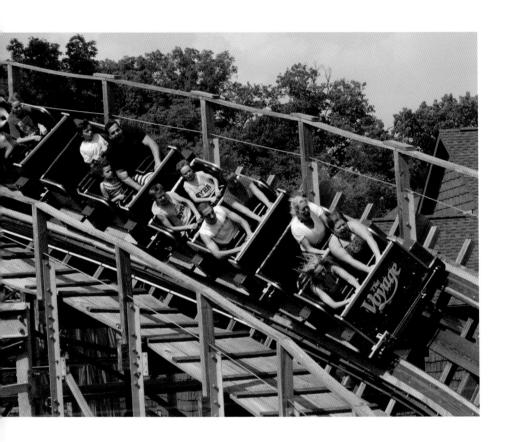

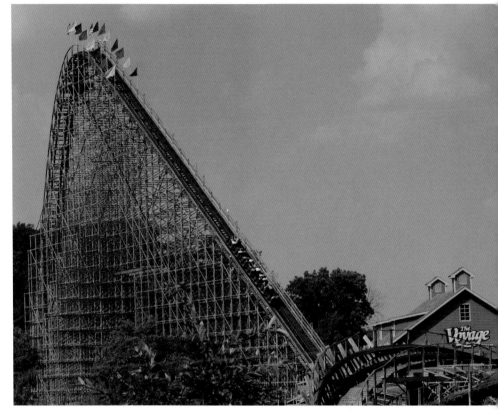

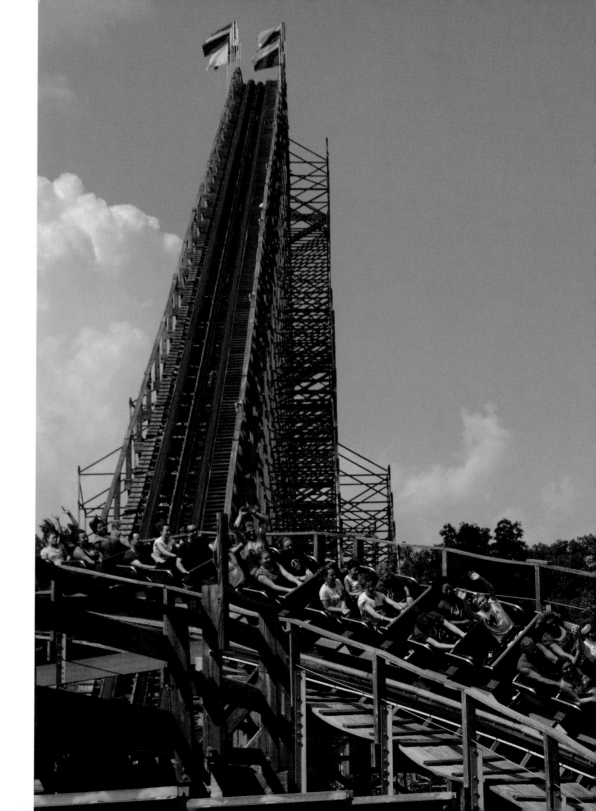

The train enters the final
sections of the ride and
there's probably still
enough track remaining
to build another coaster.

The plaque on this fountain details the six nations that influenced the development of the Midwest.

Six Flags St. Louis

Eureka, Missouri

Located on the outskirts of St. Louis, this park originally opened in 1971 as Six Flags Over Mid-America. It was the third and last park built from the ground up with the Six Flags name and is currently the only park wholly owned and operated by Six Flags. The park has a varied collection of coasters including three wood coasters, an inverted coaster, and a backward-launched steel coaster.

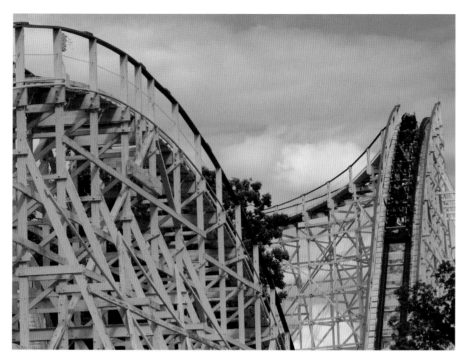

Screamin' Eagle opened as the tallest, fastest coaster in the world in 1976.

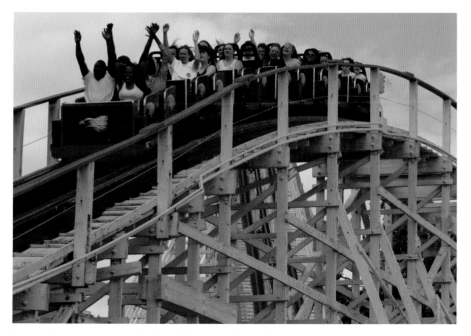

It was the last coaster designed by the influential coaster designer John C. Allen.

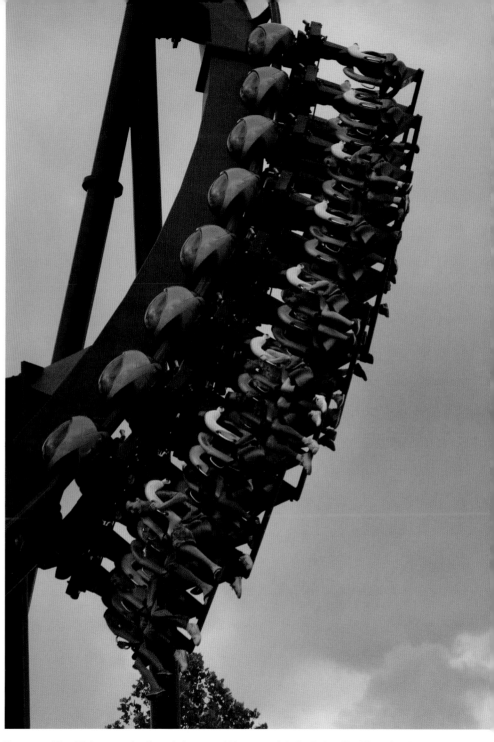

Batman: The Ride was the fourth inverted Batman ride built by Six Flags and is a mirror image of the original Batman.

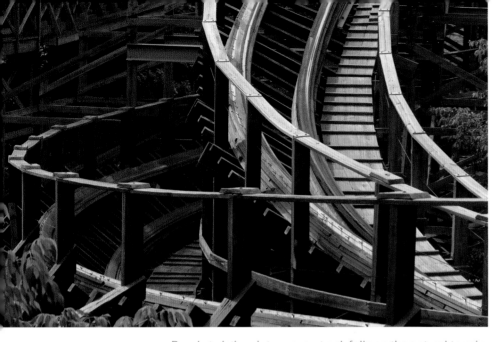

Boss's twisting, interwoven track follows the natural terrain.

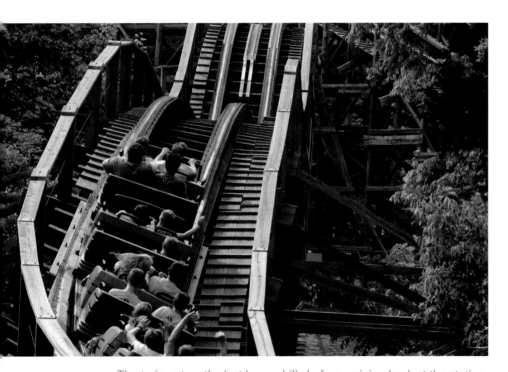

The train enters the last bunny hills before arriving back at the station.

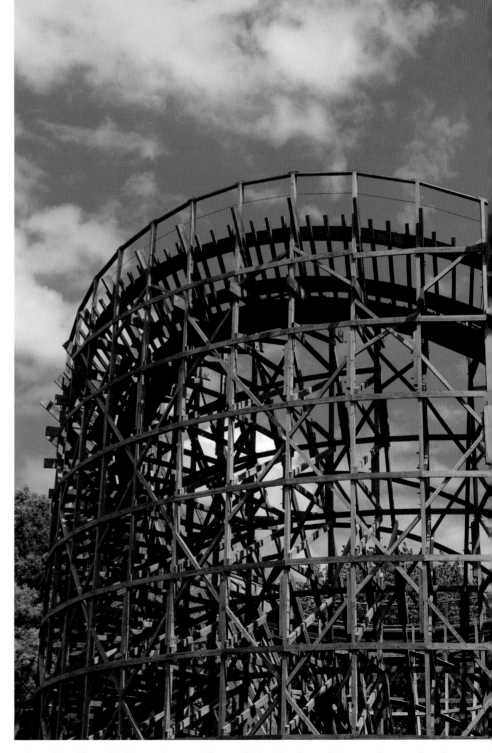

American Thunder is another excellent offering by Great Coasters International.

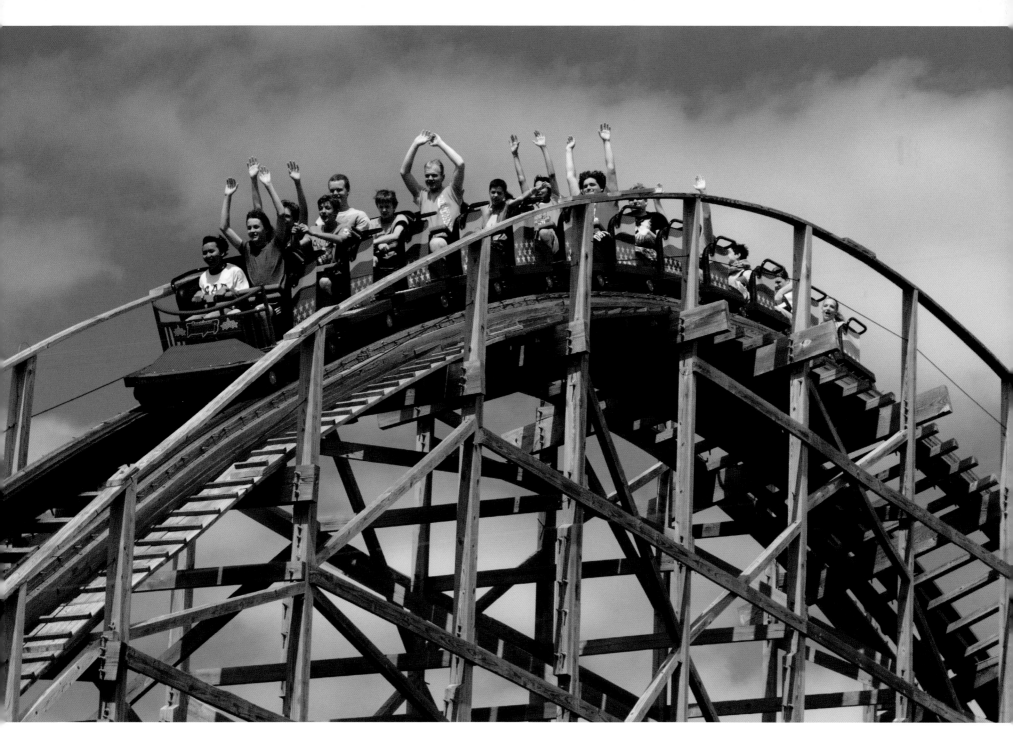

American Thunder employs a lot of airtime and constant directional changes to thrill riders.

FACING PAGE

LEFT: The feature element of this ride is the inside top hat.

TOP RIGHT: Luckily, the trains no longer have over-the-shoulder harnesses.

BOTTOM RIGHT: The train shoots up the spire before doing the whole thing again, but facing forward this time.

Riders are greeted by a well-themed entrance.

Mr. Freeze: Reverse Blast

OPENING DATE	April 1998
MAKE	Premier Rides
DESIGNER	Werner Stengel
MAX HEIGHT	218 feet
LENGTH	3,081 feet
MAX SPEED	70 mph
DURATION	2:45
INVERSIONS	1 (2 counting return trip)

Riders are electromagnetically launched from 0 to 70 miles per hour in a blistering 3.8 seconds. That's a faster launch than many high-end sports cars. It was launched forward-facing for thirteen years under the name Mr. Freeze until the park renamed it and altered the ride so passengers were launched backward. Normally this type of ride would have only one train since the track doesn't complete a circuit and must come back through the front of the station. However, this ride has two trains, thanks to an ingenious system that alternates trains by sliding them on and off the track. This makes the wait times borderline bearable.

Being launched backward is a unique thrill. The exhilarating part is that unless you've ridden it many times, you can't predict which way the train will turn next—even though you've studied it while waiting in line and think you know what to expect. Turning the trains around was the best possible thing that could have happened to this coaster. Ride this one soon after the park opens to avoid long lines.

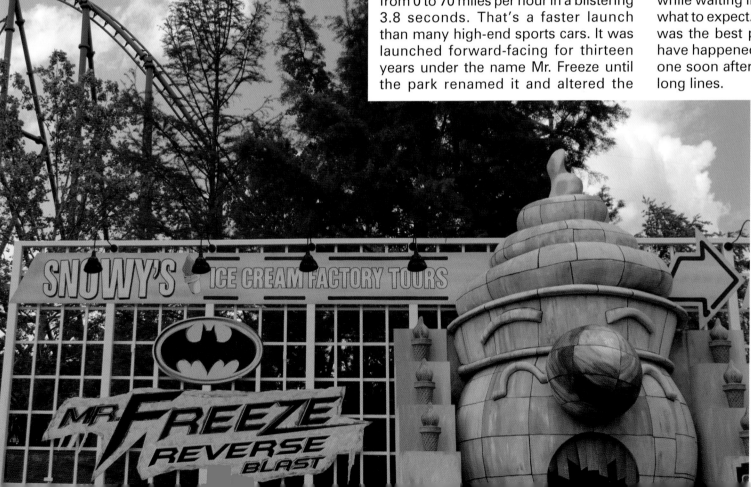

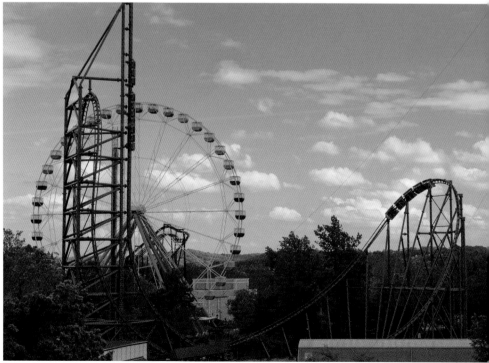

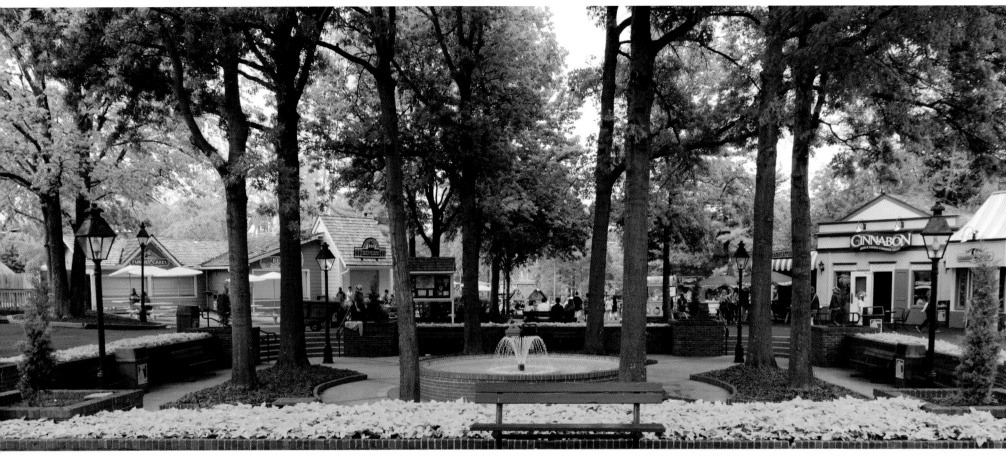

A relaxing square where visitors can sit and enjoy the surroundings.

Worlds of Fun
Kansas City, Missouri

This park has a clever theme. The Scandinavia, Africa, Europa, Orient, and Americana sections of the park are taken from Jules Verne's book *Around the World in Eighty Days*. This may be because a nearby town named Independence was part of the book's journey. Worlds of Fun was Cedar Fair's third acquisition when the company took it over in 1995, and they immediately updated the park's coaster landscape. Timber Wolf is the only coaster left over from the previous owners.

Today the park sports four solid roller coasters, and its Prowler has developed quite a fan following. So the next time you're in Kansas City, try to squeeze in a trip to Worlds of Fun between visiting the city's world-famous barbeque joints.

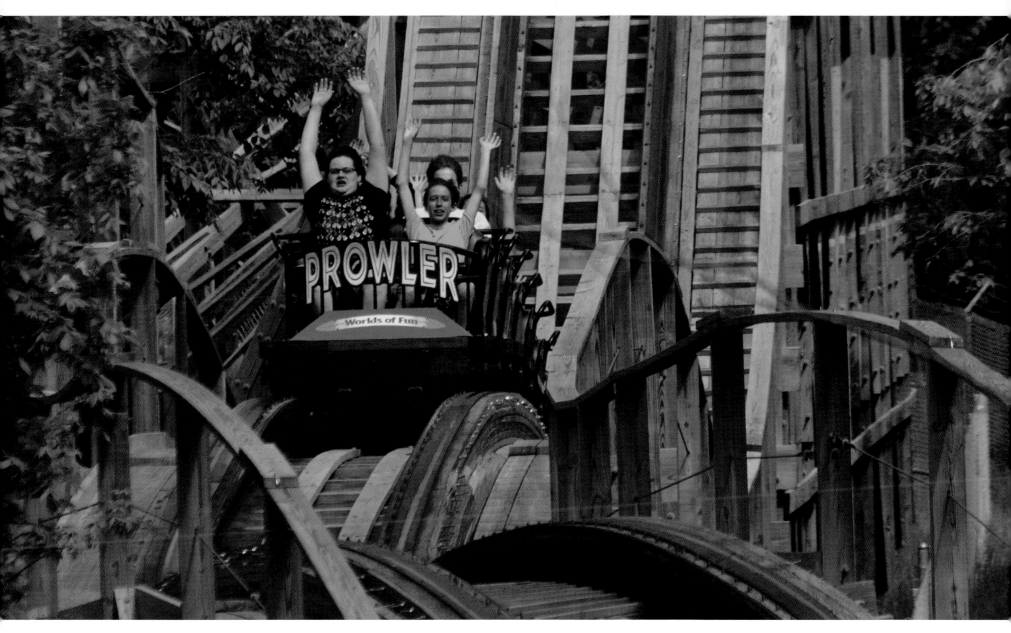

Prowler opened in May 2009, and is Worlds of Fun's second wood coaster.

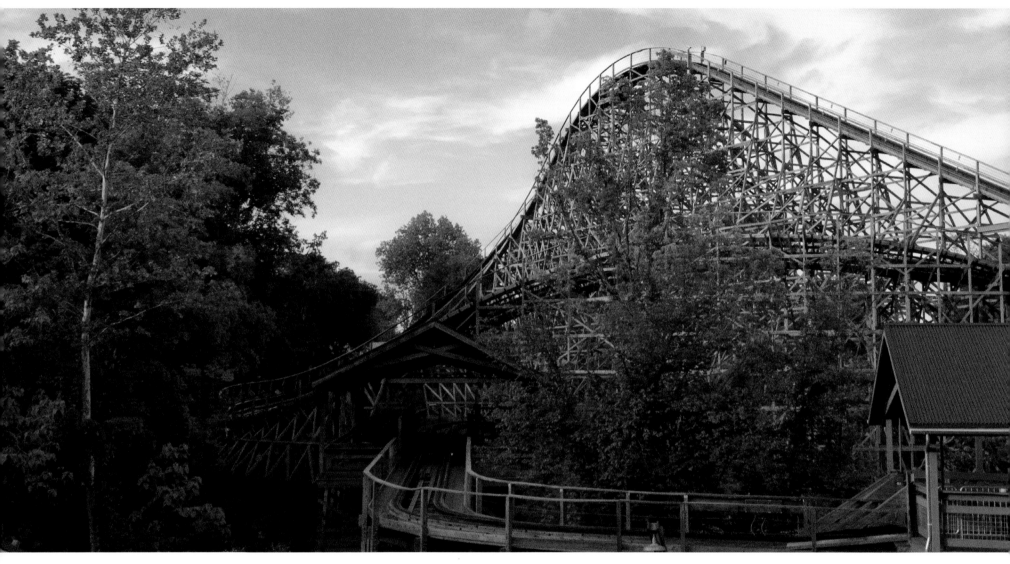

The lift hill is barely over 100 feet tall, but don't let that fool you.

The excellent product of Great Coasters International, Prowler shames bigger coasters everywhere. The intense speed combined with a constant barrage of turns makes this coaster a powerful little dynamo. It won't break any records, but that won't stop it from rising to the upper echelon on many enthusiasts' lists.

Like other GCI coasters, Prowler begs to be ridden often. Instead of steadily wearing you down, it makes you want to run from the exit to the entrance for another ride.

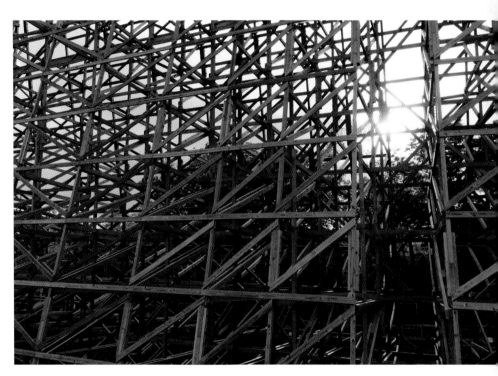

A trip on the park train will get you up close and personal with the structure.

FACING PAGE

TOP LEFT: Graceful curves make this rollover turn a joy to experience.

TOP RIGHT: The color scheme and white striping makes the ride pop out from its surroundings.

BOTTOM LEFT: There's nothing quite like blasting through the course with your legs dangling in space.

BOTTOM RIGHT: The station flyover, combined with the entrance signage, makes for a great first impression.

You get a good view of this ride as you enter the park.

Patriot

OPENING DATE	April 8, 2006
MAKE	Bolliger & Mabillard
MAX HEIGHT	149 feet (123-foot drop)
LENGTH	3,081 feet
MAX SPEED	60 mph
DURATION	2:18
INVERSIONS	4

Bolliger & Mabillard (B&M) is peerless in the world of inverted coasters. Vekoma is the only serious contender, and its inverteds are almost universally derided by coaster aficionados. Patriot is a smooth, solid, enjoyable ride, but it lacks the aggressiveness of some of the company's other efforts. That's odd, because the layout of this ride seems similar to Dorney Park's Talon. Patriot is taller and faster than Talon, but somehow it lacks the forcefulness of its cousin back East. Whether or not you see that as a positive or negative is a matter of taste. Regardless, Patriot is a beautiful ride no matter how you slice it.

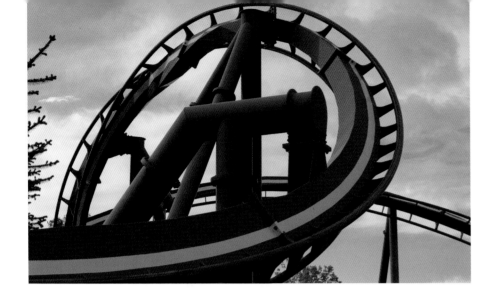

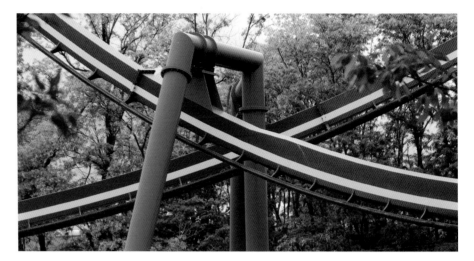

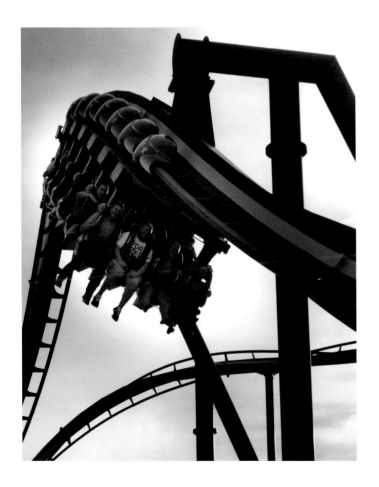

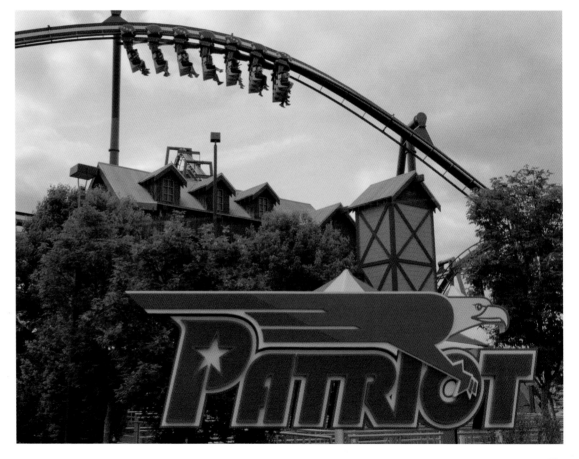

Mamba

OPENING DATE	April 18, 1998
MAKE	Morgan
MAX HEIGHT	205 feet (205-foot drop)
LENGTH	5,600 feet
MAX SPEED	75 mph
DURATION	3:00
INVERSIONS	0

FACING PAGE

LEFT: The train enters the back double helix near sunset.
RIGHT: Depth compression makes these two camelback hills look impossibly steep.

The train returns to the station after some bunny hills.

Here's another instance where Cedar Fair took a wildly successful roller coaster from Dorney Park and moved it west to Worlds of Fun. Mamba was the first roller coaster Cedar Fair built after taking control of the park in 1995. With only minor differences, this out-and-back steel with a double helix turnaround is a near twin of its older brother. That's not a bad thing, because Mamba has great airtime hills and a thrilling first drop, especially if you're in the back. One edge Mamba does have is its looks. While Steel Force is pretty, Mamba has a striking profile and there are some gorgeous shots to be had.

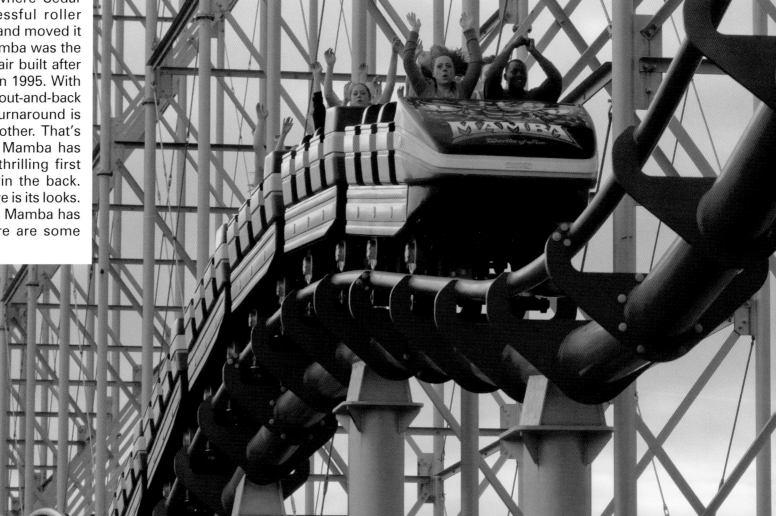

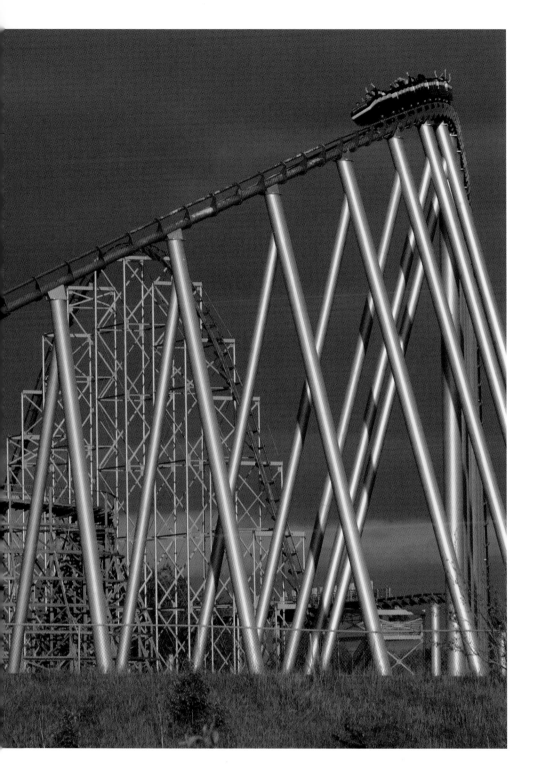

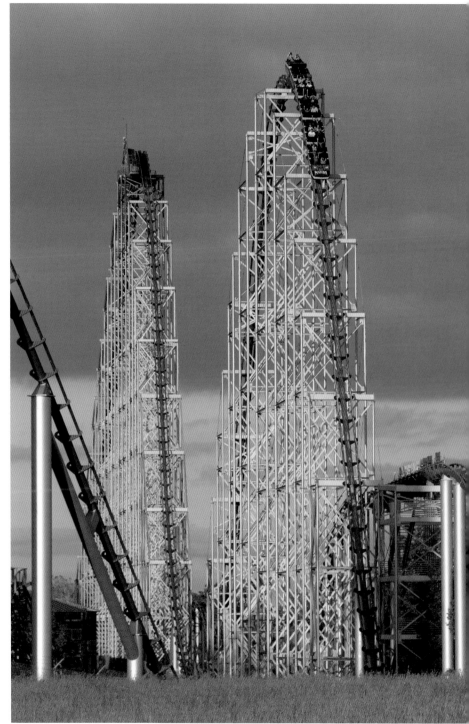

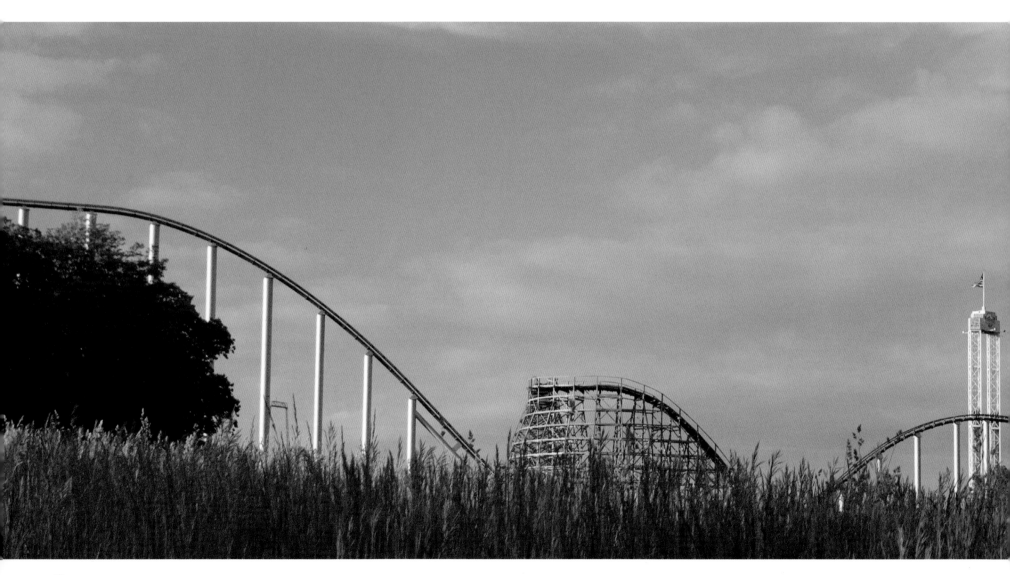

The profile from outside the park is quite striking.

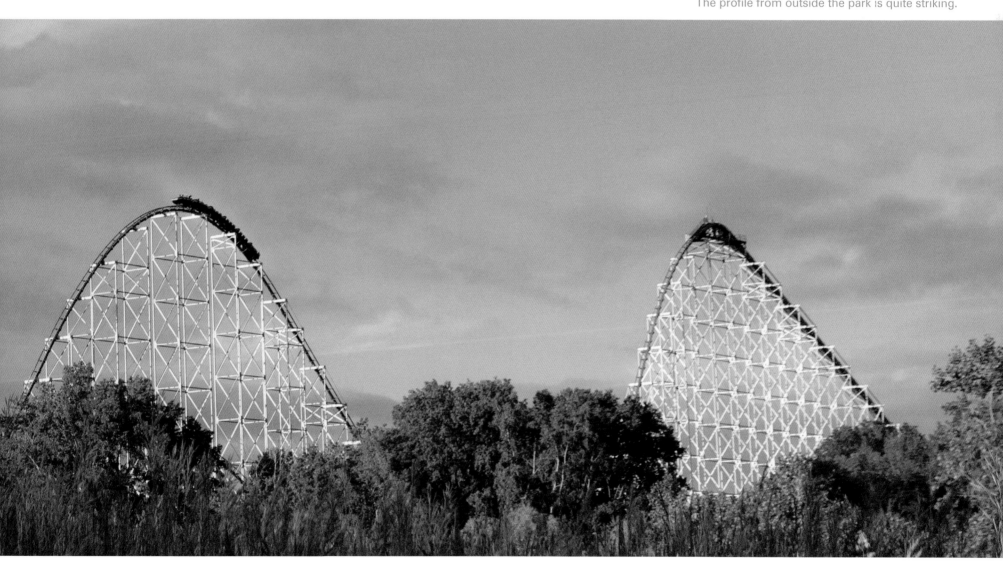

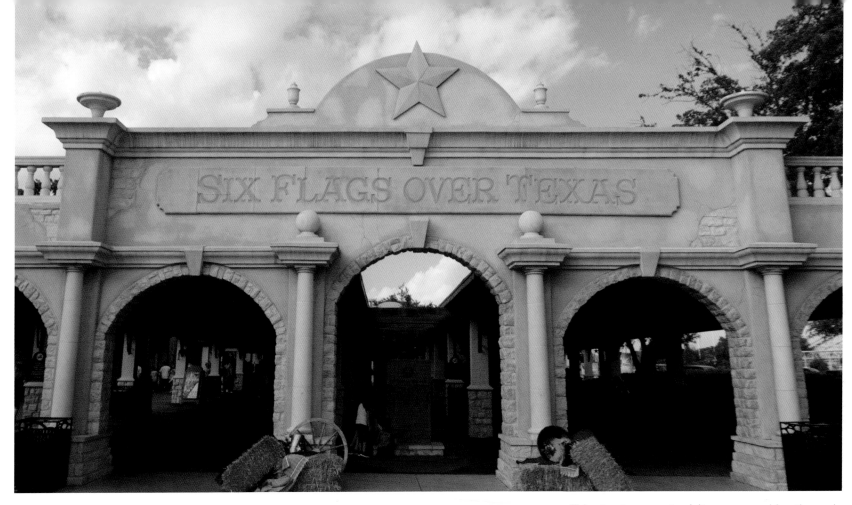

This structure greets visitors approaching the park.

Six Flags Over Texas

Arlington, Texas

This is the place where it all started. Opening in 1961, Six Flags Over Texas is the original Six Flags theme park. The name refers to the six nations whose flags flew over Texas during its history (Spain, France, Mexico, the Republic of Texas, the Confederate States of America, and the United States of America). The park originally featured a separate themed area for each nation, but has since deviated from that plan by adding other themes. The park's first owner, Angus G. Wynne Jr., opened a second Six Flags near Atlanta before selling his interest in the parks to limited partnerships. The parks have experienced regular ownership changes throughout the brand's history. Six Flags Over Texas is home to a wide variety of roller coasters—everything from a classic white woodie to a state-of-the-art wood/steel hybrid.

La Vibora is a steel bobsled coaster. Ride it when the park opens to avoid long wait times.

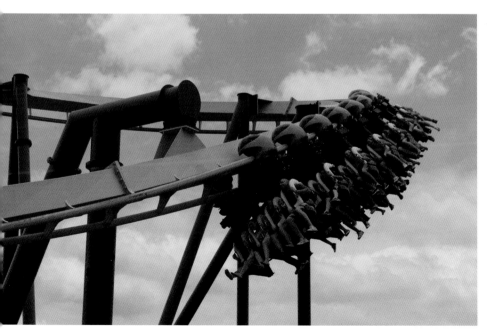

Just about every Six Flags has a Batman: The Ride, and Six Flags Over Texas is no exception.

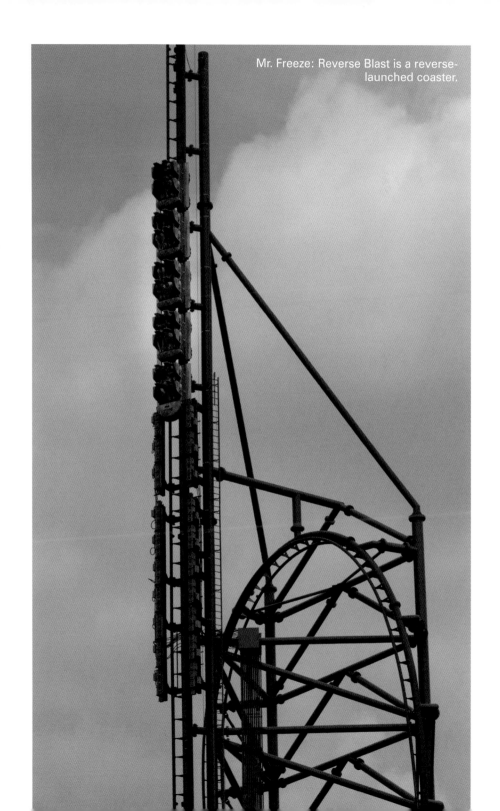

Mr. Freeze: Reverse Blast is a reverse-launched coaster.

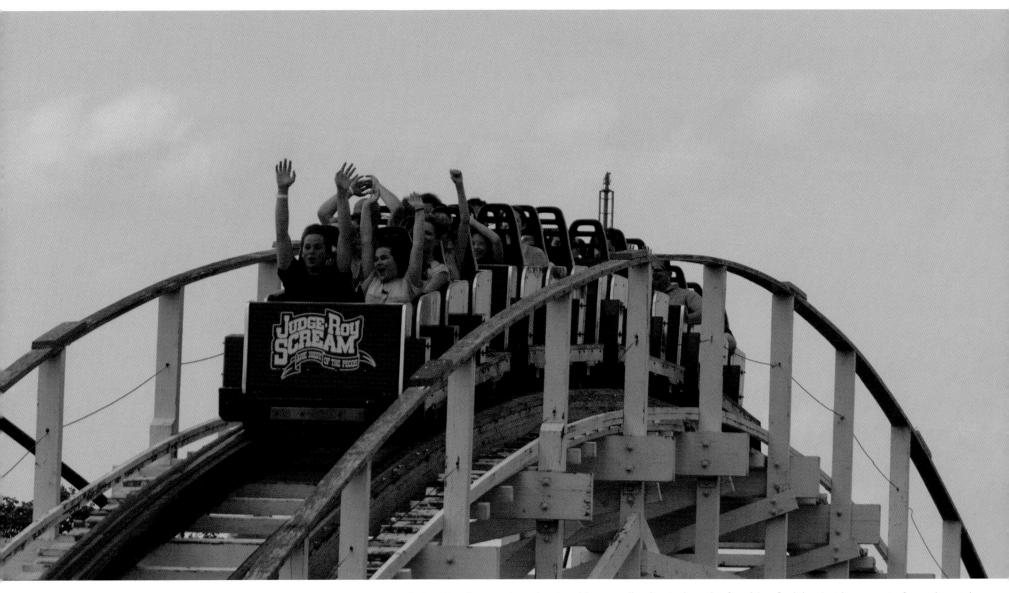

Judge Roy Scream is a classic white woodie situated on the far side of a lake that is separate from the park proper. Riders need to walk through a tunnel to get to the ride's entrance.

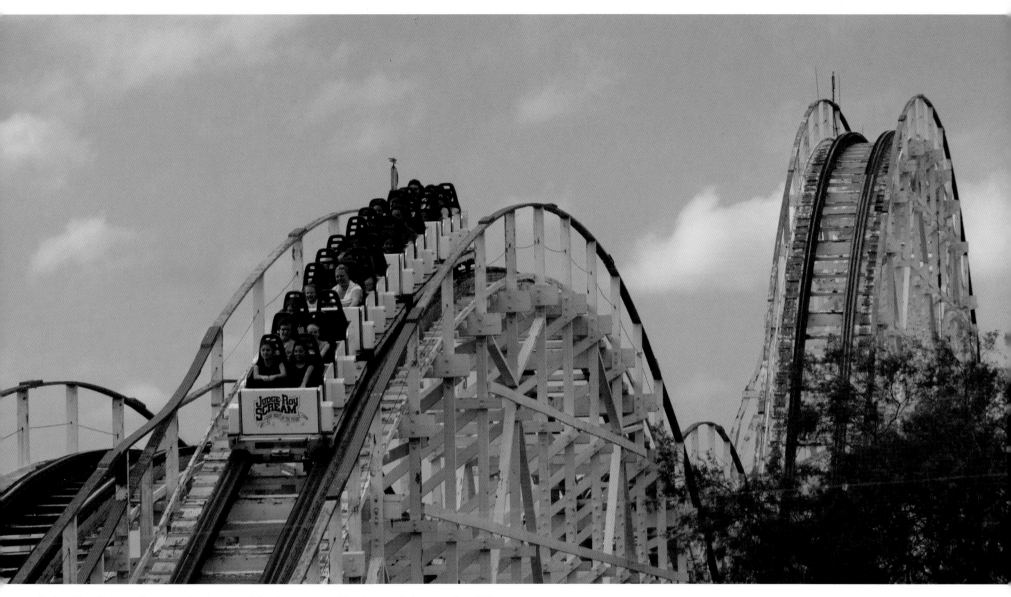

Judge Roy Scream is a standard out-and-back coaster with plenty of chances for airtime.

Titan

OPENING DATE	April 27, 2001
MAKE	Giovanola
DESIGNER	Ing.-Büro Stengel GmbH
MAX HEIGHT	245 feet (255-foot drop)
LENGTH	5,312 feet
MAX SPEED	85 mph
DURATION	3:30
INVERSIONS	0

This was the last coaster Giovanola built before spiraling into bankruptcy and then going out of business. The ride is similar to Goliath at Six Flags Magic Mountain; the main differences are a taller lift hill and an added 540-degree helix.

Titan is not for the faint of heart. The nearly consecutive 540-degree helixes (one going up and one coming down) take their toll on the body after repeat rides. I personally can't ride it more than three or four times before tapping out. While the ride is taxing, the structure is a site to behold. Its massive size reinforces the saying, "Everything's bigger in Texas."

FACING PAGE

LEFT: After the first drop, the train does an about face and races back to the heart of the ride.

RIGHT: Near dusk the sunlight hits the track perfectly.

This bit of track is between the upward and downward helixes.

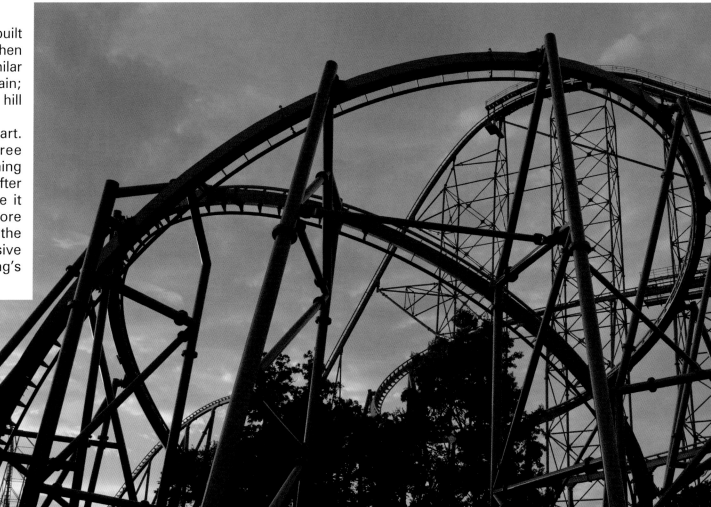

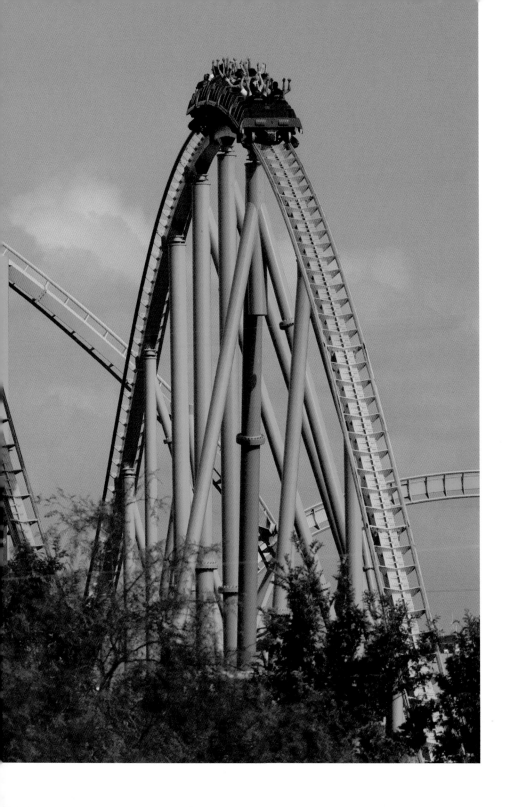
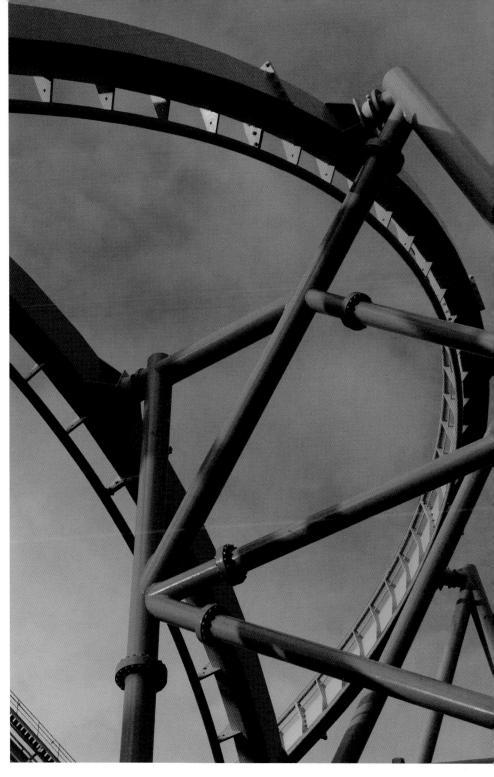

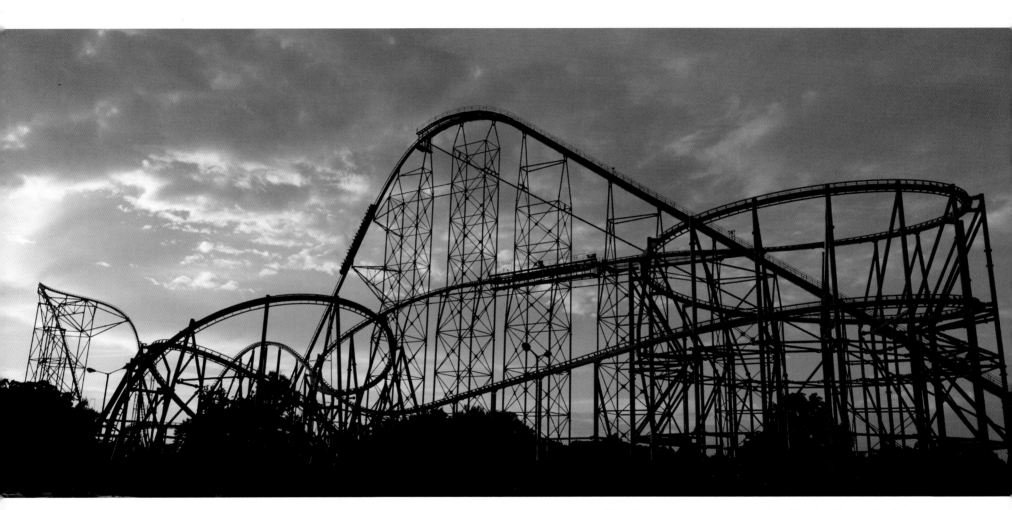

Even though there is over a mile of track, this coaster looks compact.

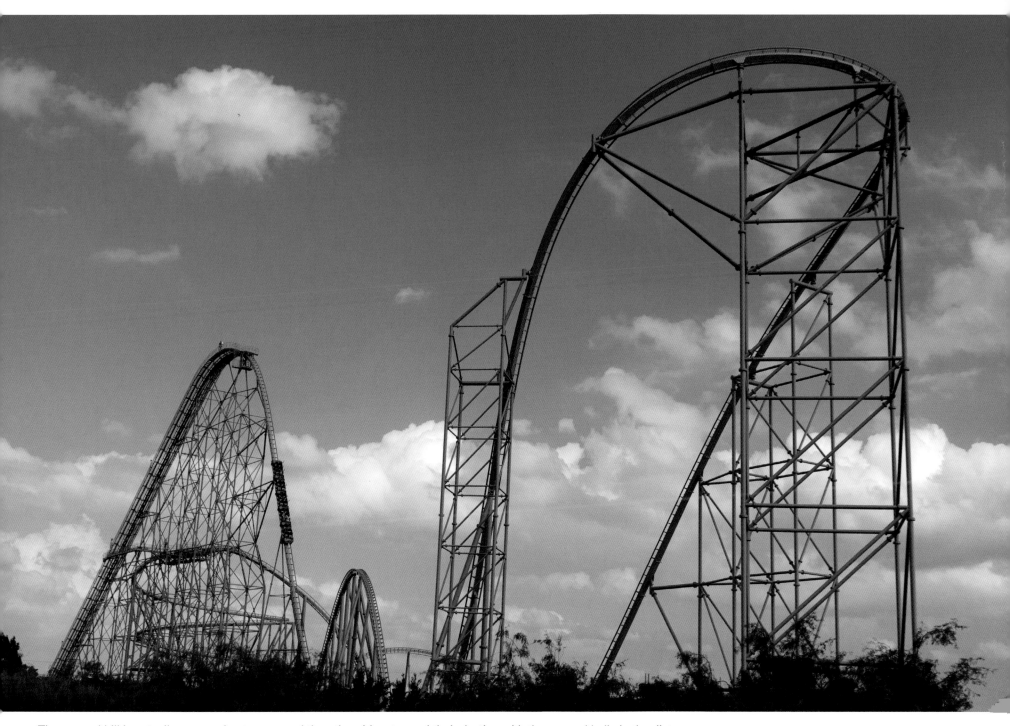

The second hill is actually a sweeping turnaround thrusting riders toward their destiny with the upward helix in the distance.

New Texas Giant

OPENING DATE	April 22, 2011
MAKE	Rocky Mountain Construction
DESIGNER	Alan Schilke
MAX HEIGHT	153 feet (147-foot drop)
LENGTH	4,200
MAX SPEED	65 mph
DURATION	3:25
INVERSIONS	0

This story is a familiar one. The Texas Giant wood roller coaster opened up in 1990 to favorable reviews, but like a lot of contemporary woodies that sought to break height and speed records, the ride experience degraded quickly. After repeatedly failing to improve it, Six Flags hired a relatively young coaster company called Rocky Mountain Construction (RMC) to build its first roller coaster and transform Texas Giant into something new.

The New Texas Giant was born. RMC's unique I-Box technology transformed the ride in significant ways. The lift hill was raised and the angle of descent steepened from 53 degrees to 79 degrees. While there are no inversions, the ride has a 90-degree banked turn and an overbanked 115-degree turn. Add to that a lot of great airtime and you have a new steel coaster that shot to near the top of many enthusiasts' lists.

This ride is perhaps the first true hybrid of steel and wood. Sure, there have been rides with wood structures and steel track, and steel structures with wood track, but in the end the type of coaster is determined by the track beneath the wheels. In this regard New Texas Giant is a steel coaster, but I call it a hybrid because it is the first steel coaster that behaves like a wood one. This new technology takes the best of both worlds and combines them in a revolutionary way.

With oil derricks, fancy trains, and twisting track, New Texas Giant is a visceral experience.

FACING PAGE

The 79-degree first drop sets the stage for a magnificent run.

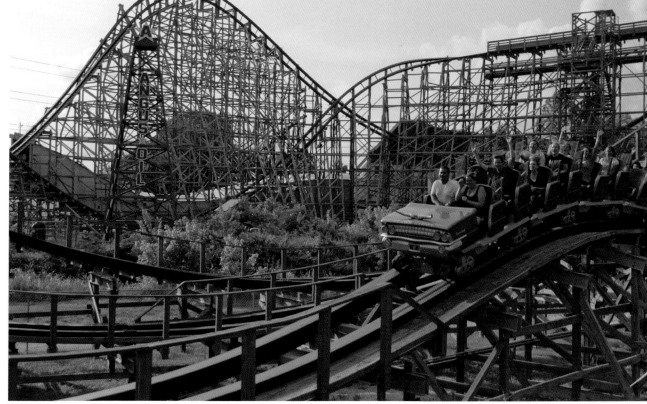

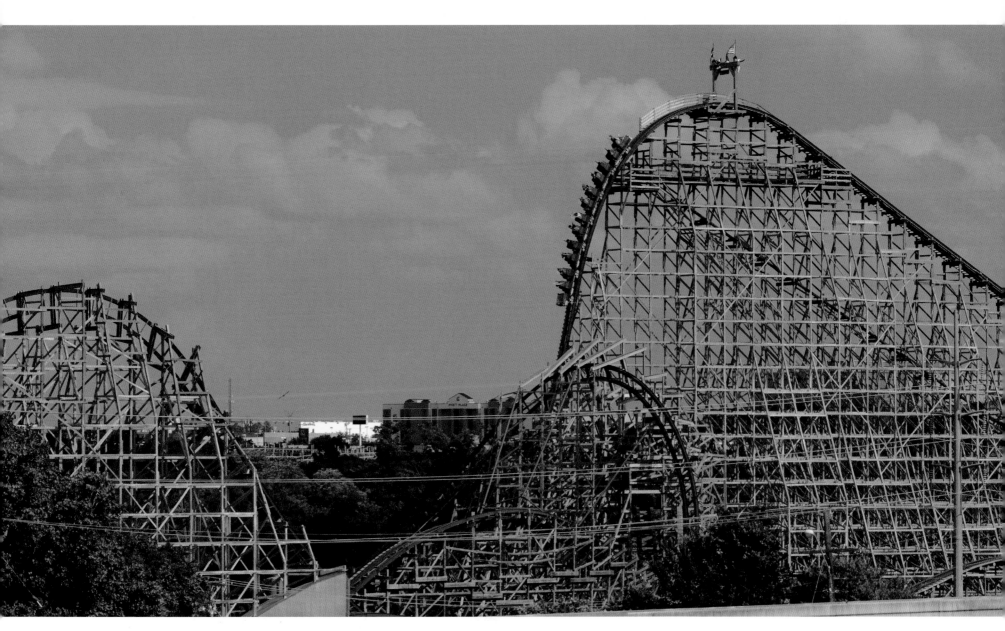

The trains are modeled after a big Texas Caddy complete with steer horns.

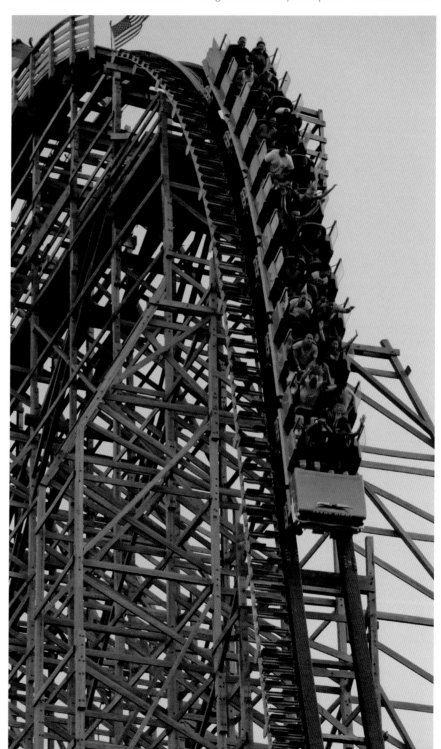

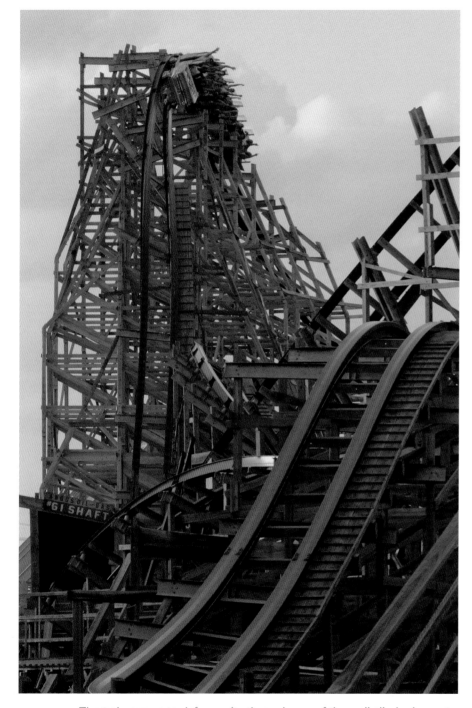

The train seems to defy gravity through one of the wall climb elements.

Night rides on the New Texas Giant are superb, especially when you speed through the "disco tunnel."

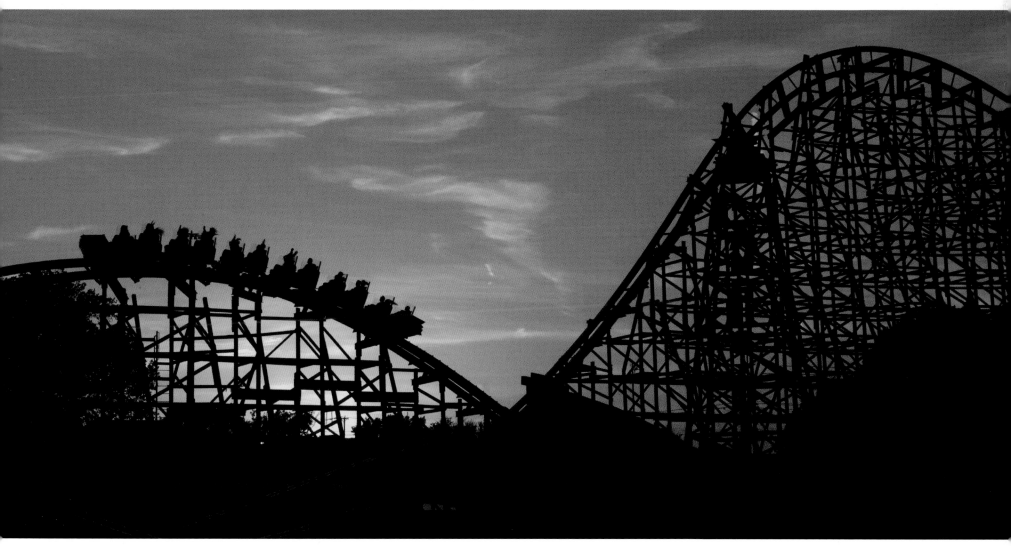

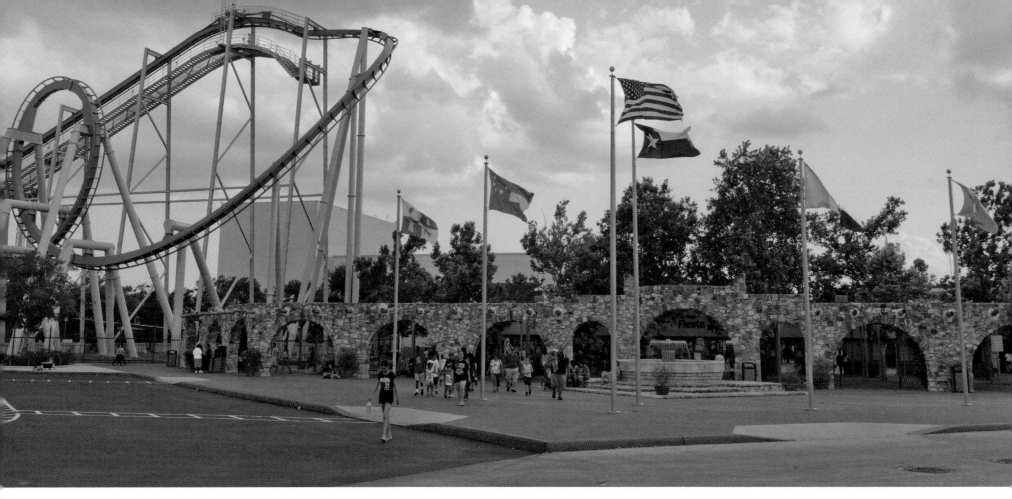

The six flags fly proud at the entrance.

Six Flags Fiesta Texas

San Antonio, Texas

This park has a very unusual characteristic: the entire park was built inside a mined-out quarry. The Beckman quarry started in 1934, and the area where the park resides ceased operations in 1988. Like many Six Flags Parks, this one has a complicated past. It was originally envisioned as a musical show park, but that idea was abandoned in favor of a more traditional theme park setup. The park lost money even though it met attendance projections, and Six Flags purchased management rights in 1996. The best thing about Fiesta Texas is that both Superman: Krypton Coaster and Iron Rattler use the quarry walls to great effect. The park also has an eclectic collection of coasters headlined by Batman: The Ride, a new 4-D roller coaster that opened in 2015.

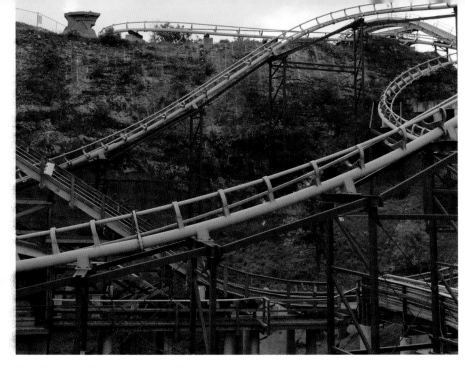

Road Runner Express is one of the better mine train coasters.

Goliath is one of only two Batman-style inverteds in a Six Flags park that is not called Batman: The Ride.

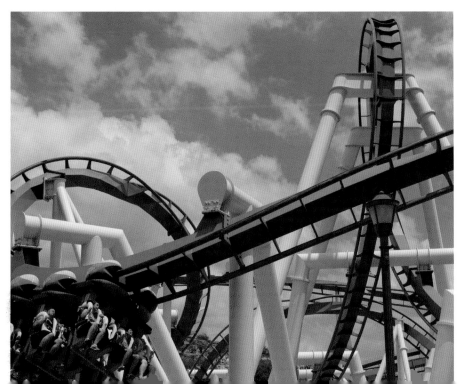

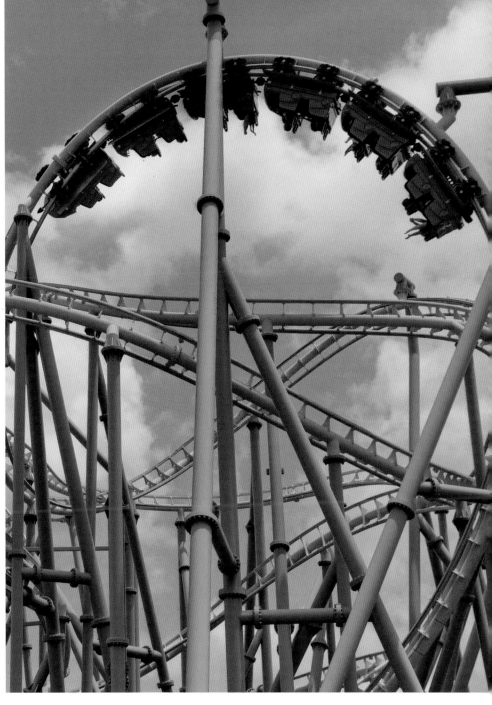

Poltergeist opened within a month of The Joker's Jinx at Six Flags America. They are nearly identical in layout.

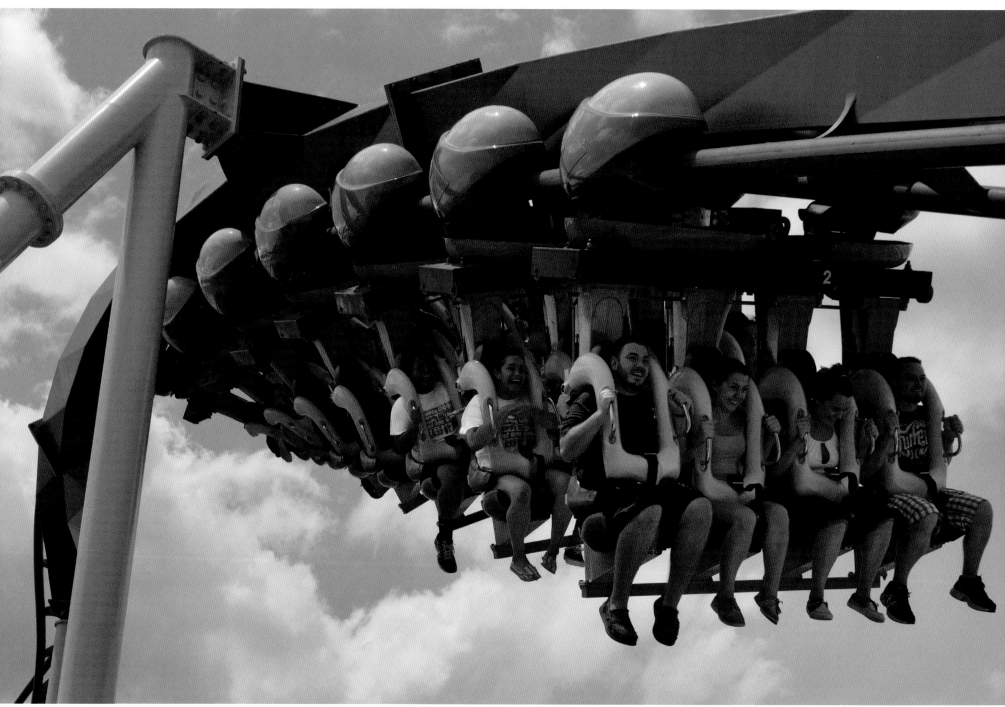

Poltergeist launches its trains using LIM (Linear Induction Motor) technology at speeds of 60 miles per hour in just 3.5 seconds.

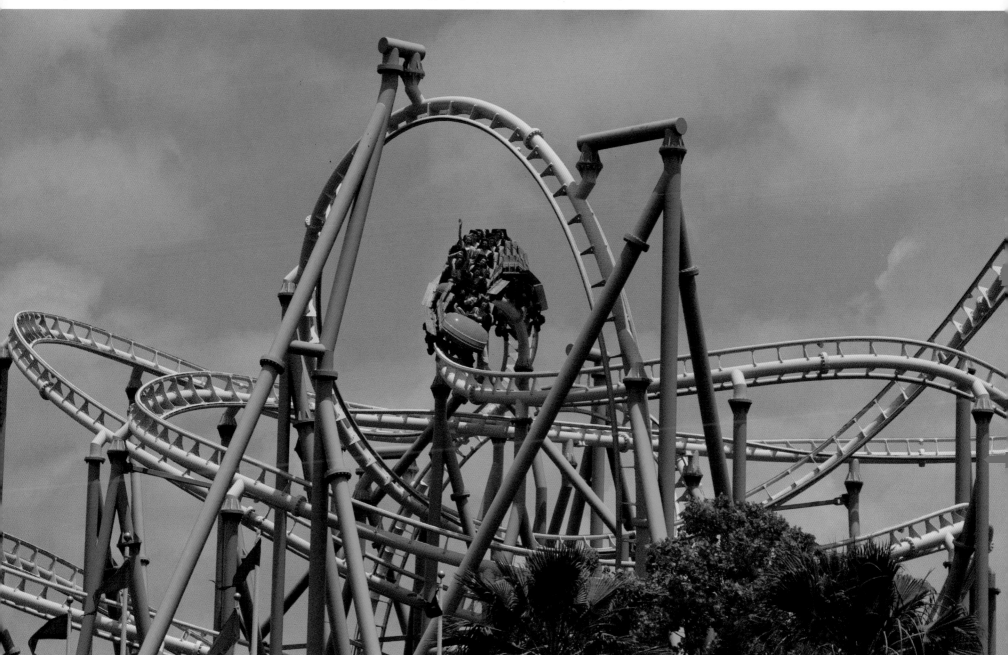

Superman: Krypton Coaster

OPENING DATE	March 11, 2000
MAKE	Bolliger & Mabillard
DESIGNER	Ing.-Büro Stengel GmbH
MAX HEIGHT	168 feet (163-foot drop)
LENGTH	4,025 feet
MAX SPEED	70 mph
DURATION	2:35
INVERSIONS	6

Superman himself stands atop what used to be the tallest vertical loop in the world. A seventh inversion was removed from the ride's original design to create the record-breaking loop. The train slows to a crawl as it crests the top of the loop, giving riders an almost weightless feeling. This floorless coaster may be the best of its kind.

Riders start their journey by climbing the quarry wall, only to turn around and plummet back down into the massive loop. From there it leaps back up on top of the quarry for another dive that leads into a zero-g roll. From there the riders are subjected to inversion after inversion before arriving back at the station, breathless.

FACING PAGE

TOP LEFT: After the mid-course brake run, riders are treated to a series of rolls before the conclusion.

BOTTOM LEFT: The nested track travels in every imaginable direction.

RIGHT: The loop is every bit as imposing at it seems.

This larger than life Superman watches over riders as they fall back to Earth.

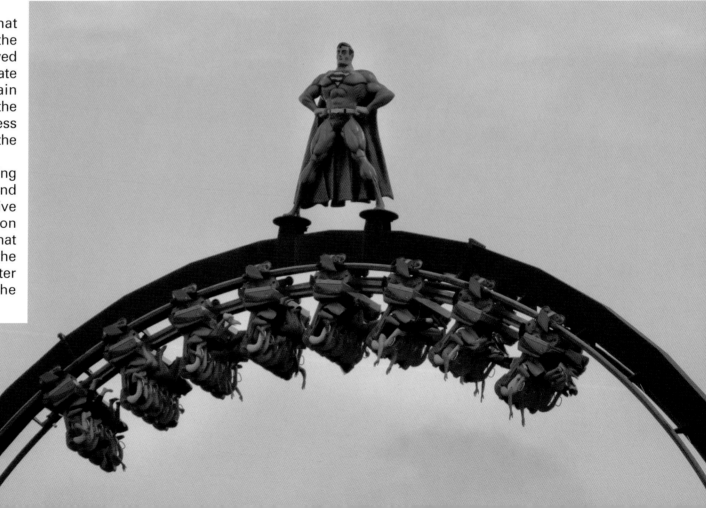

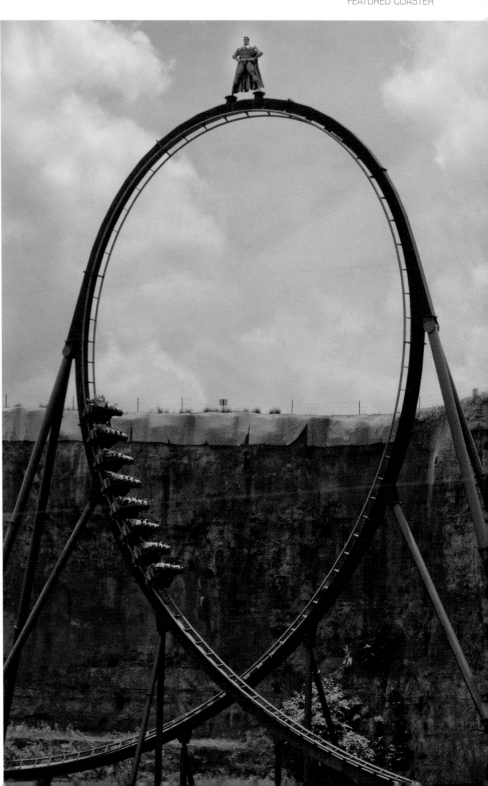

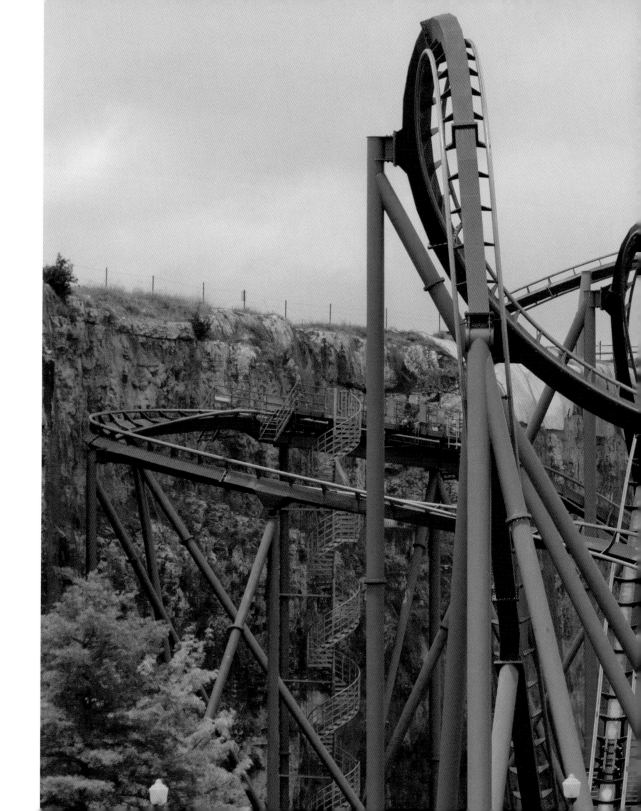

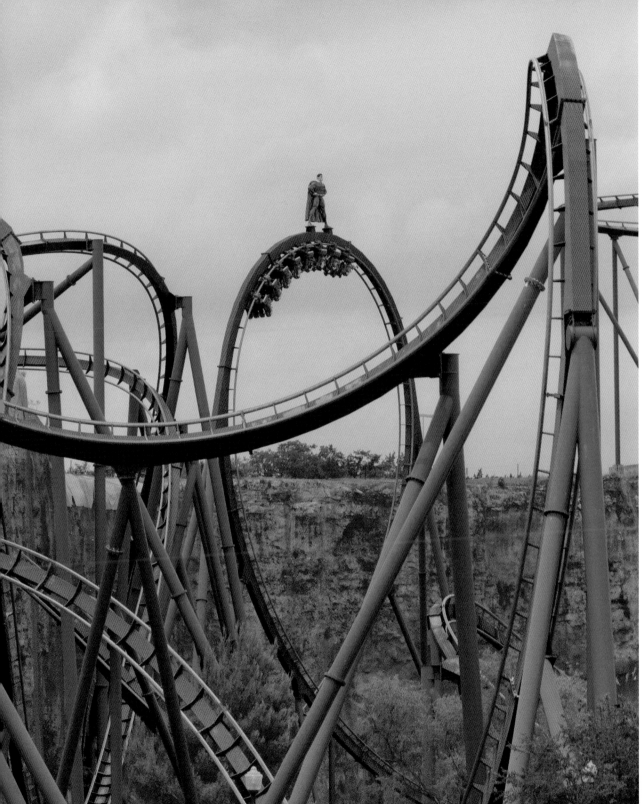

There are some great vantage points of this ride that let you get up close and personal.

Iron Rattler

OPENING DATE	May 25, 2013
MAKE	Rocky Mountain Construction
DESIGNER	Alan Schilke
MAX HEIGHT	179 feet (171-foot drop)
LENGTH	3,266 feet
MAX SPEED	70 mph
INVERSIONS	1

The story of this ride is eerily similar to the New Texas Giant. The Rattler opened in 1992 as the tallest and fastest wooden coaster in the world. Its signature feature was a behemoth triple helix. As with the Texas Giant, the ride quickly degraded into a rough and nasty experience. The 166-foot drop at 73 miles per hour created too much force for the coaster to bear, so Six Flags shortened the drop. The 42-foot reduction killed the ride's top speed and turned the triple helix into a lazy, pothole ridden affair.

Queue RMC to ride in and save the day. Its conversion of The Rattler into Iron Rattler using the company's trademark I-Box technology was a revelation. The first drop increased from 166 feet to 171 feet, but the overall length was shortened by over 1,500 feet. Most of that reduction came from removing the triple helix, with the train just skirting the outside perimeter of the old structure. Even with the shortened track, this coaster still manages a couple of overbanked turns, a zero-g roll, and a fabulous ejector-air-filled finishing drop over the quarry wall and through a colorfully lit tunnel. I recommend the front seat, but you'll find plenty of people who enjoy the back. You can't go wrong on this ride.

FACING PAGE

The 81-degree first drop is a dramatic, near-vertical start to this great coaster.

Riders tackle a wall climb as they circle back around toward the zero-g roll.

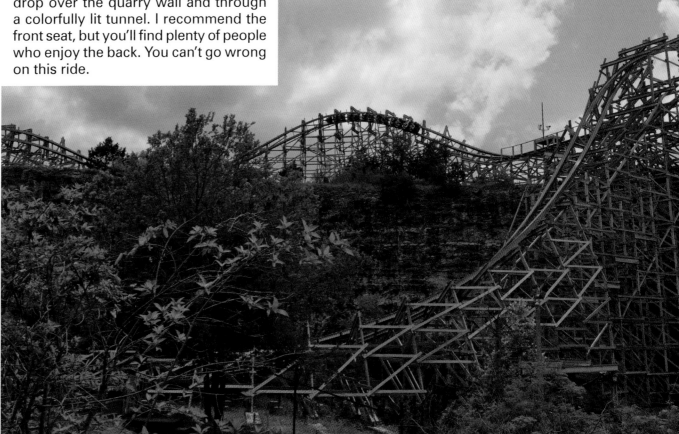

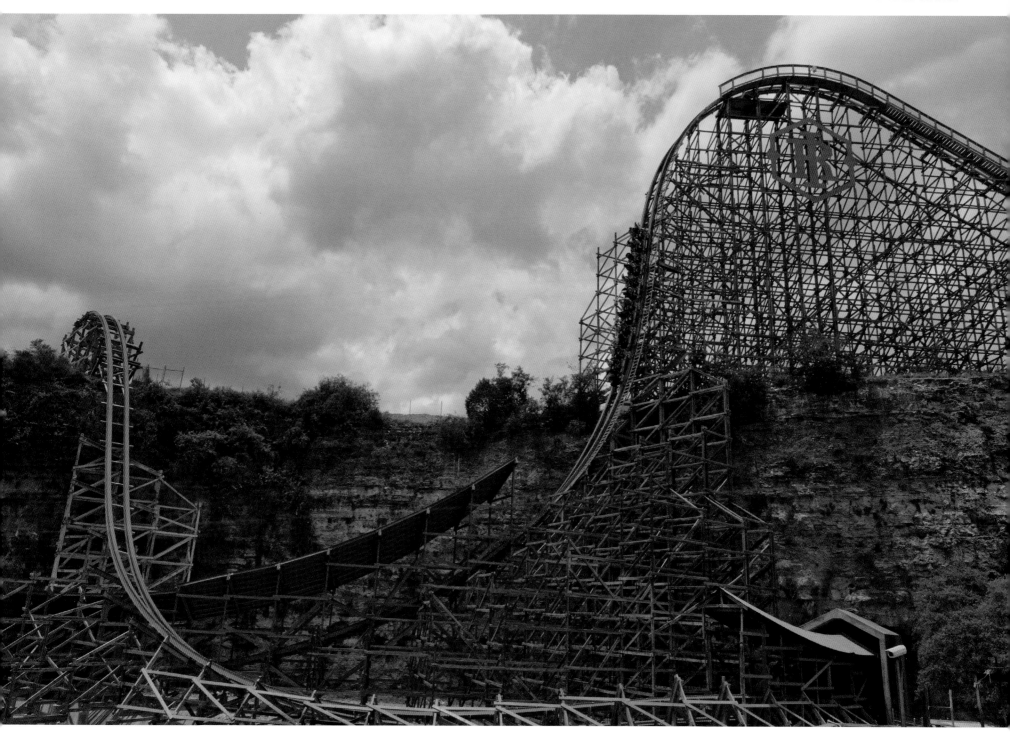

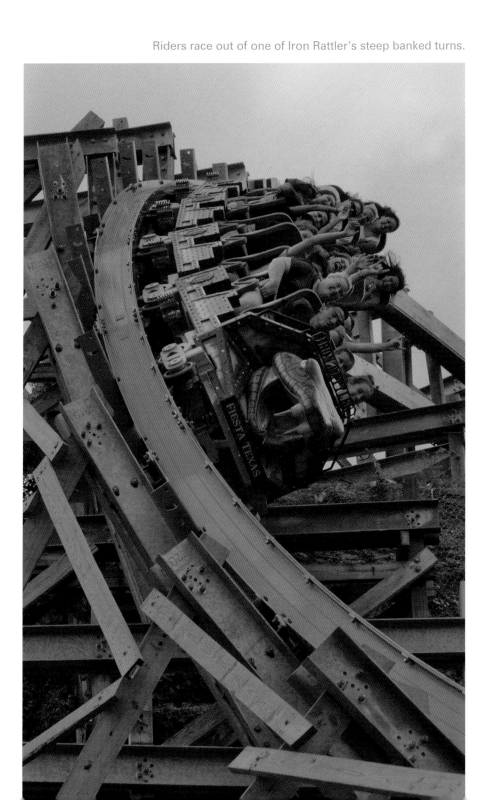

Riders race out of one of Iron Rattler's steep banked turns.

The unique train has the head of a snake and a rattle protruding from the back car.

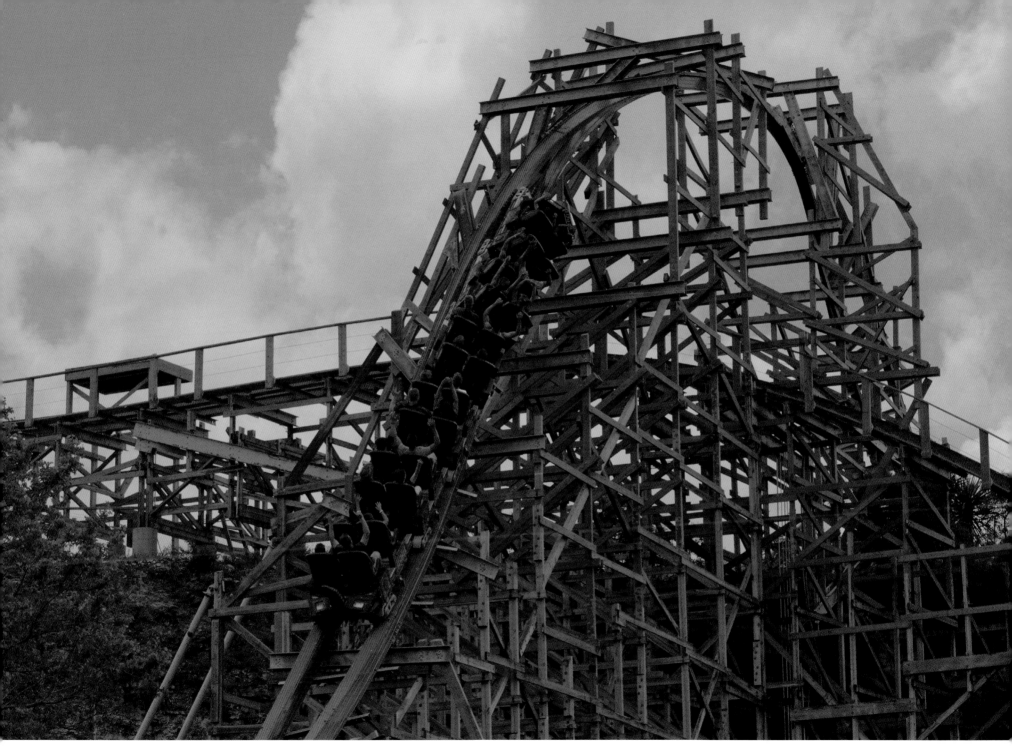

The train enters the zero-g roll, the coaster's only inversion.

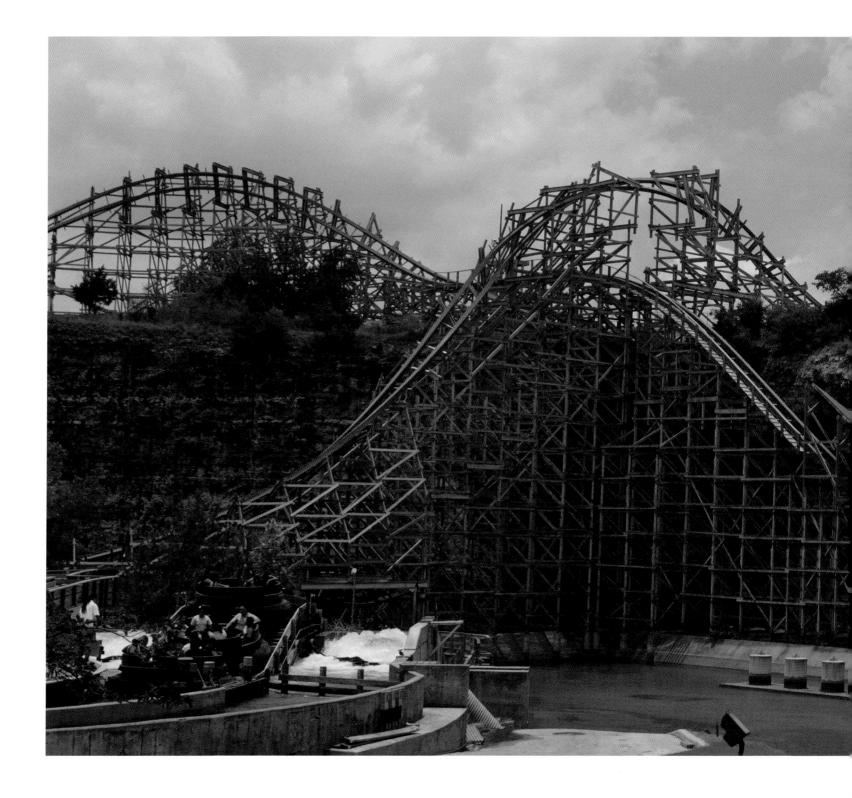

In addition to being a thrill a second, it's also a beautiful work of art.

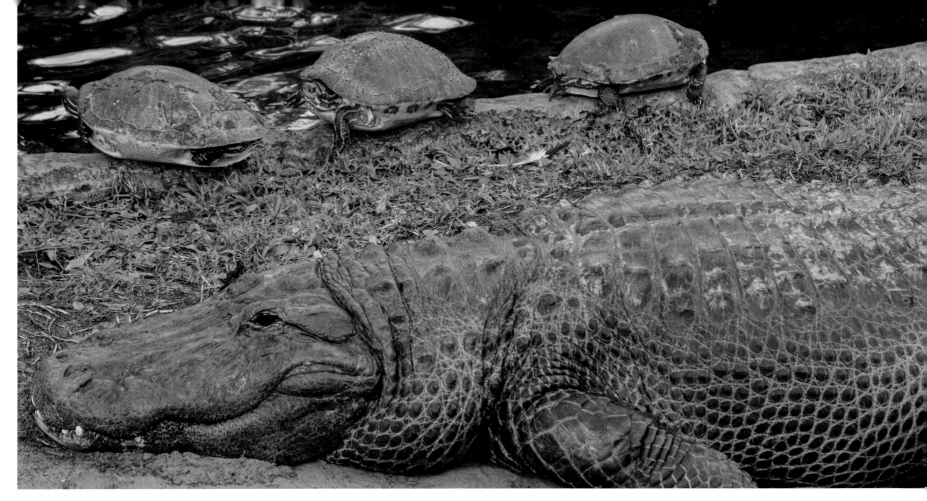

Busch Gardens Tampa started out as an animal park.

Busch Gardens Tampa

Tampa, Florida

In 1959, the park opened first as an admission-free hospitality facility for Anheuser-Busch where visitors could attend beer tastings and wander through a bird garden that still exists. The park was later expanded to include free-roaming African animals in its Serengeti Plains. Fast forward to 1976 when the first roller coaster, Python, was introduced. Today, the animal park features eight roller coasters and is divided into many areas, most of them African-themed. Busch Gardens Tampa draws just over 4 million people a year, far fewer than the heavy-hitters in Orlando, Florida, but at or near the top of the heap for all other major parks in the United States.

The flora and fauna around the park make for a pleasing atmosphere.

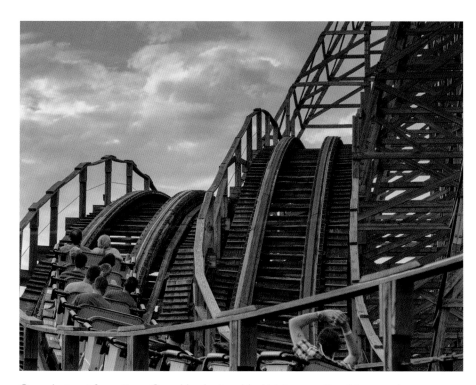

Gone but not forgotten: Gwazi had a troubled history as the ride experience degraded into a rough-and-tumble affair. It closed in 2015 and has since been demolished. Time will tell what replaces it.

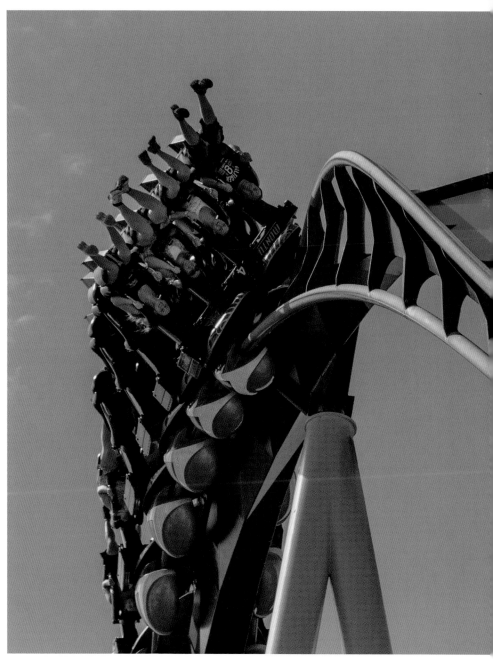

Riders zoom through one of Montu's inversions.

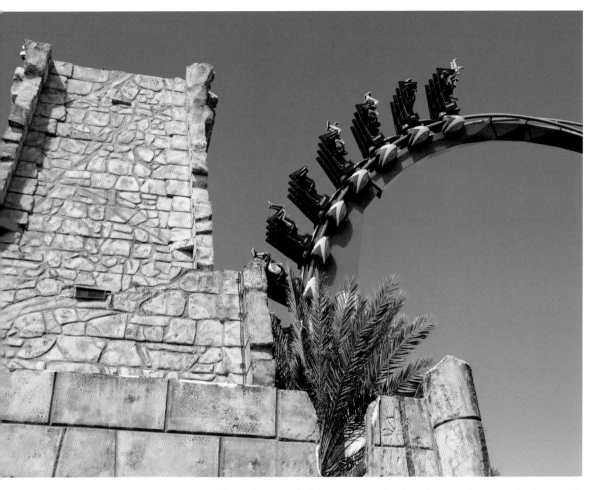

Montu is regarded by many as the best inverted coaster in the world.

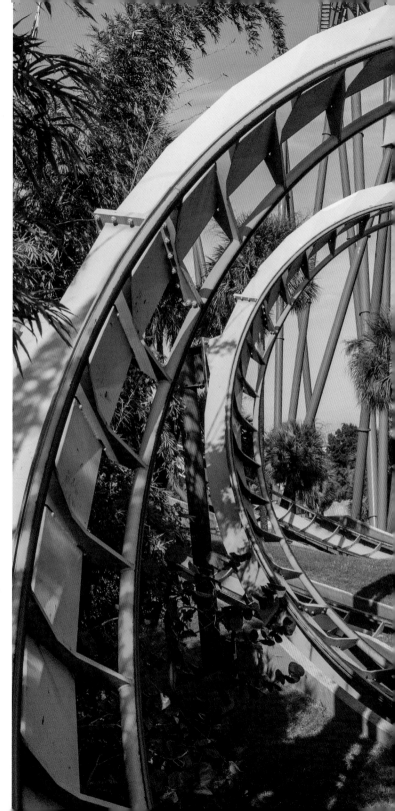

Kumba might be the most eye-catching coaster around. It's a feast for the eyes while also providing an exceptional ride experience.

Kumba burst onto the scene in 1993 with the world's tallest vertical loop and instantly became Busch Gardens Tampa's signature ride. In the late nineties it was regarded as a top-five steel coaster. Today it's still within the top fifty, no small feat considering the huge number of coasters that came on the scene in subsequent years.

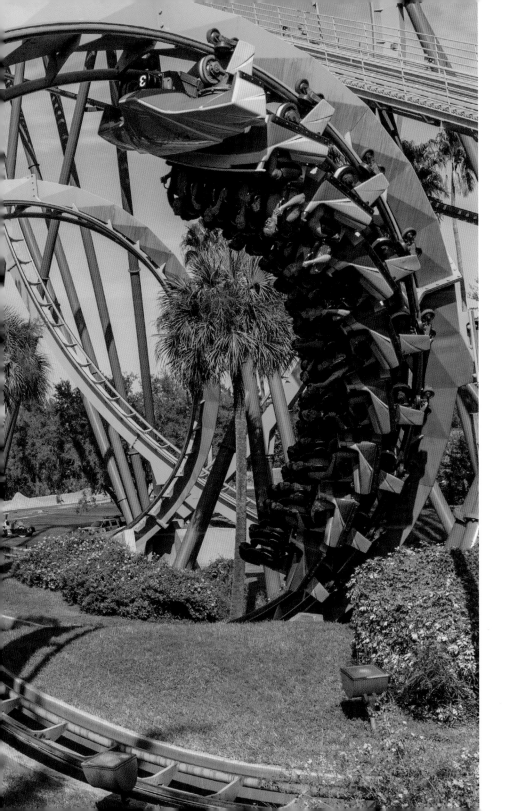

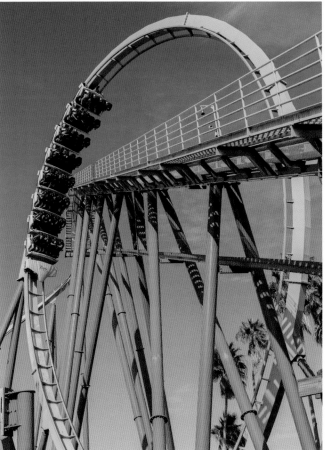

Kumba's most recognizable feature is the loop that encircles the lift hill.

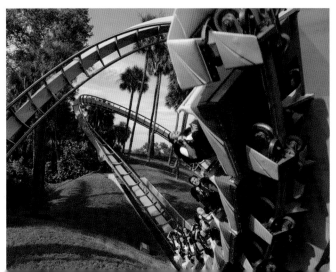

Unlike its newer contemporaries, Kumba's trains have floors.

Cheetah Hunt

OPENING DATE	May 27, 2011
MAKE	Intamin AG
MAX HEIGHT	102 feet (130-foot drop)
LENGTH	4,429 feet
MAX SPEED	60 mph
DURATION	3:30
INVERSIONS	1

Few coasters tell a story through their layout and design. Cheetah Hunt illustrates the hunting habits of this magnificent beast. After a timid launch out of the station, riders are treated to a full-on 60 miles per hour launch up a hill and into the figure-eight element that is the tallest part of the ride. This element personifies the cheetah circling, biding its time before engaging its prey.

The figure eight drop-out sends riders on a romp through the plains, staying close to the ground as much as possible. Rapid changes of direction emulate the cheetah's pursuit of its meal, and once the mighty beast locks onto its target, riders are launched again as the cheetah overtakes its prey to finish the ride.

This nearly flawless execution shows that a coaster doesn't have to be just a collection of hills and turns on a plot of land. Cheetah Hunt is great fun but could use more speed. I want to feel the thrill of dashing through the grass on the back of the world's fastest land animal. Instead, I felt like a spectator following closely behind.

That's not to say it's a bad ride. It's actually quite good. This criticism is the kind you level against something you thought had a chance to be unforgettable, but instead was merely excellent.

To coincide with the coaster's launch, Busch Gardens opened Cheetah Run, a cheetah habitat that allows visitors to watch live cheetahs do what they do best. All in all, Cheetah Hunt is a distinctive ride that meshes well with Busch Gardens Tampa's already superlative coaster collection.

FACING PAGE

TOP LEFT: Visitors are treated to a great view of the iconic figure eight.

TOP RIGHT: The shortened train allows for sudden changes of direction.

BOTTOM: The train crests a small hill after the initial launch out of the station and heads towards the main launch, which will catapult riders atop the figure eight.

The train dives out of the figure eight.

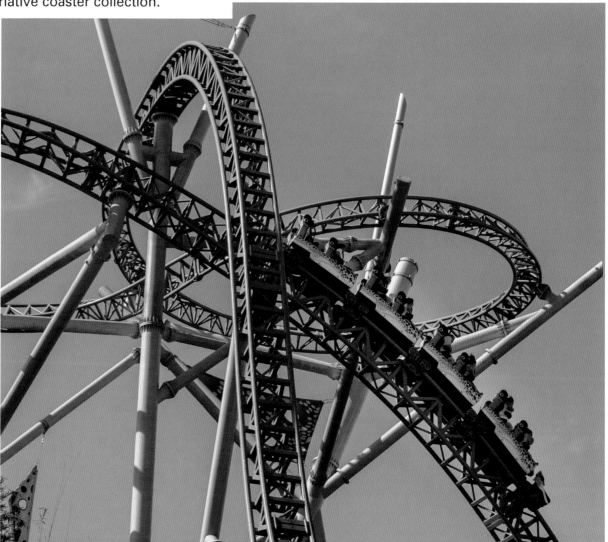

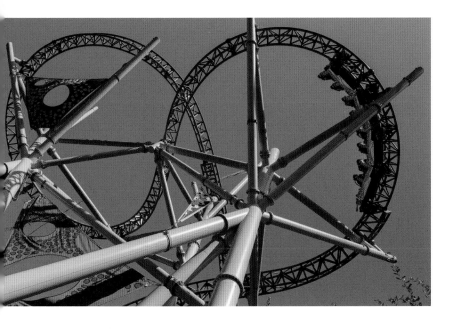

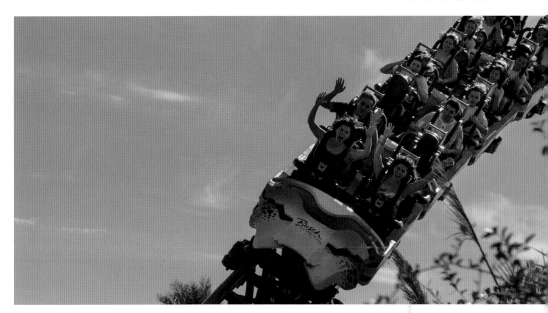

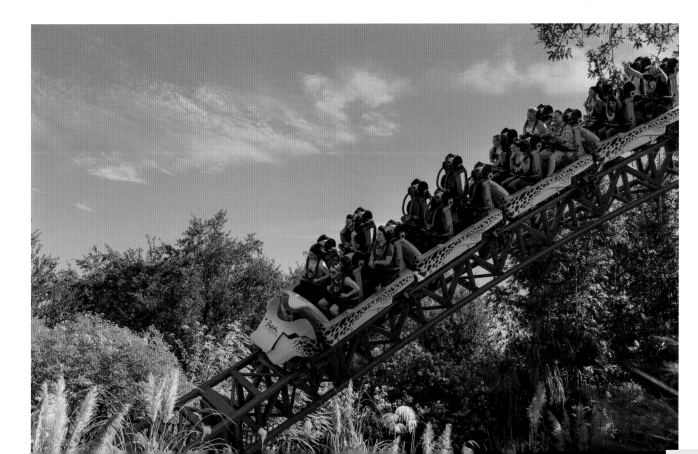

SheiKra

OPENING DATE	May 21, 2005
MAKE	Bolliger & Mabillard
MAX HEIGHT	200 feet
LENGTH	3,188 feet
MAX SPEED	70 mph
DURATION	2:20
INVERSIONS	1

This ride was not only the first dive coaster in America, it was the longest, tallest, and fastest dive coaster ever built. It also was the first dive coaster with a 90-degree drop.

The unique seating spans ten riders across three rows. Riders on the outside of each row feel the sensation of flying through the air with nothing above or below them. The experience is unlike anything else in the coaster world.

At first blush it seems like a gimmick, but after the ride, you appreciate the way it takes the industry forward with yet another legitimate style of roller coaster. This is one of the few coasters where, if you really want a front-seat ride, you're going to get it without much fuss. Snagging a seat on the very end of the row is another story.

When it first opened, the trains had floors, but in 2007 and roughly coinciding with the opening of Griffon, Busch Gardens's other dive coaster at Busch Gardens Williamsburg, the trains' floors were removed, enhancing the experience tenfold.

FACING PAGE

SheiKra was the first dive coaster to incorporate a splashdown element where the train drags two scoops through the water, creating the plumes of water shooting out the back.

The unique ten across, three-row train design is brilliant.

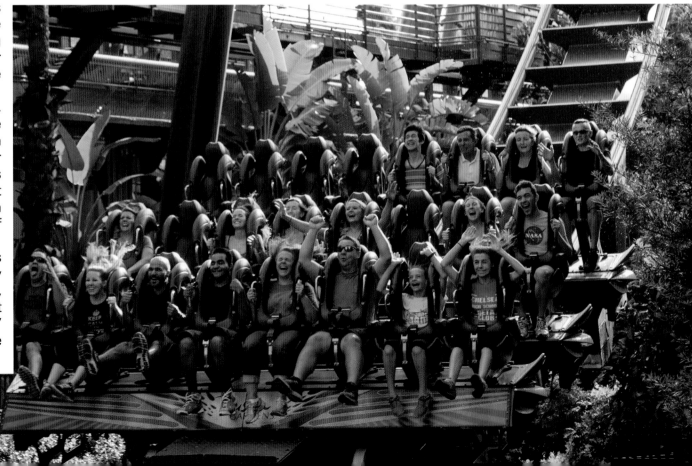

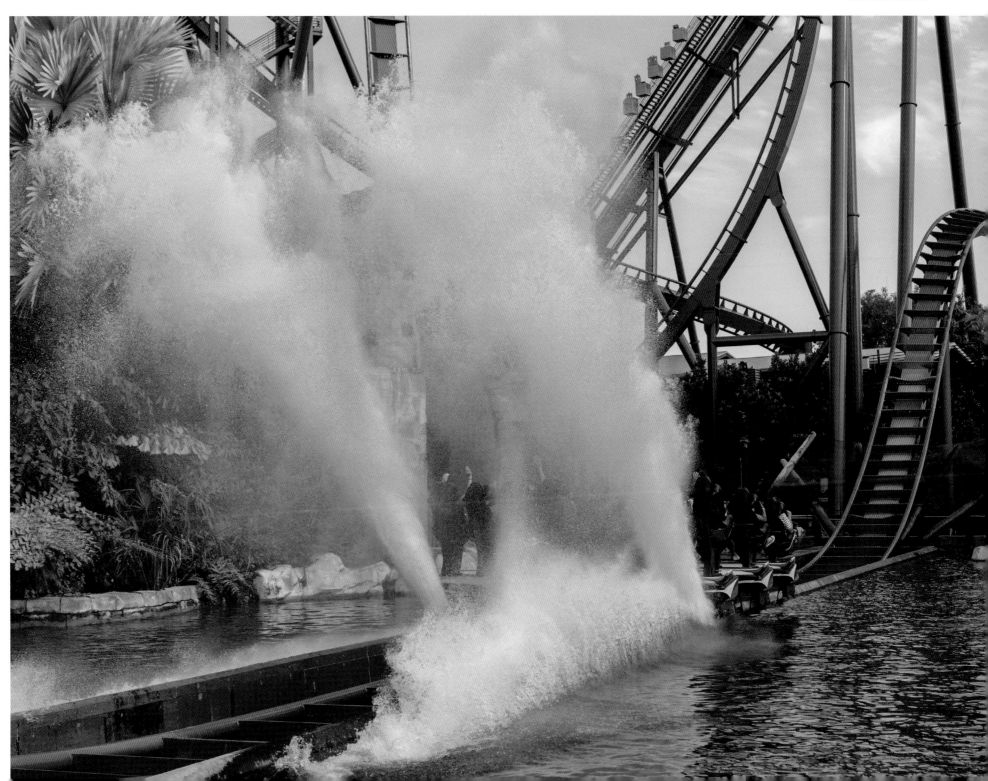

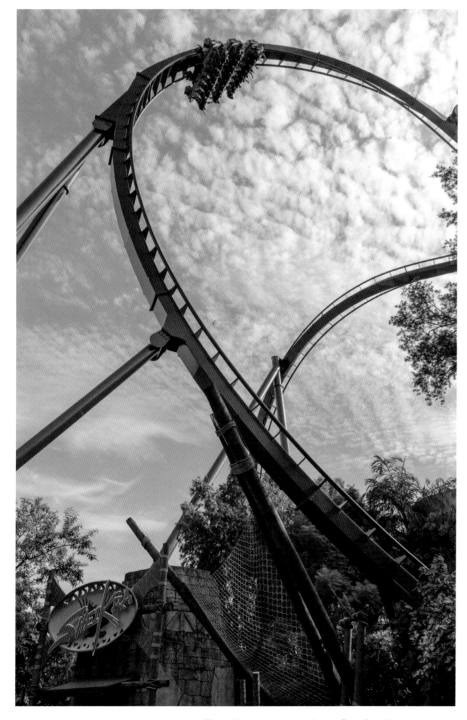

This dive loop was also a first for dive coasters.

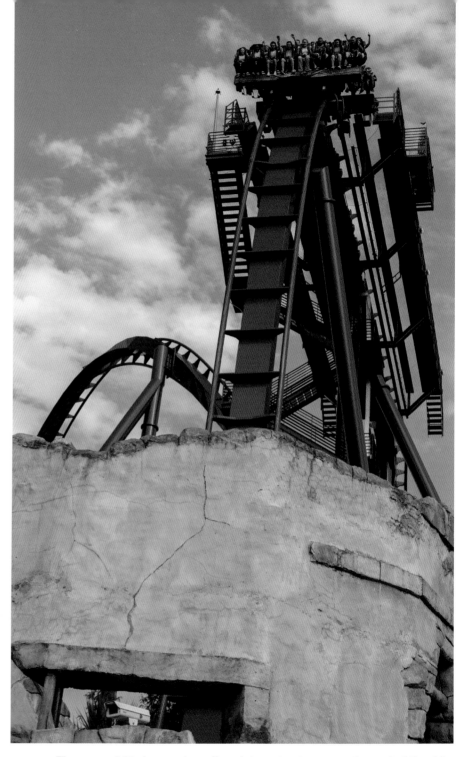

The second 90-degree drop dives into a structure near the end of the ride.

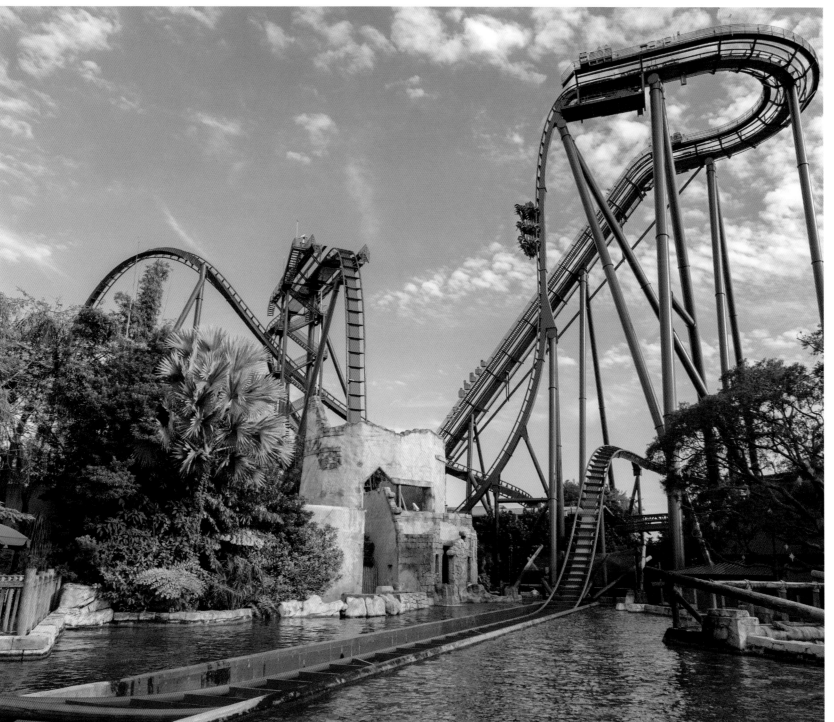

SheiKra looks stunning, like just about every other coaster at the park.

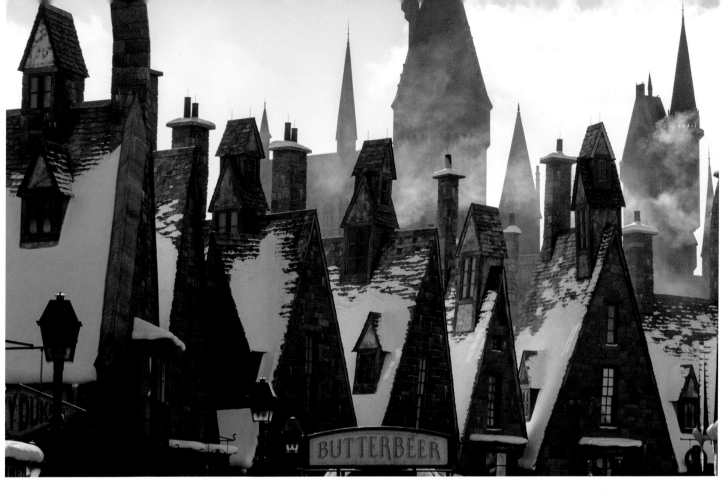

The town of Hogsmeade is dressed in winter. It's a tough sell in the summer heat, but don't be surprised if you feel a slight chill while walking through.

Universal Studios Florida and Universal Islands of Adventure

Orlando, Florida

Universal Studios Florida and Universal Islands of Adventure have always been good parks, but when the Harry Potter sections of each park were completed, Universal was suddenly elevated above the competition. Never has a vision been so thoroughly realized down to the tiniest detail.

Park-goers are ensconced in the Harry Potter world. In Islands of Adventure it's Hogsmeade and the impossibly large Hogwarts castle. In Universal Studios it's the painstakingly realized Diagon Alley. And to top it off, the Hogwarts Express train links them together in the best way possible (if you have a two-park pass, that is).

And that's just one section of these parks. They also include Jurassic Park, Springfield USA (Simpsons), Dr. Seuss, Marvel Super Heroes Island, and a few more, to say nothing of the coasters. There are three full-size coasters between the two parks. While they take a back seat to the other park attractions, they mostly hold their own.

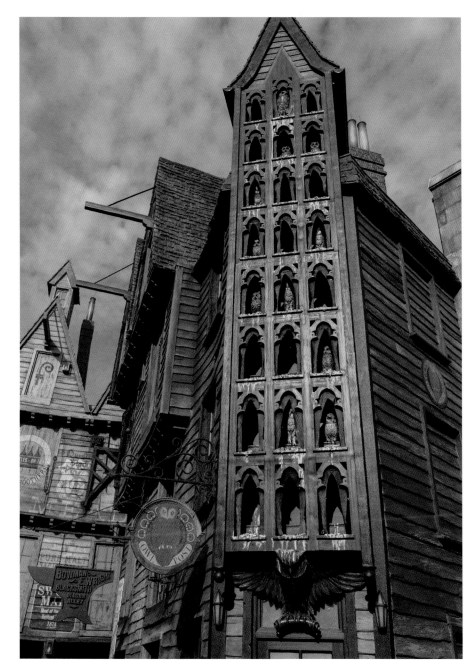

They even recreated the owl droppings at the Owl Post.

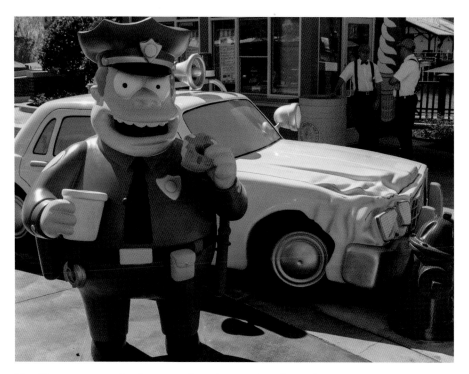

The Simpsons area is also reproduced exceptionally well.

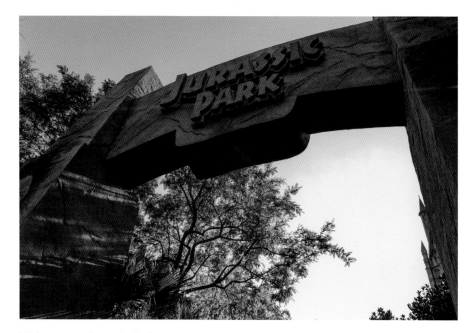

Welcome to Jurassic Park.

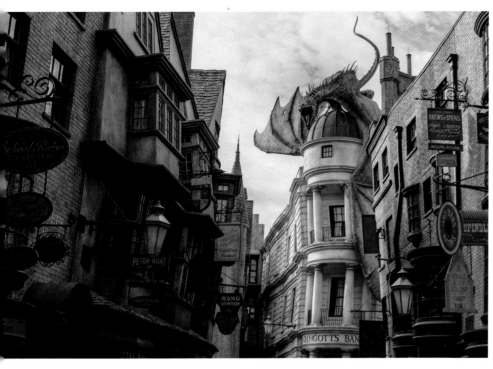

The dragon atop Gringott's Bank roars and breathes fire.

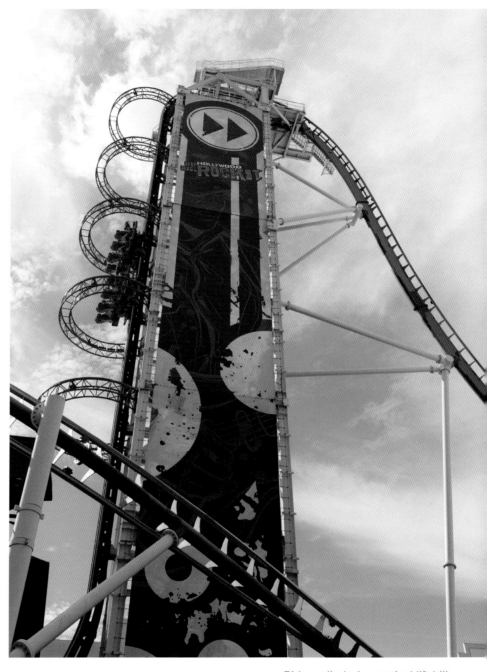

Rip Ride Rockit lets riders choose the ride sound track. The loading platform is constantly moving, so riders have to hop up and get buckled in quickly before the vertical climb up the lift hill. I was half-expecting a mediocre ride and was pleasantly surprised to find some airtime and a generally enjoyable experience.

Riders climb the vertical lift hill.

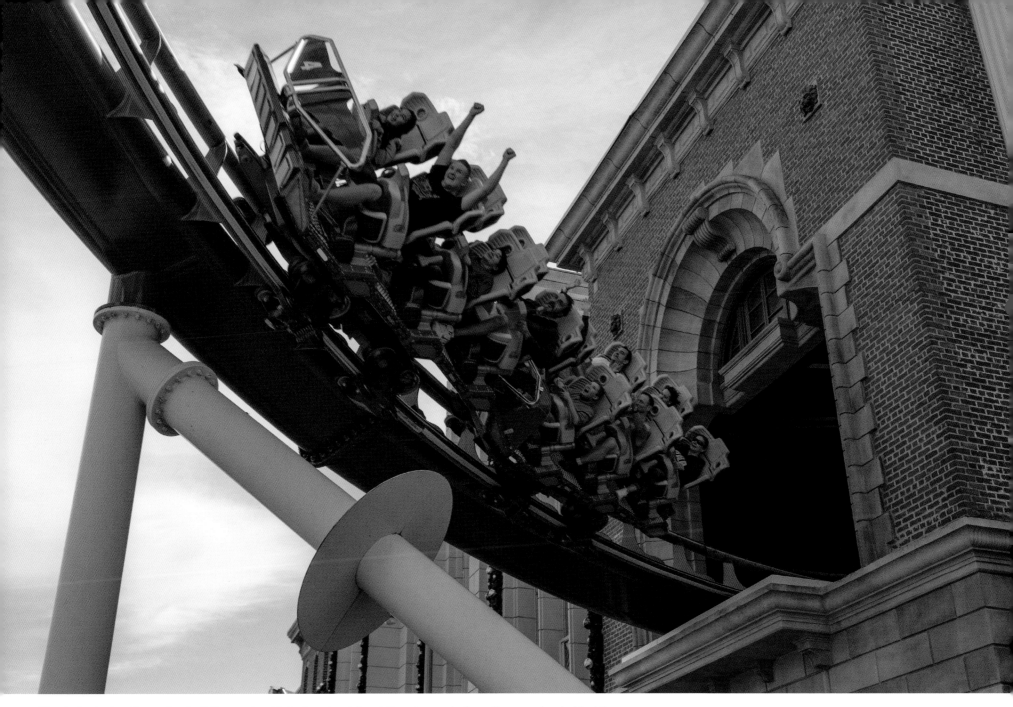

The train dashes through a building and out into the street for visitors to see before disappearing behind the scenery.

The Incredible Hulk Coaster

OPENING DATE	May 28, 1999
MAKE	Bolliger & Mabillard
DESIGNER	Ing.-Büro Stengel GmbH
MAX HEIGHT	110 feet (105-foot drop)
LENGTH	3,700 feet
MAX SPEED	67 mph
DURATION	2:15
INVERSIONS	7

This coaster is the only one with a launched lift hill (instead of being launched horizontally). The system uses a series of tires to propel the train up the hill to a speed of 40 miles per hour before being thrust into a gigantic cobra roll. The Hulk is slated to undergo renovations and reopen for the summer of 2016. Rumor has it that major changes will be made to the queue as well as the launch system, replacing the tires with an electromagnetic launch.

The Incredible Hulk is another coaster that tells a story. Its launch through the tub is meant to represent Bruce Banner's transformation into the Hulk, and the subsequent turns and inversions represent his rage. The Incredible Hulk is packed with aggressive elements and well deserving of its namesake.

LEFT: Riders rush through one of two loops.
RIGHT: The train launches directly into a zero-g roll.

The ride concludes with a dash through a corkscrew and into a hidden second loop.

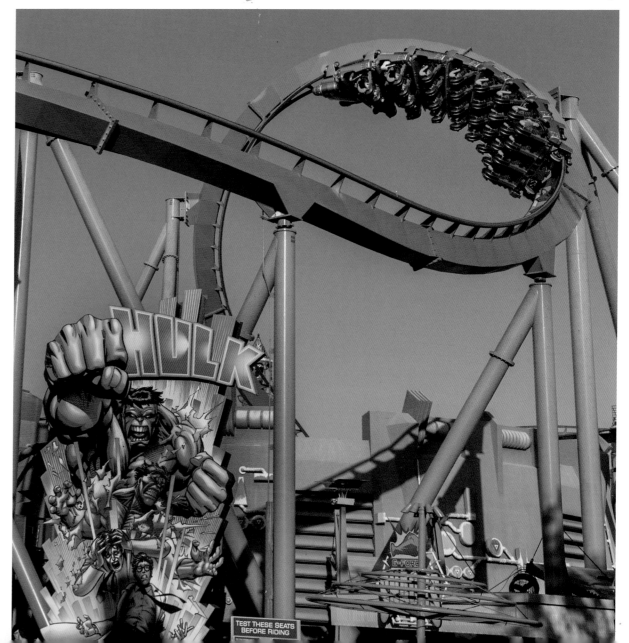

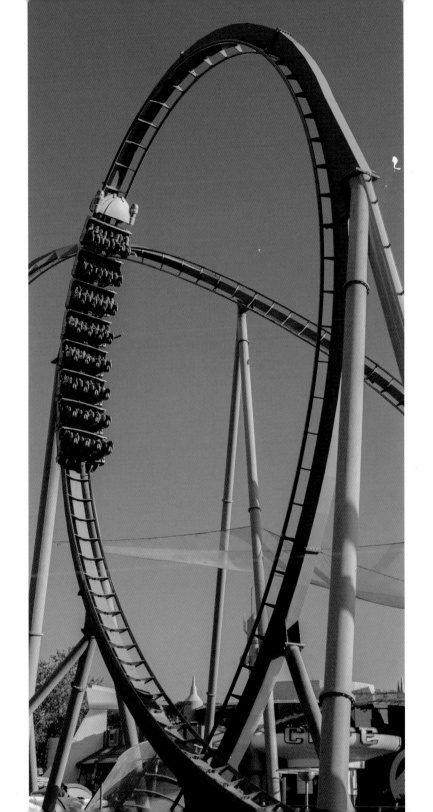
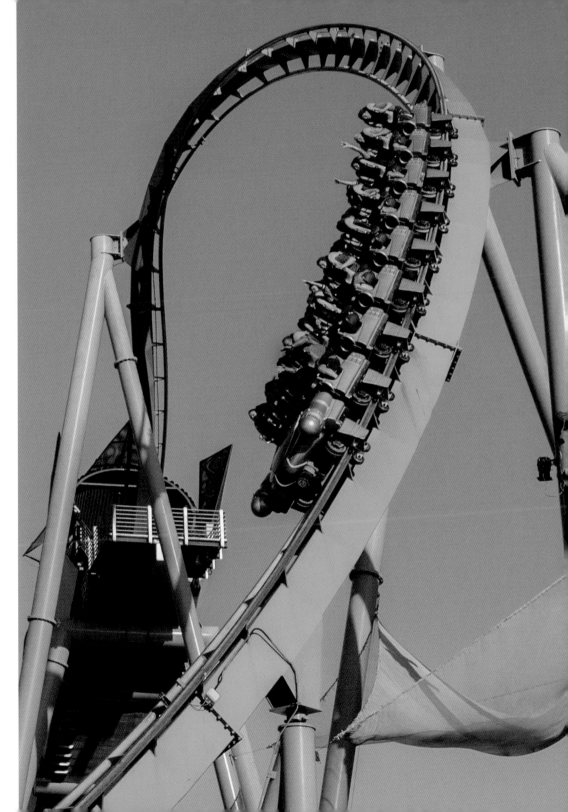

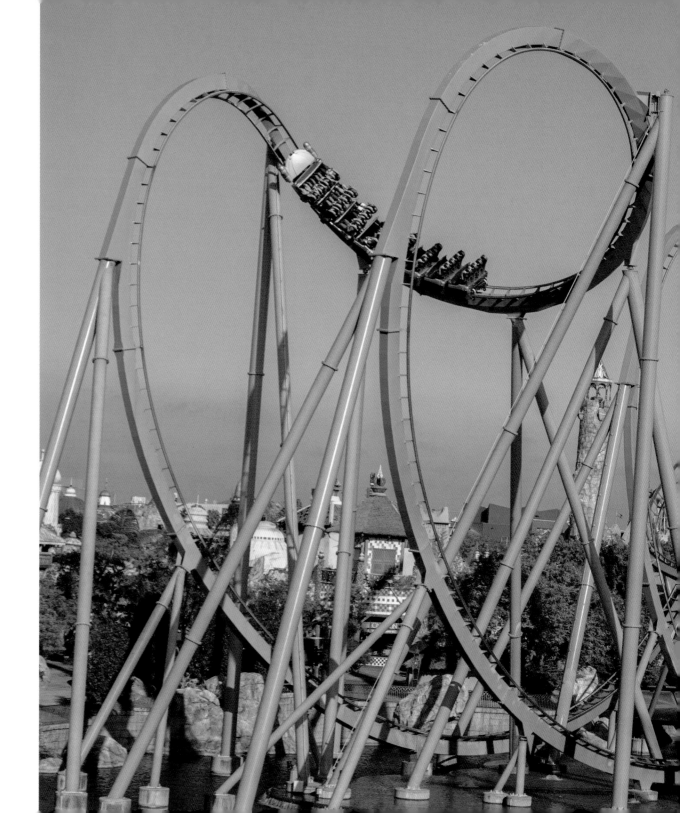

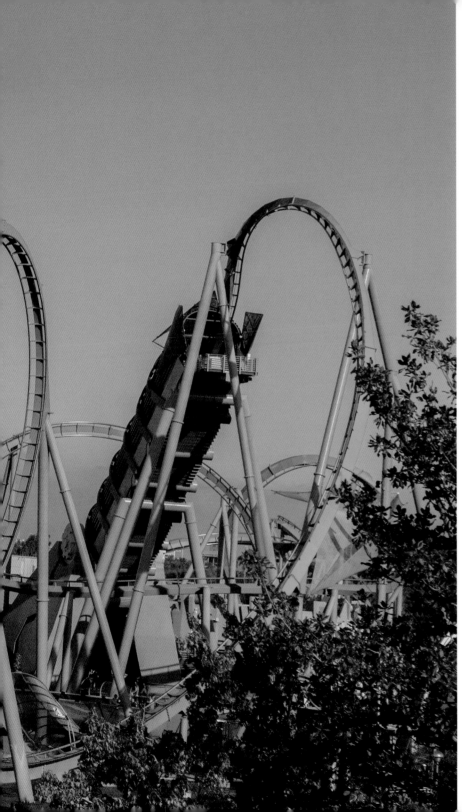

The train winds around a huge
cobra roll.

Dragon Challenge

OPENING DATE	May 28, 1999, as Dueling Dragons June 18, 2010, as Dragon Challenge
MAKE	Bolliger & Mabillard
DESIGNER	Werner Stengel
MAX HEIGHT	Chinese Fireball 125 feet (115-foot drop) Hungarian Horntail 125 feet (95-foot drop)
LENGTH	3,200 feet (each side)
MAX SPEED	Chinese Fireball 70 mph Hungarian Horntail 55mph
DURATION	2:25 (each side)
INVERSIONS	5 (each side)

In 1999 this coaster opened as Dueling Dragons and was the first inverted dueling coaster in the world. It is actually two separate coasters that intermingle with one another to emphasize its dueling nature. When dispatched simultaneously, there are several near-miss events designed into the ride.

Unfortunately Universal chose to stagger the release of the trains after two patrons suffered injuries (one serious) when objects hit them as the trains passed each other. It's a shame, as the dueling aspect made the experience more fun.

In 2010, that section of the park changed its name from The Lost Continent to the Wizarding World of Harry Potter, and with it came a coaster name change and re-theming. Dragon Challenge was born, and the two trains changed names as well. Fire and Ice became Chinese Fireball and Hungarian Horntail, two dragons in the Harry Potter universe.

Both coasters provide a solid experience, although the taller, faster Chinese Fireball takes the cake overall. But don't take my word for it. Be sure to ride them both.

FACING PAGE
The Hungarian Horntail flies through a cobra roll.

It's a shame the trains no longer duel.

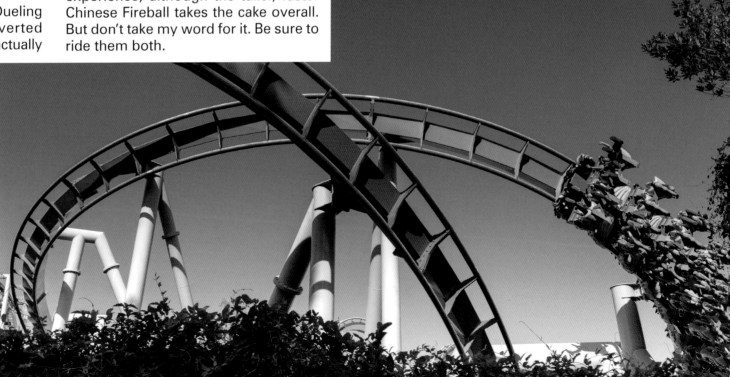

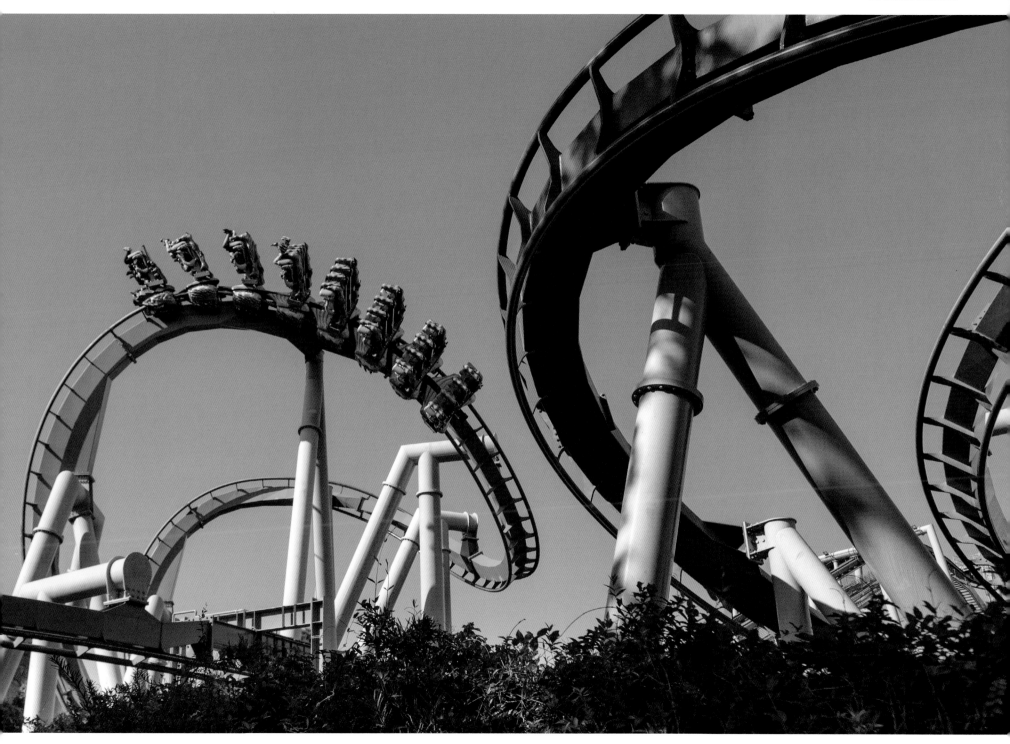

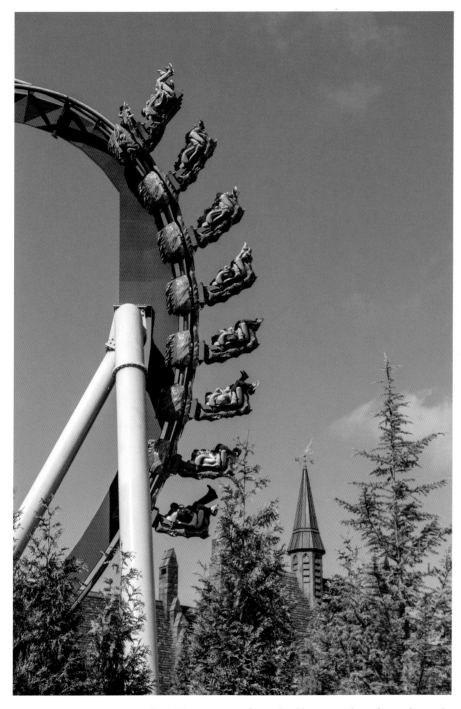

The Chinese Fireball as seen as from the Hogsmeade train station exit.

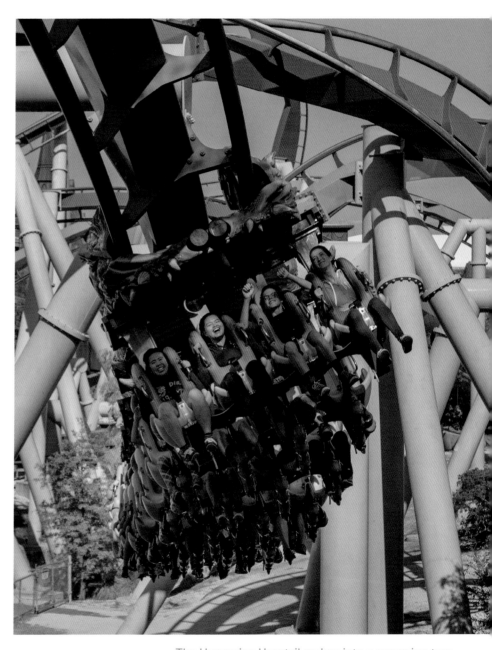

The Hungarian Horntail rushes into a sweeping turn.

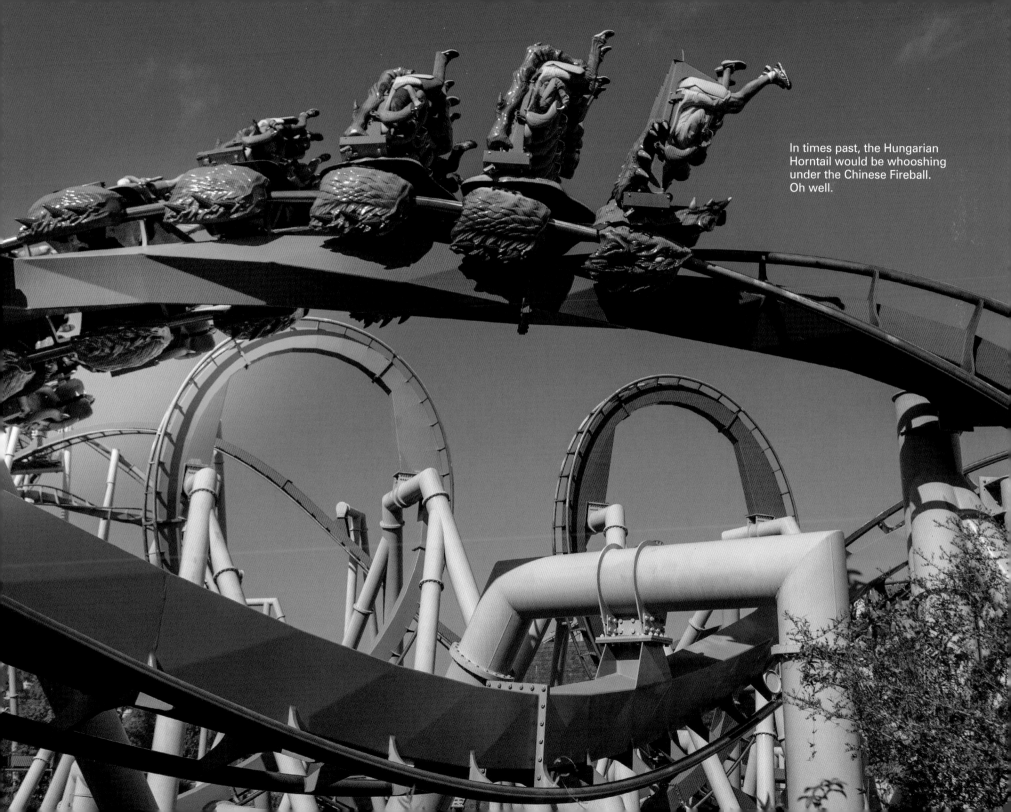

In times past, the Hungarian Horntail would be whooshing under the Chinese Fireball. Oh well.

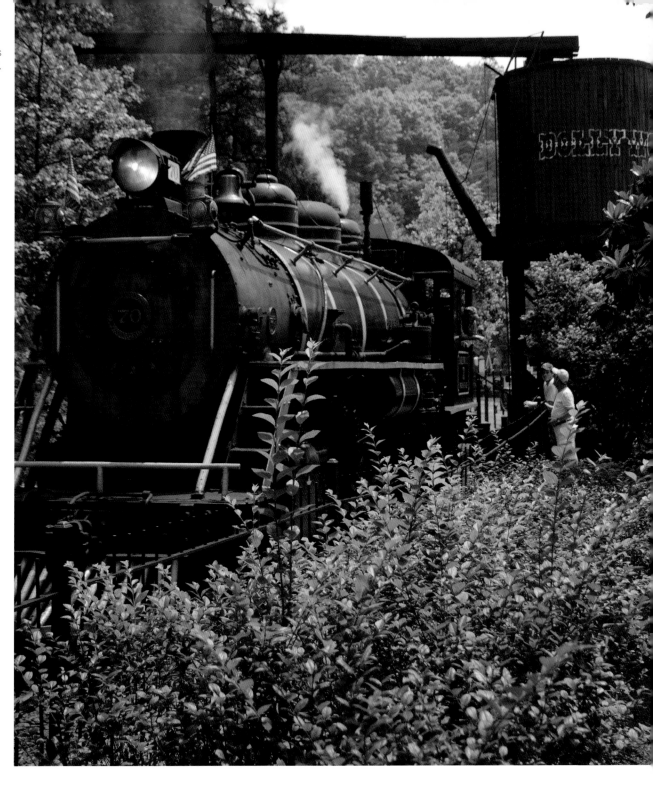

An authentic coal-fired steam engine takes riders for a trip around the park.

Dollywood
Pigeon Forge, Tennessee

In 1961, what would eventually become Dollywood opened under the name Rebel Railroad and centered on a steam train that allowed riders to experience an attack by Union troops and to see Confederate rebels save the day. Eventually Jack and Pete Herschend acquired it as a sister park to their successful Silver Dollar City in Branson, Missouri. This park would be called Silver Dollar City Tennessee until 1986, when Dolly Parton bought into Silver Dollar City and had the park renamed Dollywood.

In the early years, Dollywood wasn't about roller coasters. It had the old Blazing Fury that is part roller coaster, and a Mine Train roller coaster that has since been removed. It wasn't until 1999 that the park started regularly building roller coasters. As of this writing, Dollywood has seven roller coasters if you count Blazing Fury and a kiddie coaster, and the park is opening a new coaster, Lightning Rod, in 2016. Even with the recent influx of thrill rides, Dollywood maintains a down-home feel with great food, entertaining shows, and a host of artisans plying their time-honored trades.

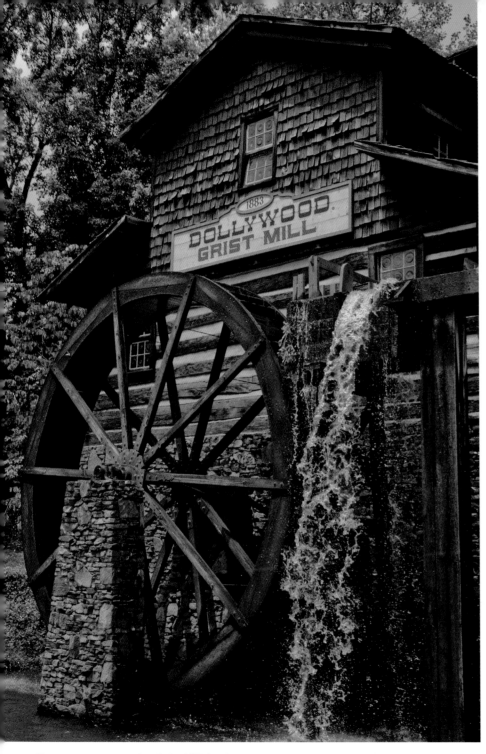

Be sure to stop at the Grist Mill for homemade cinnamon bread.

It's quite odd to be able to see such a natural setting inside of a bustling amusement park.

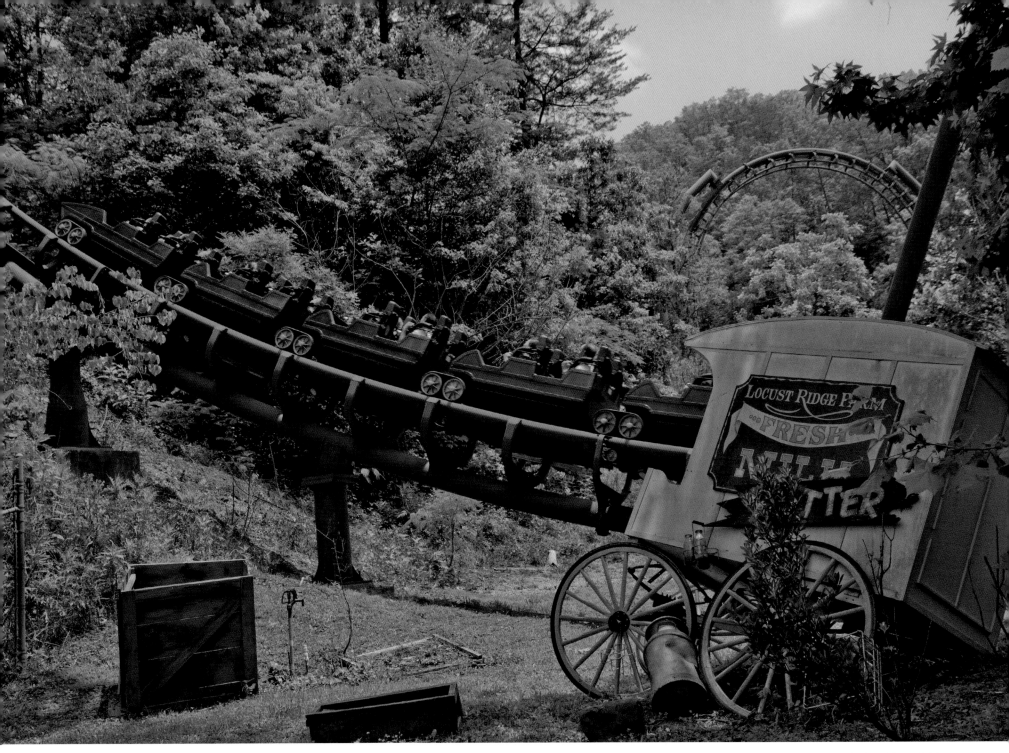

The Tennessee Tornado is one of the last Arrow loopers. It's extremely short, but uncannily smooth for rides of this type.

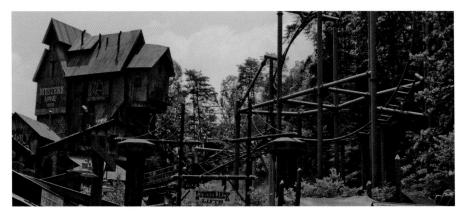

Outside and in, this ride's visuals are impressive.

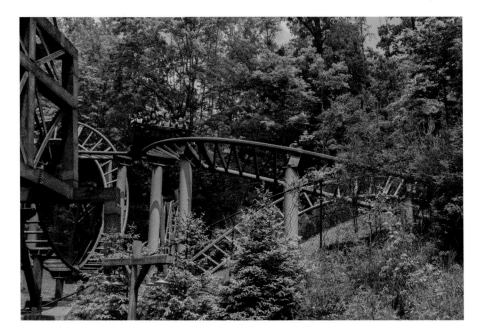

The cars are small with only two rows, four per row.

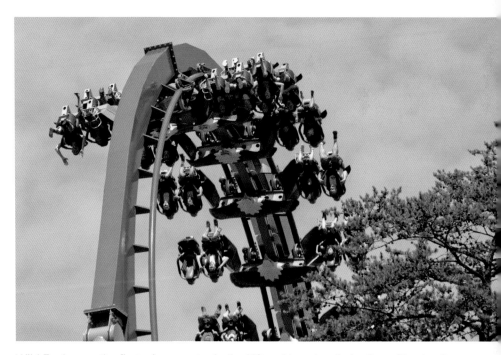

Wild Eagle was the first wing coaster in the US and has the distinction of having its own theme song sung by Dolly Parton herself.

Mystery Mine is well themed as a haunted mining operation. Built in 2007, it was the first Gerstlauer Euro-Fighter-style coaster in the United States and had the steepest drop of any roller coaster in the US (95 degrees) until Indiana Beach's Steel Hawg beat it a year later.

The ride has some very dramatic features. The two vertical climbs and drops give riders quite a scare. The sad part is that this ride seems to become rougher with each passing year.

FireChaser Express

OPENING DATE	March 22, 2014
MAKE	Gerstlauer Amusement Rides GmbH
MAX HEIGHT	161 feet (148-foot drop)
LENGTH	2,427 feet
MAX SPEED	34.5 mph
DURATION	2:19
INVERSIONS	0

The entire ride seems to be dedicated to volunteer firefighters, and you become one of the volunteers as you board the train. Riders are launched out of the station as if speeding to a fire. Then it's on to a standard lift hill that sets the rest of the ride in motion. The train rushes toward a fireworks emporium to stop a huge firecracker from going off. The train stops inside the emporium, but it's too late, and the train is launched backward as pyrotechnics go off. The coaster experience concludes by backing riders into the station.

It's a great show for kids and parents alike, and a stepping stone for kids transitioning to more thrilling rides. The ride itself is great fun and a welcome respite from the usual thrill machine.

FACING PAGE

LEFT: The train rushes over a waterfall.
RIGHT: The trains are modeled after a locomotive and have plenty of room for adults.

The entire ride feels like a tribute to firefighters.

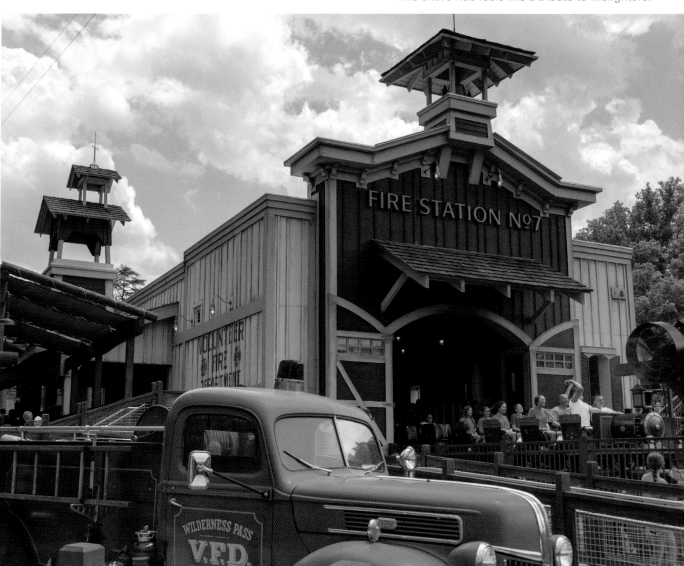

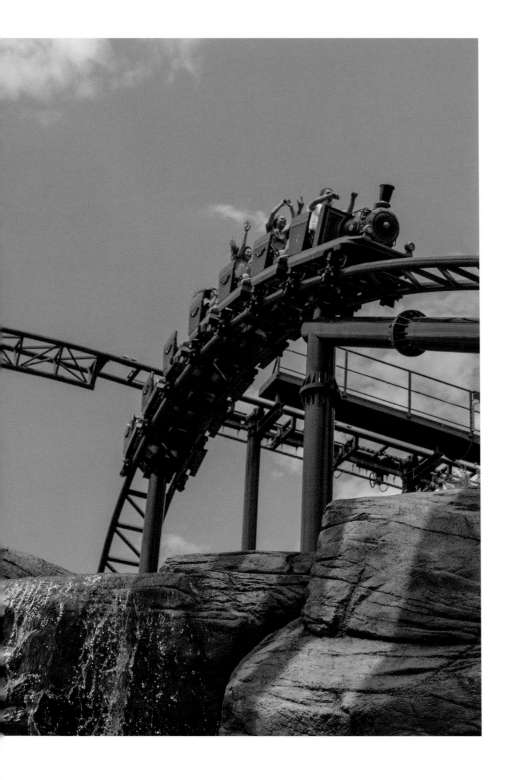

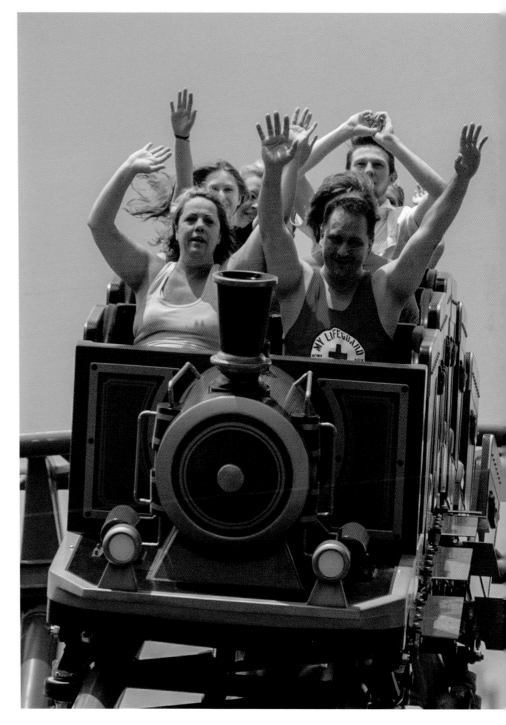

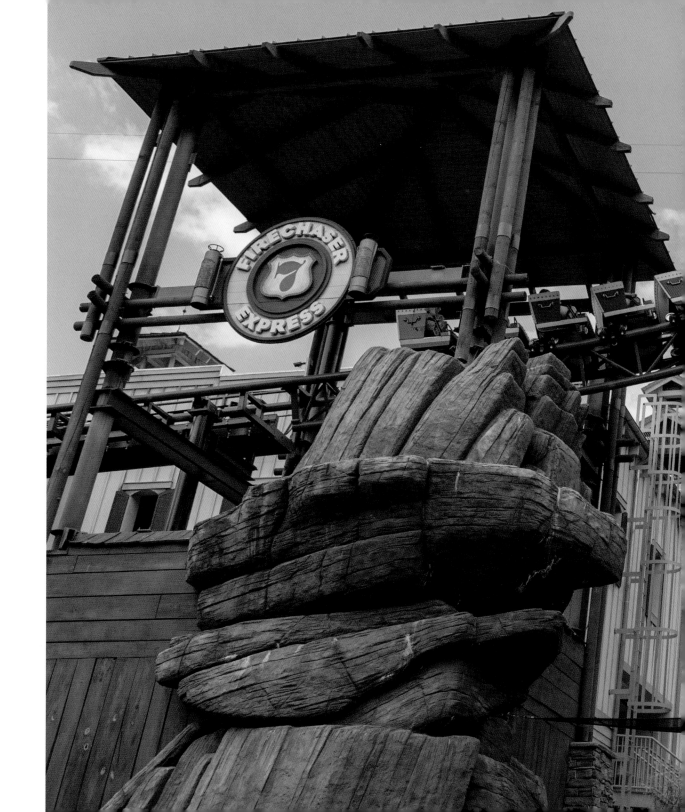

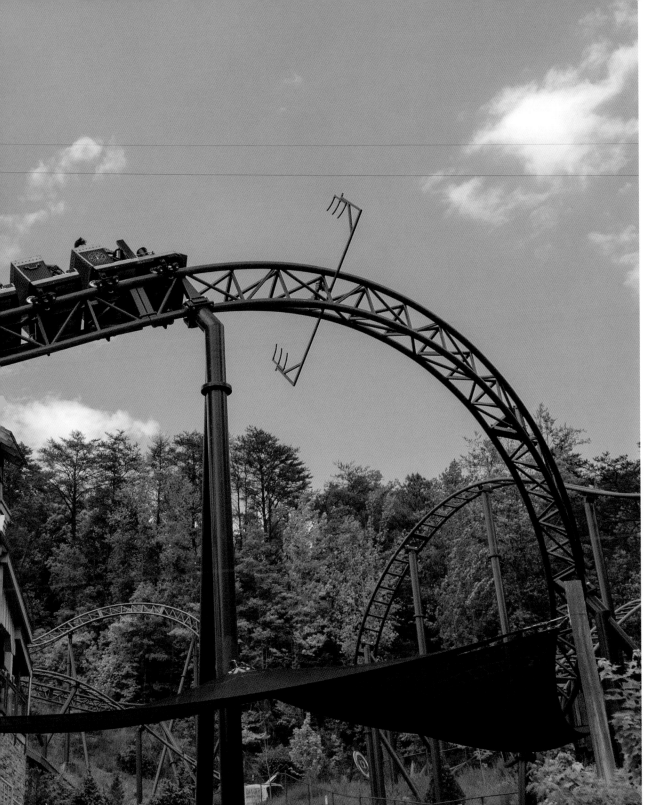

The coaster was built on top of the grounds where Adventure Mountain used to be. Here the train passes through one of the old towers.

Thunderhead

OPENING DATE	April 3, 2004
MAKE	Great Coasters International
DESIGNER	Mike Boodley
MAX HEIGHT	100.4 feet (100-foot drop)
LENGTH	3,230 feet
MAX SPEED	55 mph
DURATION	2:30
INVERSIONS	0

Named after a mountain in the nearby Great Smoky Mountains National Park, this ride lives up to its name. Thunderhead is special for many reasons, but mainly because it represents a watershed moment for Great Coasters International. GCI made good, solid wood coasters that were similar to those that came before. With Thunderhead, GCI came up with a design language that would inform every new coaster it built.

The sudden, effortless changes of direction and the sweeping turns and relentless airtime have become hallmarks of a GCI coaster. What's more, the design manages to do all this without putting excessive force on the structure, resulting in a smooth, consistent ride that doesn't require a ton of maintenance.

The most memorable moment occurs as soon as you begin to crest the lift hill. The track laid out before you is so different and beautiful that you can't wait to experience every last inch of it. GCI has improved on its designs over the years, but to me, Thunderhead will always signify something special.

FACING PAGE

LEFT: There is something pure about a close-up of a wood coaster.
TOP RIGHT: GCI builds its own custom Millennium Flyer trains that allow the company to make nimble coasters.
BOTTOM RIGHT: GCI seems to crave complex coaster design.

The train sprints around a sweeping turn near the middle of the ride.

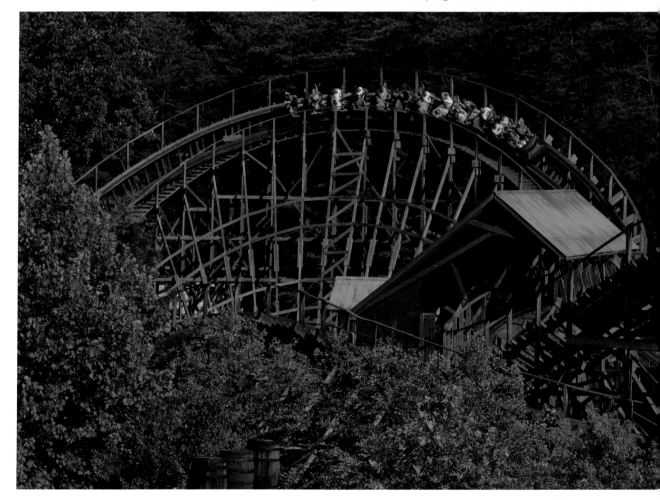

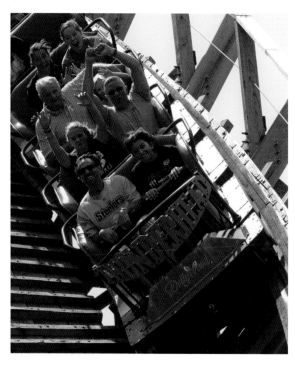

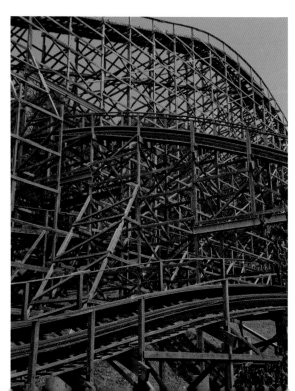

Dollywood's Thunderhead.

Q&A with Adam House, Senior Engineer, Great Coasters International

Q: *GCI coasters have a distinctive look and feel. What makes a GCI coaster a GCI coaster?*

A: We always incorporate certain things, such as progressively increasing the pacing and directional changes. We want to make a ride that is thrilling, yet family-oriented.

Q: *Your early coasters like Wildcat and Roar have a forceful, turbulent feel to them. Lightning Racer, in retrospect, has a kind of transitional feel. But it seems that Thunderhead established your current coaster vocabulary because every GCI coaster I've ridden since then seems to have its roots there, with lots of smaller hills and quick changes of direction. Do you agree?*

A: Thunderhead was an exciting change for us. The biggest change was the complexity of the shapes. I think this translates over the history of roller coasters. The classic out-and-back rides were simple lines and parabolas, but were really fun. We have taken those same exciting elements and evolved them into twisted, complex shapes. I think you can see—and most importantly, feel—this difference, especially in comparing two rides like Wildcat and Lightning Racer, both at Hersheypark.

Q: *GCI coasters seem to age well. To what do you attribute the consistent ride experience from year to year?*

A: I attribute this to two main things: our specialized track construction methods and our Millennium Flyer trains. We are the only wooden roller coaster manufacturer to design, build, and supply our own trains. This control over the entire process makes it easy for us to design layouts that we know our guys can build and our trains can negotiate.

Q: *Why did GCI develop its own trains instead of using an established train manufacturer like PTC?*

A: Our Millennium Flyer trains were specially designed to maneuver on our super-twisted track layouts. We like to push the limits of what our trains can do. We realized that to get complex shapes and know how our rides will fare over time, we needed to develop and perfect our own rolling stock. Now, with more than thirty Millennium Flyer trains in operation, we have the most proven articulating trains in wooden roller coasters.

Q: *What aspect of roller coaster design/building/maintenance do coaster enthusiasts under-appreciate?*

A: The true craftsmanship of a wooden roller coaster is really under-appreciated. Every board and every nail is installed on-site by our team. The carpenters and installation crew are very good at what they do, and at the end of the day a wooden roller coaster is truly a hand-built masterpiece.

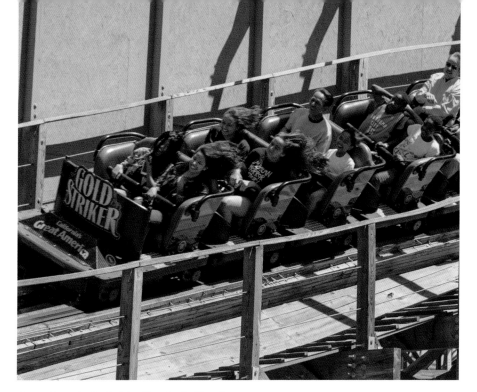

Great America's Goldstriker in California.

Q: *How does the process of making a roller coaster begin? Do the parks approach you, or is there a request for proposals and competition among various manufacturers?*

A: Typically a park will reach out to manufacturers knowing the type of roller coaster they want, i.e. wood or steel. They generally give us a list of constraints such as budget, ride specs (height, length, speed), and capacity. Occasionally, the park will want ideas for two or more potential sites within the park. They request feedback and layout ideas for each site from us and other wooden roller-coaster manufacturers.

Q: *How long does it take to design a coaster?*

A: Design alone can take three to six months. Obviously, the site's size and complexity affect the time line significantly. Typically, we send a preliminary ride layout to the park for review. We often go through several iterations before the design is finalized. After that we are constantly improving drawings, making modifications, and supporting our construction crews by answering questions. Ultimately, we want the customers to get the exact ride that they expect.

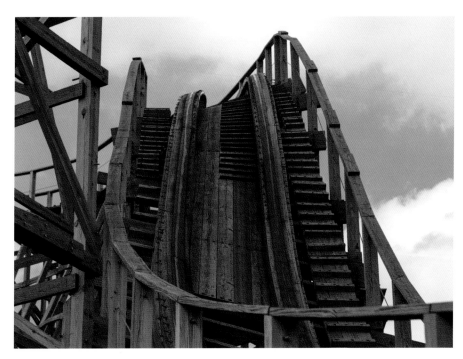

Beech Bend Park's Kentucky Rumbler.

Q: *How involved are you with the maintenance of your coasters?*

A: We have taken a lot of time to perfect our product, so much so that we do not specify a schedule for track repair. Typically, the track repairs are simple enough for park employees to perform. Obviously, we give the parks direction on off-season rehab and maintenance, but track work is done at the park's discretion. After the ride commissioning, we spend a week or more training park personnel on what to look for during maintenance and safety checks, as well as proper operation of the ride.

This ties into what I tell people is the wooden coaster advantage: it can last forever through proper care and maintenance.

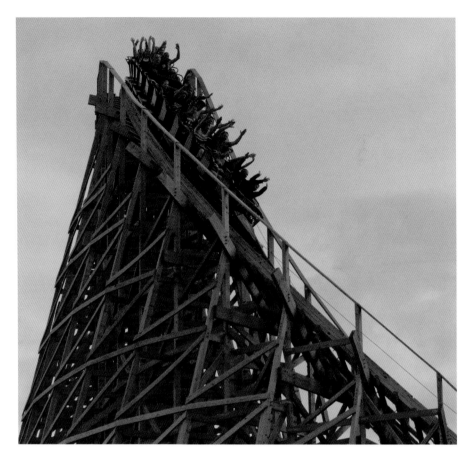

Worlds of Fun's Prowler.

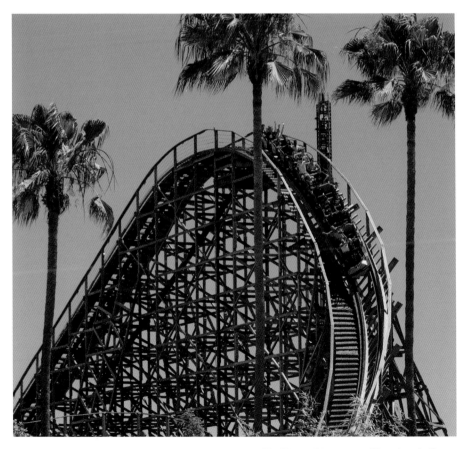

Six Flags Discovery Kingdom's Roar.

Q: *How much consideration is given to how a coaster looks from the line or the nearby walkways?*

A: This is one of the things we consider when designing a new ride. Wooden roller coasters are both beautiful and iconic. We strive to give parks rides that are not only fun, but also works of art.

Q: *What is the most challenging aspect of designing and building a coaster?*

A: It's always a challenge to create something that is innovative but still holds true to the classic look and feel of a wooden roller coaster. We want to develop elements that push the envelope and keep this industry moving forward, without losing sight of what a wooden roller coaster is—an amusement park icon.

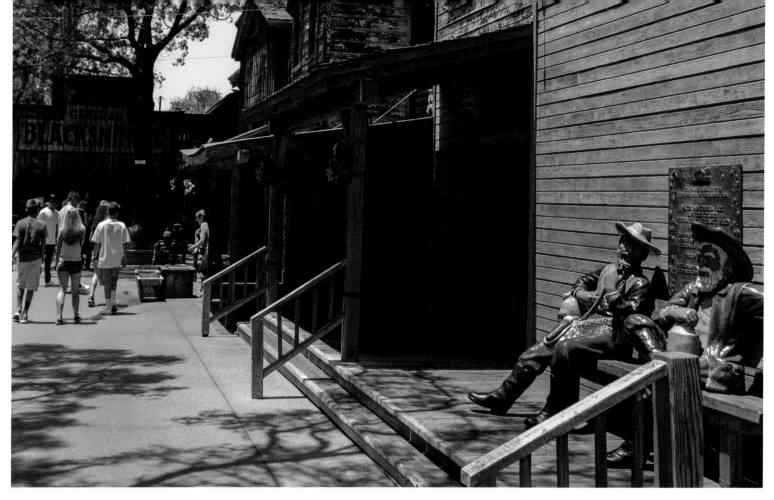

The Ghost Town section of the park dates back to the park's beginning.

Knott's Berry Farm

Buena Park, California

Knott's Berry Farm began its farming operation around 1920. Soon the owners started selling chicken dinners at Mrs. Knott's Chicken Dinner Restaurant, and when that became a tourist attraction they opened up several shops. That led to the construction of a replica ghost town that survives to this day. In 1968, visitors started being charged admission at the gate, and a theme park was born with the slogan "America's First Theme Park." While that claim is disputed by parks like Holiday World, there is no mistaking the rich history and popularity of Knott's establishment.

Knott's Berry Farm had plenty of rides over the years, including some roller coasters, but it wasn't until Cedar Fair bought the park in the late 1990s that it became a serious coaster park. Today it is home to ten roller coasters, including one kiddie coaster. Six have been added since 1998 when Ghost Rider burst onto the scene and showed that Cedar Fair meant business.

Montezooma's Revenge dates to 1978 and is the last ride of its kind operating in the United States. The launch is controlled by a flywheel. It's one of the rare looping coasters that doesn't use over-the-shoulder restraints for its riders, who are launched at 55 miles per hour. The train speeds through the loop both forward and backward before returning to the station.

The train flies backward through the station and up a hill before returning.

It's hard to get a clear shot of the loop because other coasters have been built around the ride over the years.

Coast Rider may be just another wild mouse ride, but its surroundings are gorgeous.

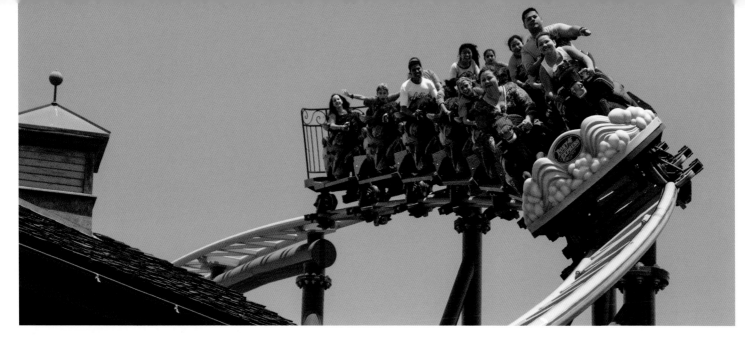

Pony Express is a unique coaster that has riders on horseback.

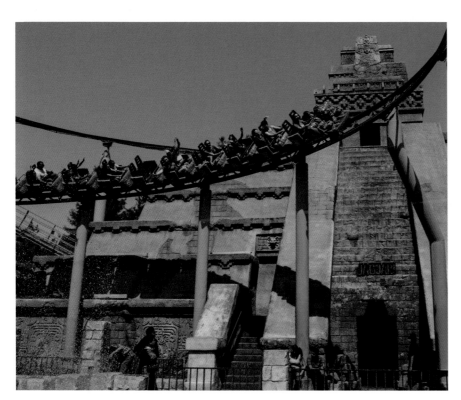

Jaguar is a neat Mayan-themed family coaster.

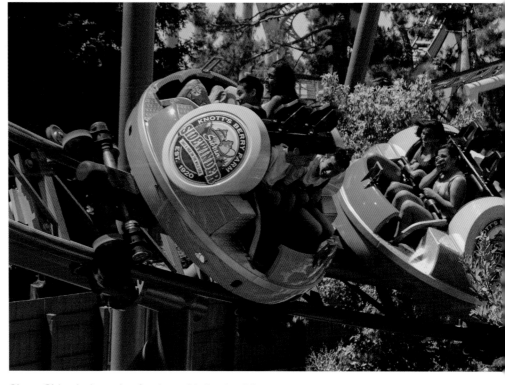

Sierra Sidewinder spins freely and is loads of fun.

GhostRider reaches speeds of up to 56 miles per hour on the first drop.

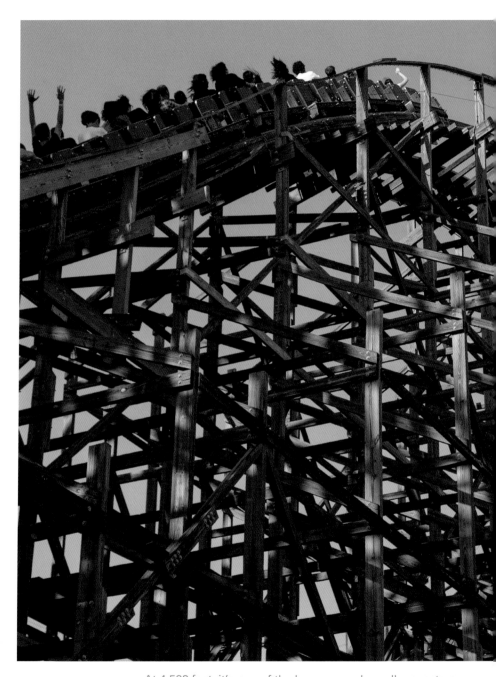

At 4,533 feet, it's one of the longer wooden roller coasters.

Due to earthquake prevention codes, GhostRider was built with nearly twice as much wood as would normally be required.

Xcelerator

OPENING DATE	June 22, 2002
MAKE	Intamin AG
DESIGNER	Ing.-Büro Stengel GmbH
MAX HEIGHT	205 feet (200-foot drop)
LENGTH	2,202 feet
MAX SPEED	82 mph
DURATION	1:02
INVERSIONS	0

Before there was Top Thrill Dragster or Kingda Ka, there was Xcelerator. This was the first Intamin ride to use hydraulic launch technology, which the company would later scale up for use in the previously mentioned behemoths.

Riders are catapulted to 82 miles per hour in just 2.3 seconds and pushed up and over the 205-foot hill. Unlike Top Thrill Dragster or Kingda Ka, this ride actually has some twists and turns after the initial hill. Unfortunately, those twists and turns don't do much to lengthen the ride time— 22 seconds from launch to brakes.

Being a pioneering ride has its drawbacks. The wait time can be tedious because the trains are unloaded, reloaded, and launched from one spot in the station. In newer rides, trains are taxied out to a launch position so the next train can get ready for launch. Six Flags Great Adventure's Kingda Ka and Hersheypark's Storm Runner also use dual-loading stations to shorten wait times.

Despite its drawbacks, Xcelerator is loads of fun. The launch up and over the top hat element never gets old.

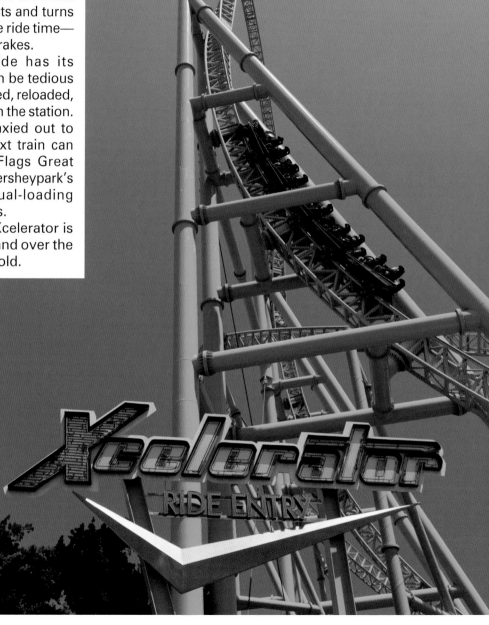

The train is launched straight up the top hat element.

FACING PAGE

TOP: The train pulls out of a sweeping turn after plummeting down the 205-foot hill.

BOTTOM LEFT: The train is modeled after a '57 Chevy Bel Air.

BOTTOM RIGHT: The train picks up a lot of speed diving straight down out of the top hat element.

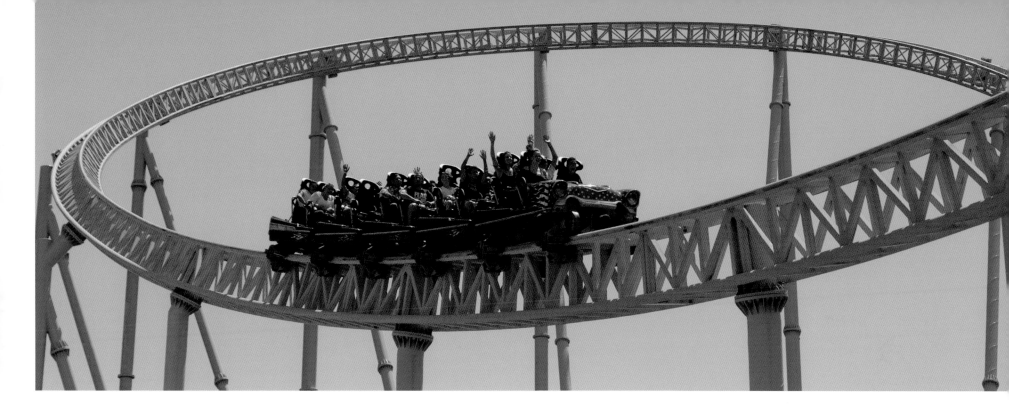

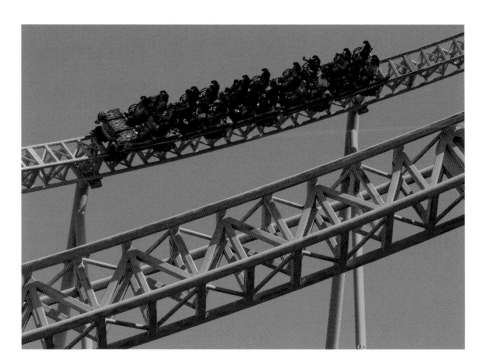

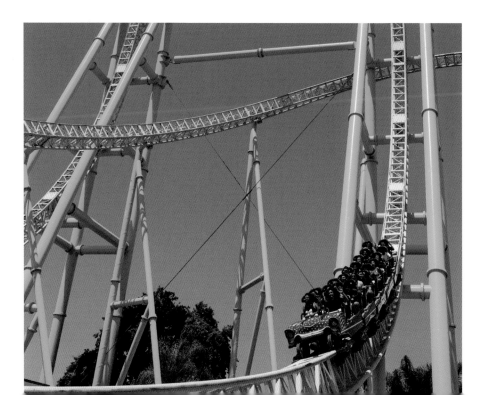

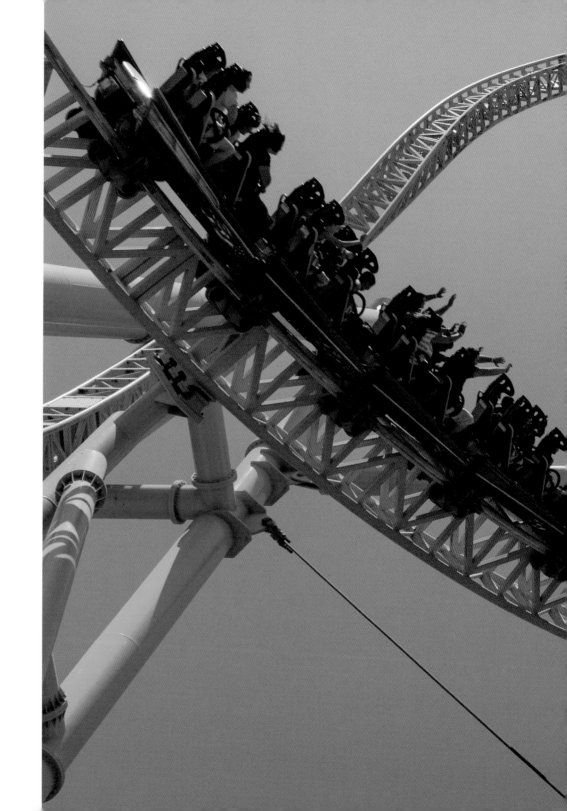

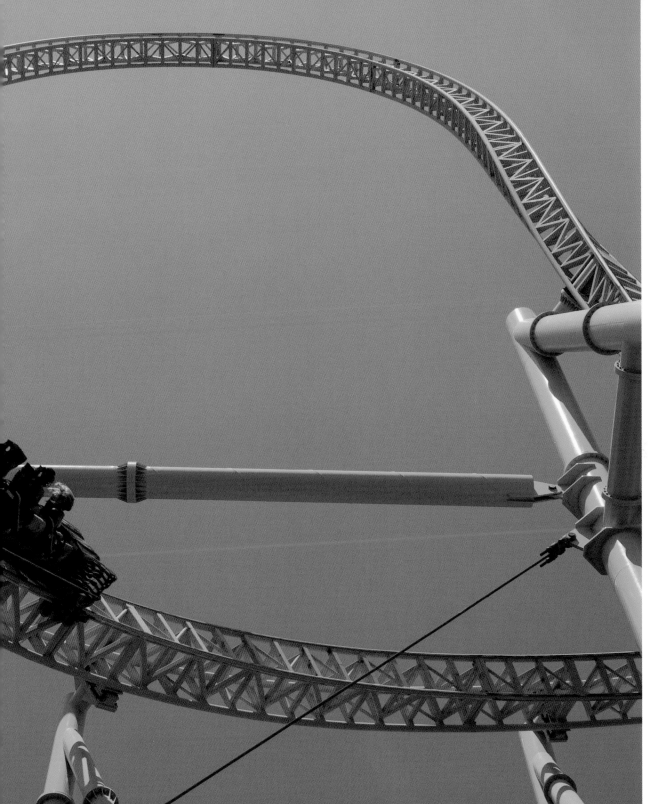

Expectant riders get a great view of the coaster from the queue.

Silver Bullet

OPENING DATE	December 7, 2004
MAKE	Bolliger & Mabillard
MAX HEIGHT	146 feet (109-foot drop)
LENGTH	3,125 feet
MAX SPEED	55 mph
DURATION	2:30
INVERSIONS	6

Simply put, Silver Bullet is a joy to ride. It is silky smooth and not overly forceful, so you can sit back in the beautiful Southern California weather enjoying the flips and dips as they come. There's something to be said about not having to worry about a ride slamming you around or making you feel like all the blood in your body is pooling into your shoes. Instead you become one with every loop, roll, and turn.

This ride is also unusually photo-friendly. The color scheme pops against the blue sky, and striking vantage points are everywhere.

FACING PAGE

TOP LEFT: The train navigates a sweeping turn.
TOP RIGHT: This downward helix leads into some corkscrews to end the ride.
BOTTOM LEFT: Riders exit one of the corkscrews.
BOTTOM RIGHT: This is one of the prettiest sights in the coaster world.

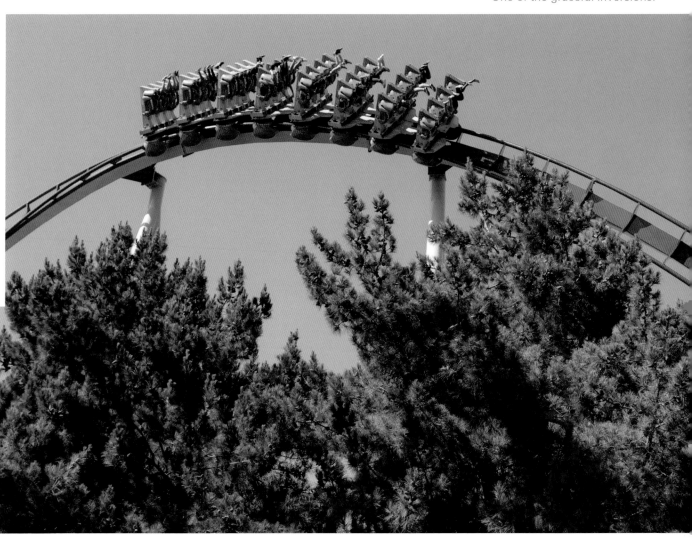

One of the graceful inversions.

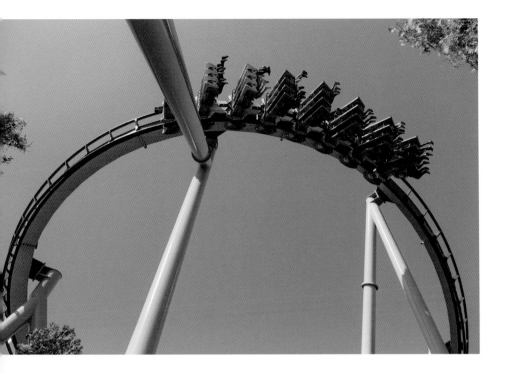

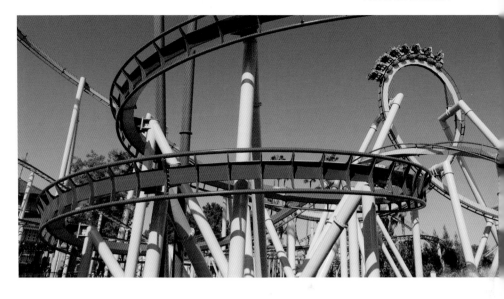

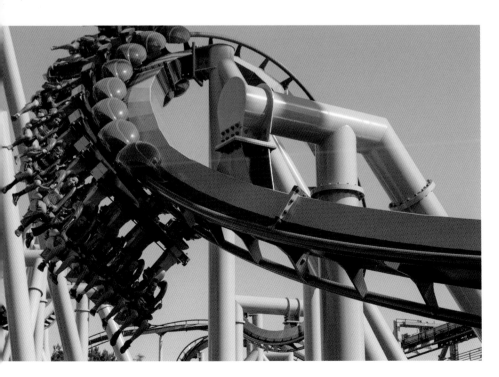

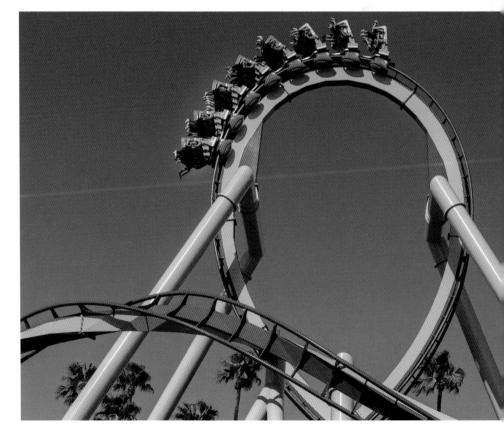

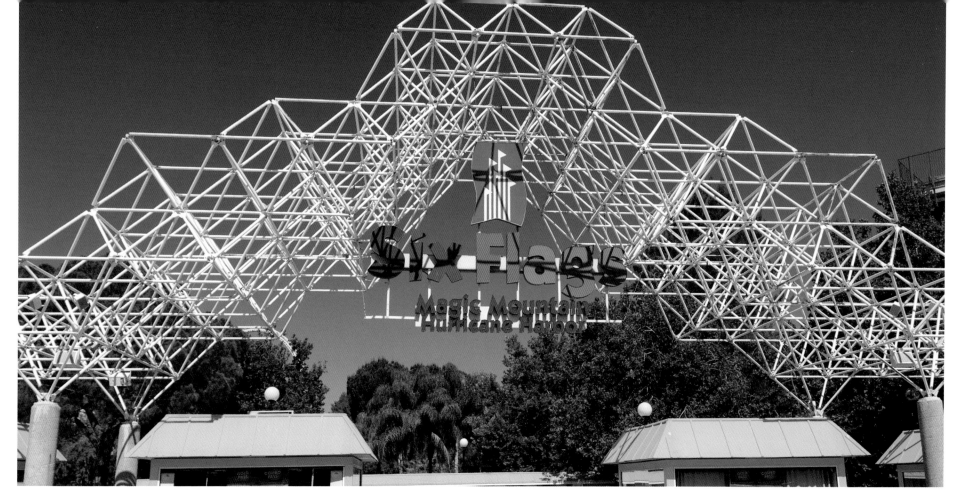

The park entrance.

Six Flags Magic Mountain

Valencia, California

Cedar Point is generally regarded as the king of roller coaster parks, but after visiting Six Flags Magic Mountain one has to rethink that position. Yes, this park has more roller coasters than any other park in the world, but that's not what makes this place so special. If you're a coaster enthusiast, you've undoubtedly traveled far and wide in search of new experiences. Unfortunately, the more you travel, the more you see that most coasters are variations on a theme. Tall steel? Check. Wood? Check. Boomerang? Yes, and so on.

Magic Mountain may have the most eclectic collection of coasters anywhere. Sure, the park has tried-and-true coasters, but it also has experiences like X2, Full Throttle, Green Lantern, and Superman: Escape from Krypton, which are nearly unrivaled around the world. Add to that rides like Tatsu and the new Twisted Colossus (not pictured) that take existing types of rides and dial them up to eleven. For these reasons, Six Flags Magic Mountain is the must-visit park for coaster enthusiasts. The problem, of course, is location. The Midwest and Northeast are a hotbed for roller coasters. Amusement parks in the West are more dispersed, with few heavy hitters.

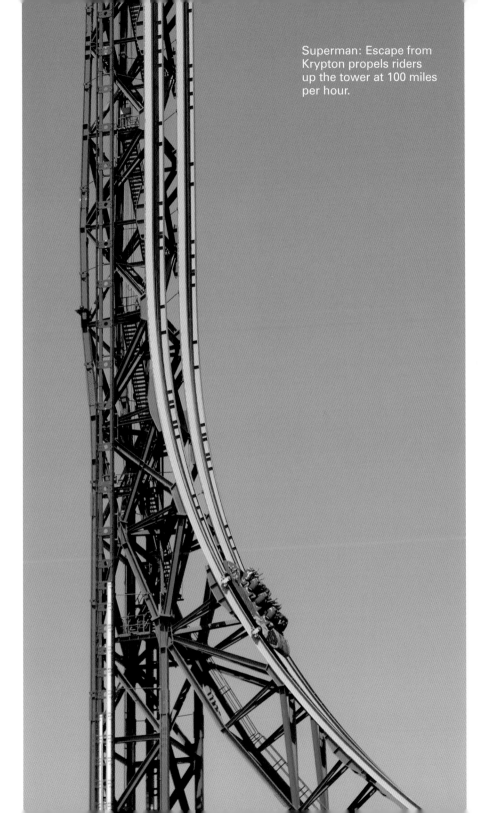

Superman: Escape from Krypton propels riders up the tower at 100 miles per hour.

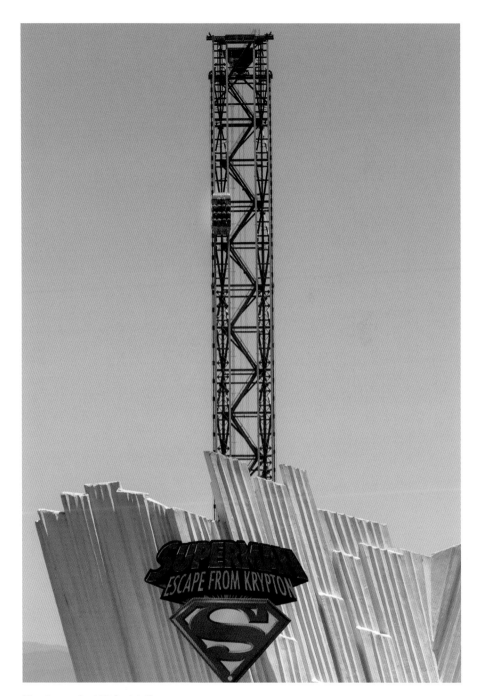

The tower is 415 feet tall.

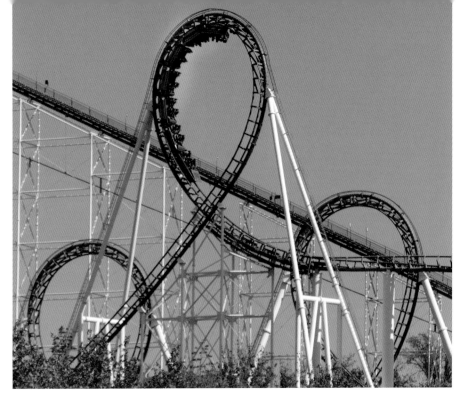

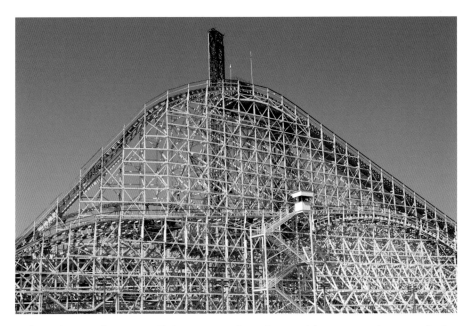

Gone but not forgotten: Colossus was the tallest and fastest wood coaster in the world in 1978.

Viper was similar in design to the now-defunct Great American Scream Machine at Six Flags Great Adventure.

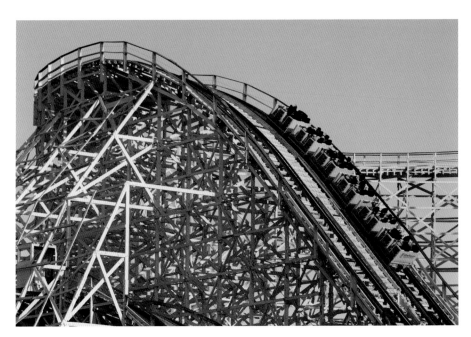

Revolution was the first modern coaster in the world with a vertical loop.

Colossus was transformed into Twisted Colossus, a hybrid steel coaster by Rocky Mountain Construction in 2015.

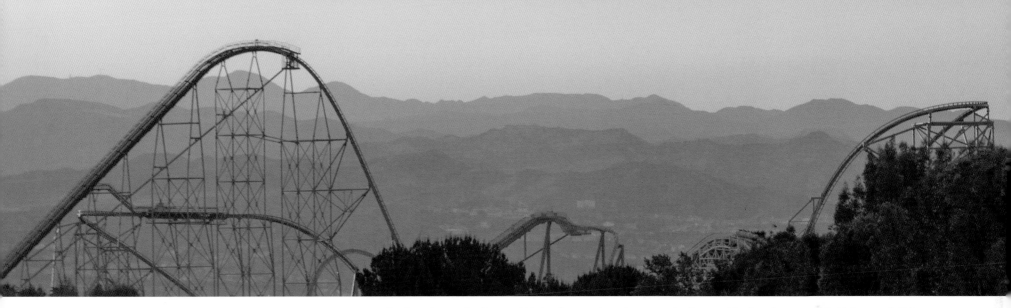

For a brief three-month period, Goliath had the longest drop (255 feet) and was the fastest (90.2 miles per hour) coaster in the world when it opened in February 2000.

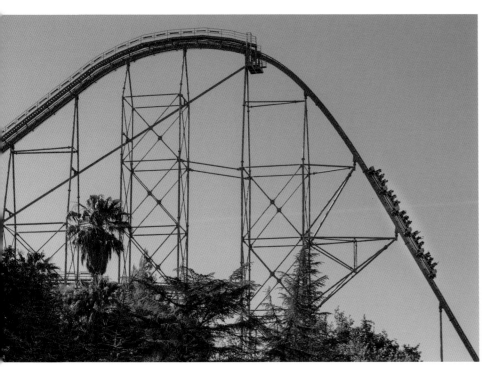

Only 235 feet tall, Goliath gets its drop by using an underground tunnel

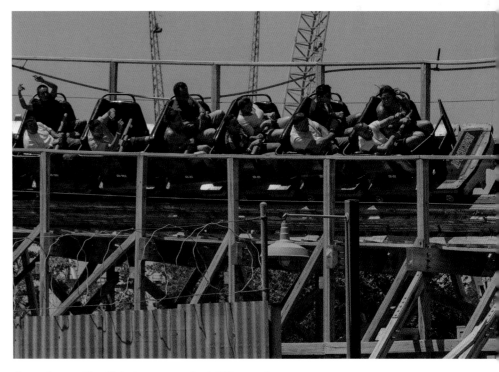

Apocalypse: The Ride is a competent GCI woodie.

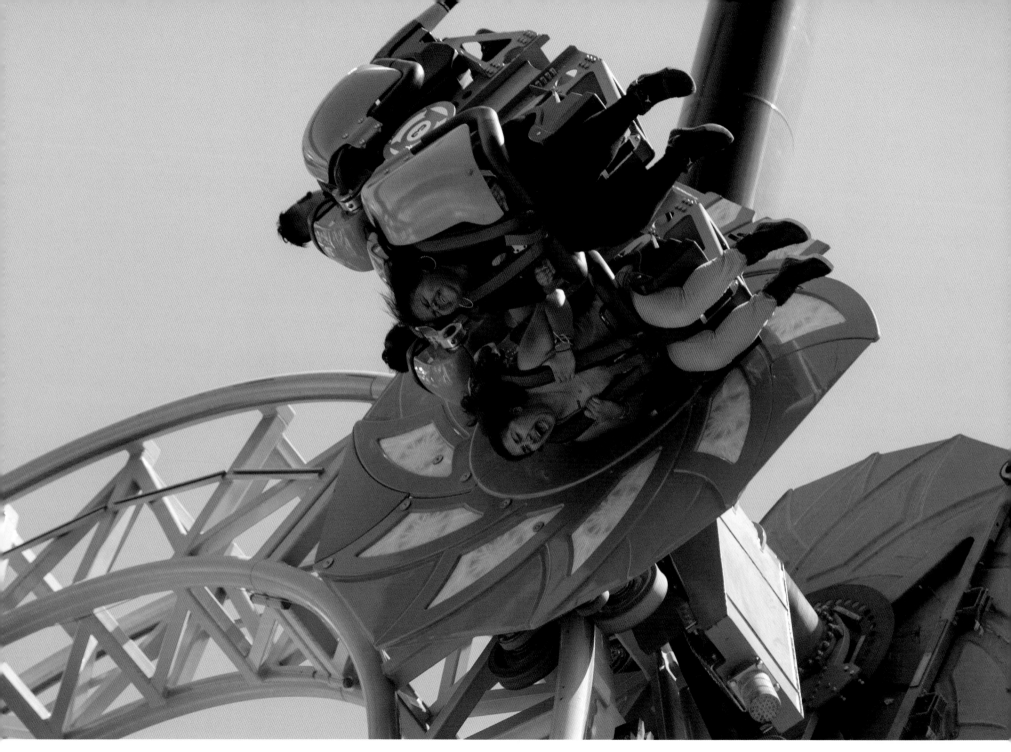

Green Lantern: First Flight features free spinning cars

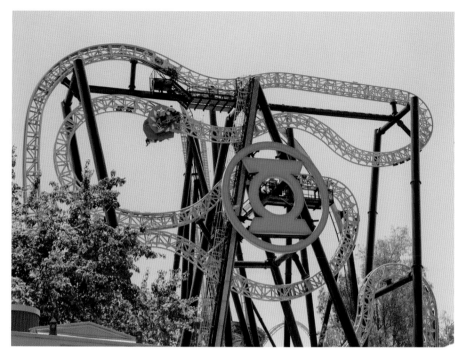

Green Lantern's 2-D design makes it the strangest coaster in the park.

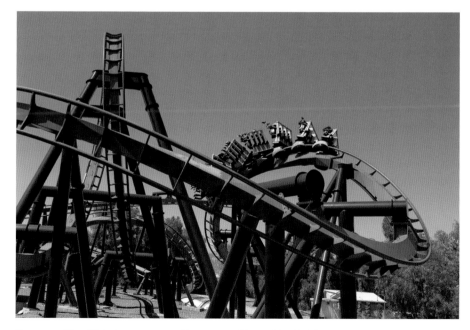

Batman: The Ride is a rare cookie-cutter ride at Magic Mountain.

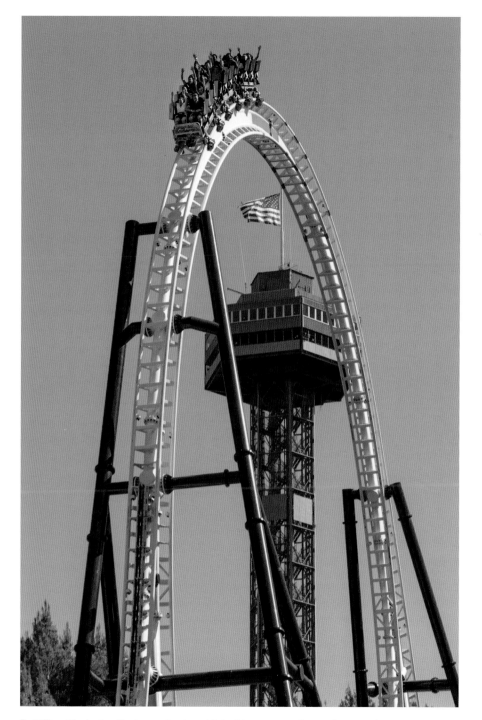

Full Throttle is the first coaster in which riders go under and over a loop.

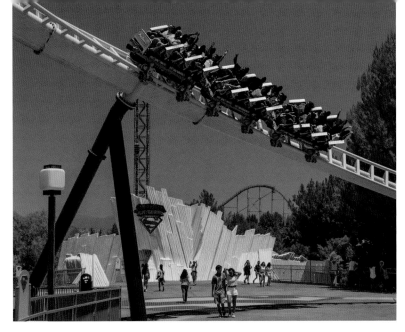

Full Throttle features three launches. One of them is backwards.

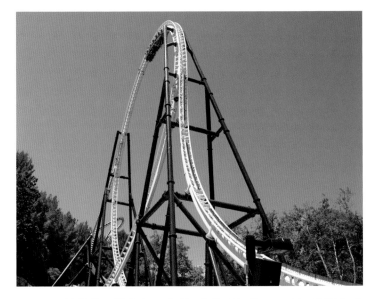

Full Throttle's loop is the tallest in the world at 160 feet.

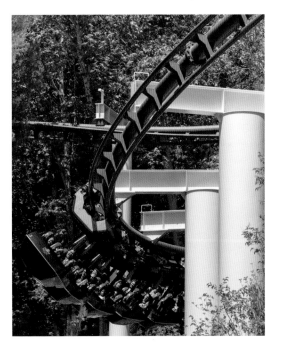

Ninja debuted in 1988 and is one of only three Arrow Dynamics suspended coasters remaining in the United States.

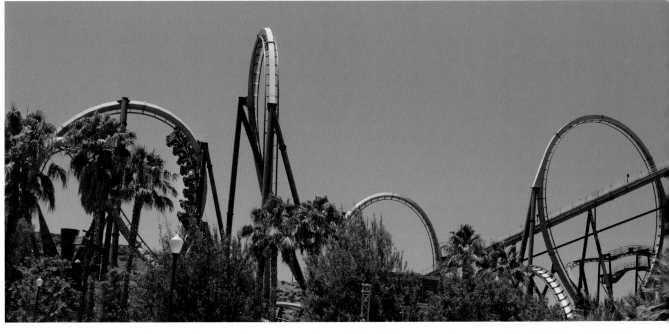

The Riddler's Revenge is a stand-up coaster that redefined what a stand-up was when it debuted in 1988.

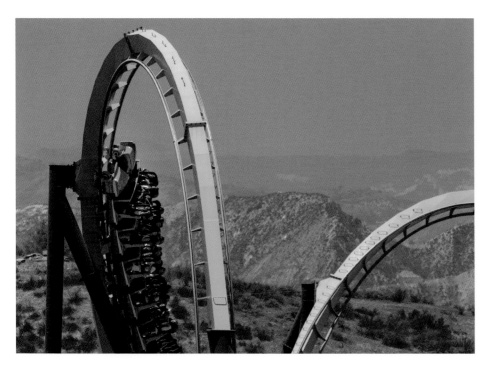

It also had the tallest vertical loop in the world.

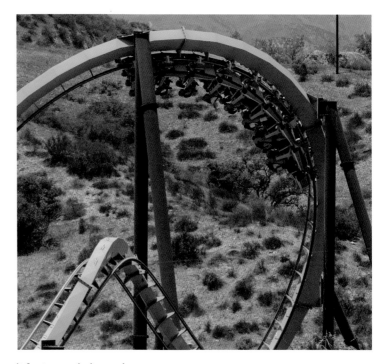

It features six inversions.

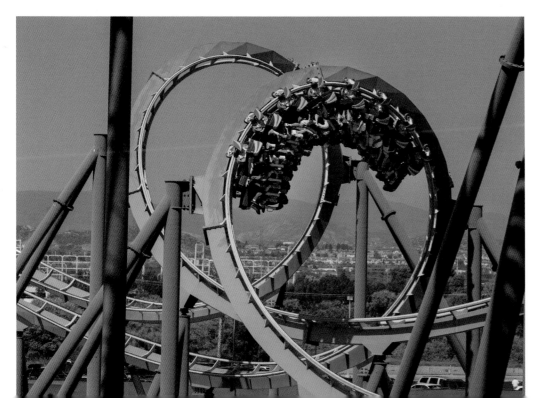

Scream is a floorless coaster that is a mirror image of Bizarro at Six Flags Great Adventure.

X2

OPENING DATE	January 12, 2002
MAKE	Arrow Dynamics
DESIGNER	Alan Schilke
MAX HEIGHT	175 feet (210-foot drop)
LENGTH	3,610 feet
MAX SPEED	76 mph
DURATION	2:00
INVERSIONS	2

Here it is, the world's first 4-D roller coaster. It's also the last roller coaster conceived and built by Arrow Dynamics, which filed for bankruptcy before the ride opened. In addition to the two standard rails that form the roller coaster track, two additional rails dictate the rotation of individual cars. This allowed the designers to place the riders in different positions while passing through elements. For example: on the first drop riders are rotated to face toward the ground, and then rotated onto their backs when pulling out of the dive.

The ride first debuted as X, but closed after six years of technical and mechanical issues. In May of 2008 it reopened as X2 with a new coat of paint, a sound track, flame throwers, and, most importantly, redesigned trains.

X2 continues to be one of the most popular rides in the park, and wait times are long. Riding it first thing when the park opens may be the only way to get a quick ride in without shelling out lots of money for Flash Pass access.

FACING PAGE

TOP LEFT: Riders are positioned on the outside of the track.

BOTTOM LEFT: Look closely: The additional rails control the car's rotation. See how the front of the train is oriented differently than the back.

RIGHT: This train is traveling backward, but with a half-rotation, suddenly the riders are facing forward.

The track layout is as odd-looking as the trains.

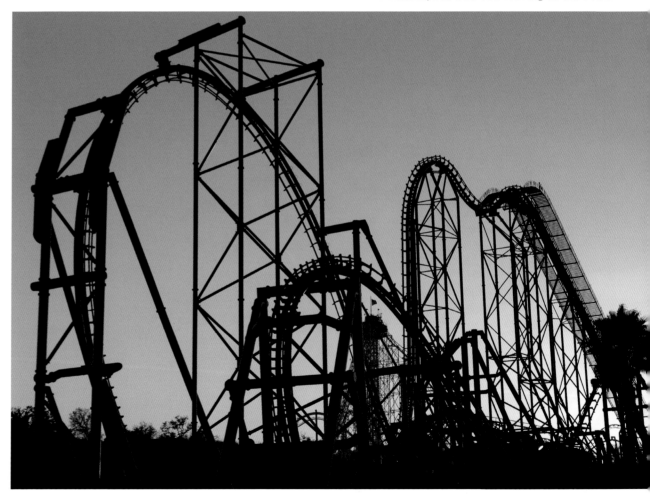

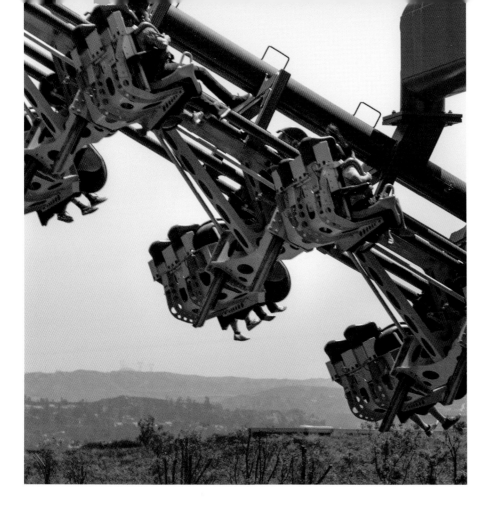

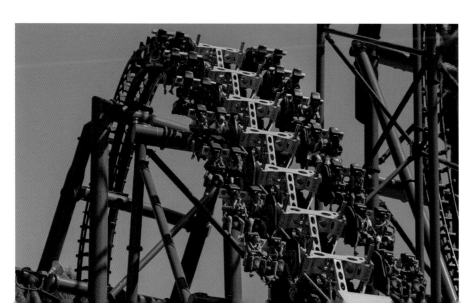

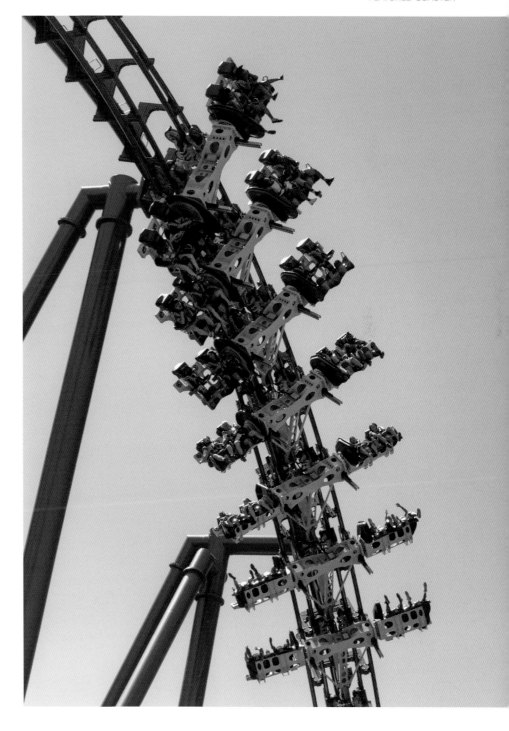

Tatsu

OPENING DATE	May 13, 2006
MAKE	Bolliger & Mabillard
MAX HEIGHT	170 feet (111-foot drop)
LENGTH	3,602 feet
MAX SPEED	62 mph
DURATION	2:00
INVERSIONS	4

It's the tallest, fastest, longest-flying coaster in the world. It also has the world's tallest pretzel loop and is the only flying coaster with a zero-gravity roll. Tatsu has it all, and it just might be the best flying coaster anywhere. A good argument can be made for Manta at Sea World Orlando, but I think the sheer scale of Tatsu and the way the entire ride seems perched on the side of a cliff, making it feel even taller, gives it a visceral edge to all challengers.

Magic Mountain's landscape enables a flying coaster to actually let riders soar through the sky and through the park instead of being limited to a narrow plot of land or forced to spend most of its time close to the ground. There's no other way to fly.

FACING PAGE

TOP LEFT: This tight right-hand turn gives riders a bird's-eye view of the park.

TOP RIGHT: This high-flying turn transitions into an exciting roll.

BOTTOM LEFT: The train swoops close to the ground in a few spots.

BOTTOM RIGHT: Time to buzz the tower.

The coaster is located on one of the highest elevations in the park.

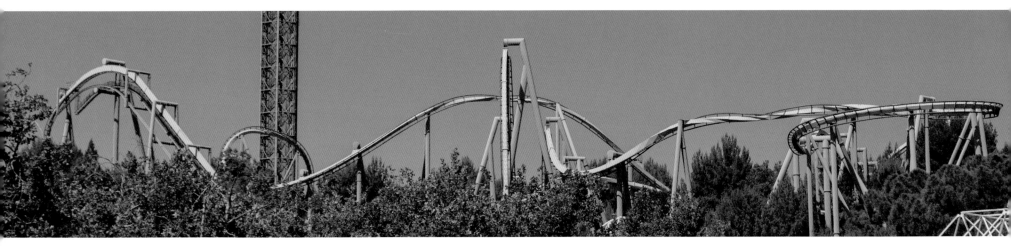

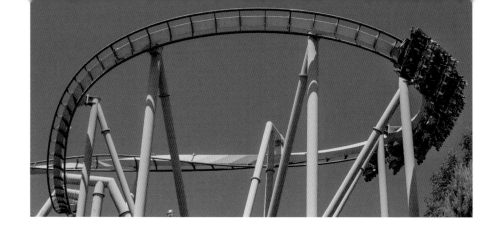
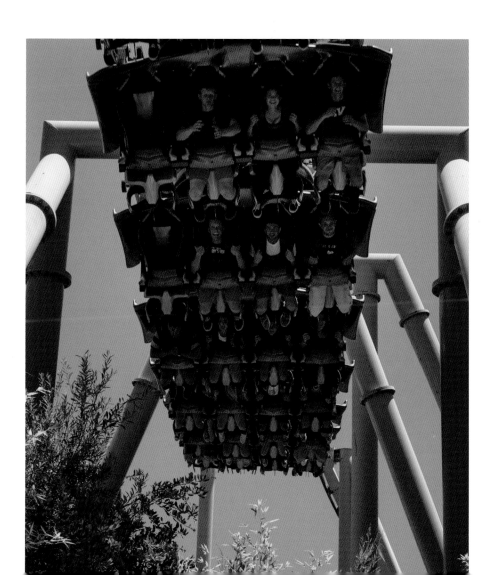
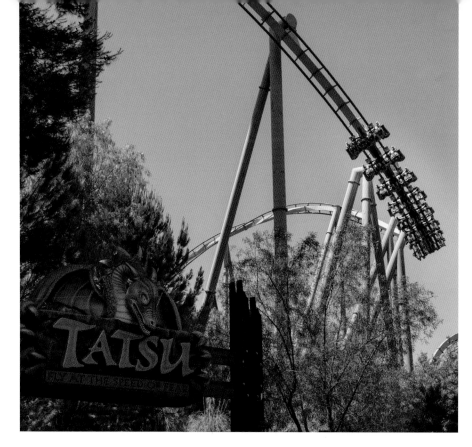
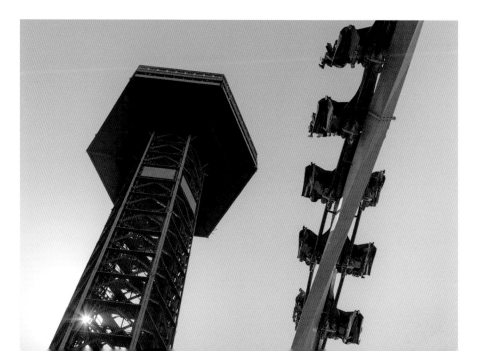

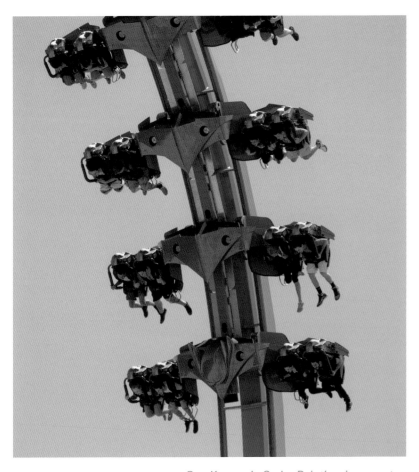

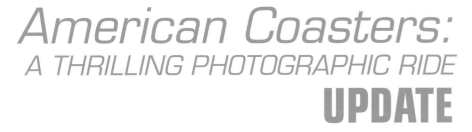

GateKeeper is Cedar Point's wing coaster.

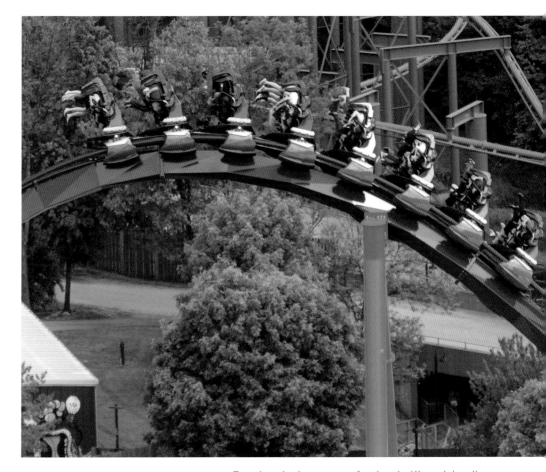

Banshee is the newest feather in Kings Island's cap.

American Coasters:
A THRILLING PHOTOGRAPHIC RIDE
UPDATE

The coaster landscape is forever changing, and in the years since publication of *American Coasters: A Thrilling Photographic Ride* several featured parks opened new coasters. A sampling includes a wing coaster at Cedar Point, the longest inverted coaster in the world at Kings Island, the tallest traditional roller coaster in the world at Carowinds, and the re-imagining of an old woodie at Six Flags New England by RMC, the hottest new roller-coaster builders on the planet.

Fury 325 streaks across the sky.

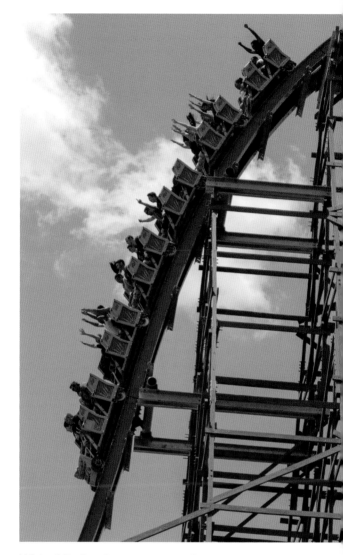

Wicked Cyclone's new, steeper drop.

Banshee at Kings Island
King's Island, Ohio

OPENING DATE	April 18, 2014
MAKE	Bolliger & Mabillard
MAX HEIGHT	167 feet (150-foot drop)
LENGTH	4,124 feet
MAX SPEED	68 mph
DURATION	2:40
INVERSIONS	7

In *American Coasters: A Thrilling Photographic Ride*, I wrote a passage about Son of Beast and wondered what would become of it. The ride was demolished, and in 2014 Kings Island opened Banshee, a beast of a ride that shares some common ground with Son of Beast.

Banshee is the longest inverted coaster in the world. The lift hill rises 167 feet into the air, but there is a 208-foot difference between that height and the lowest point on the ride. Because of the varied elevation, maximum speed isn't reached until halfway through the ride, allowing for a second vertical loop late in the course.

Banshee packs in an amazing array of elements. It's a pleasure to rocket through the seven inversions. The length of the track allows for three trains to run simultaneously. As a result, the line moves very fast. This ride is a win-win on many levels.

FACING PAGE

TOP LEFT: The design doesn't waste any time getting into the action.
BOTTOM LEFT: The train snaps over the first vertical loop.
RIGHT: The train rushes through a dive loop, one of the first elements in the ride.

You can catch this view of the back half of the ride from The Bat's queue.

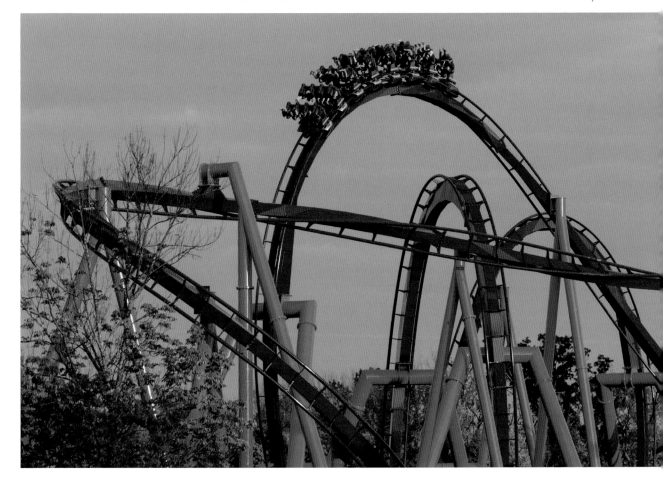

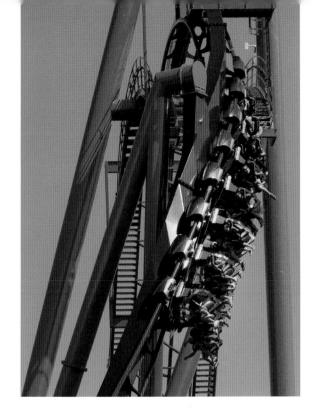

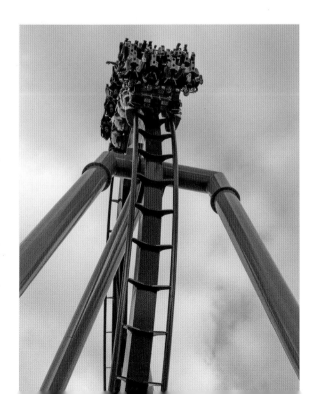

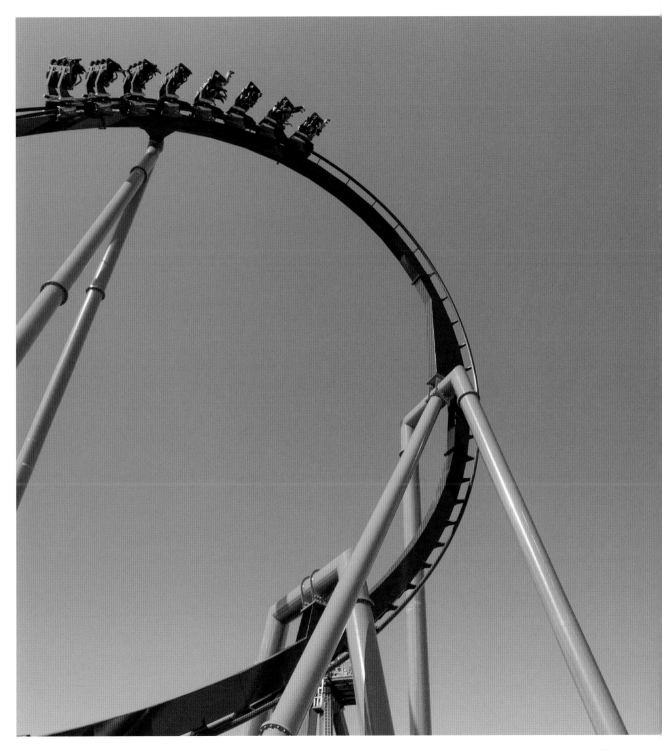

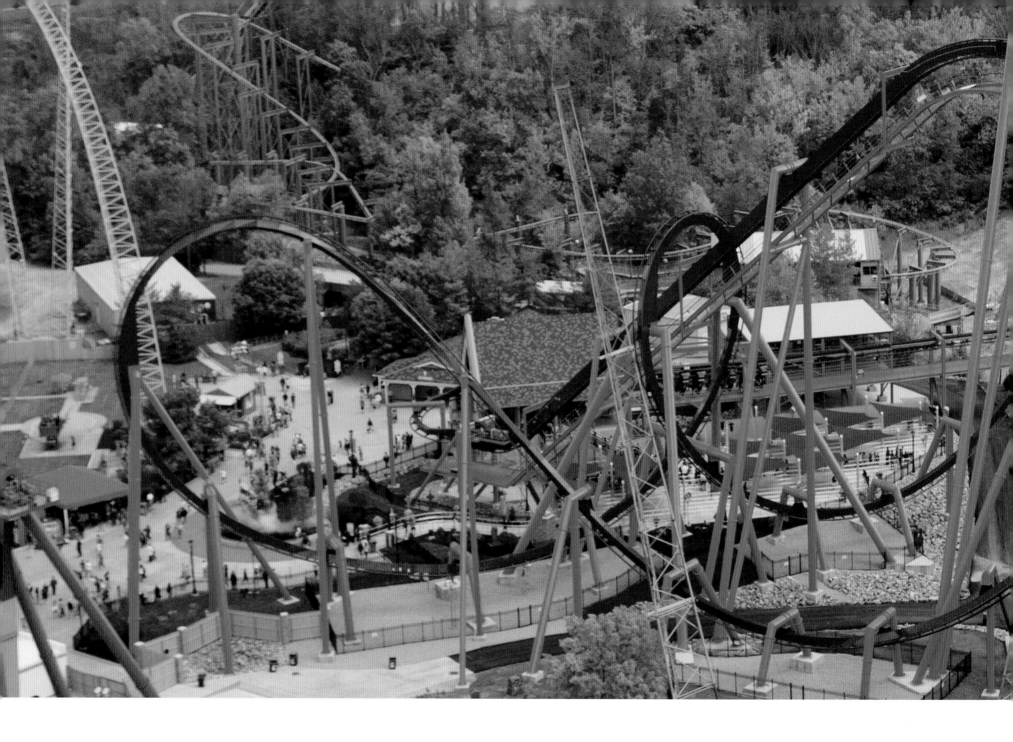

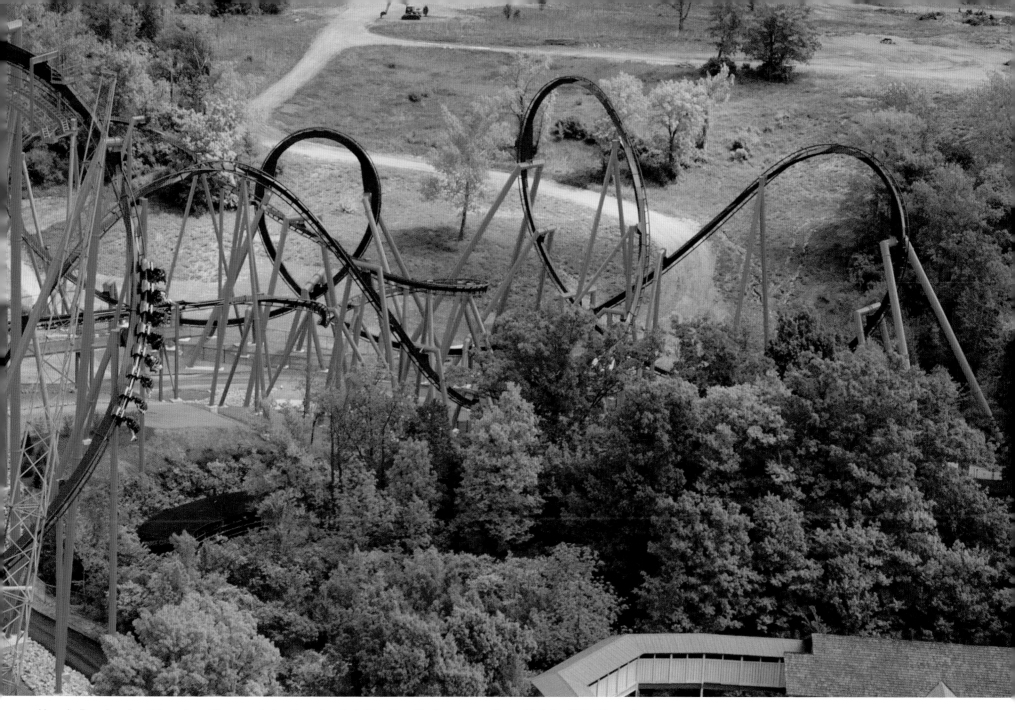

Here is Banshee in all her glory. The purple track contrasts brilliantly with its surroundings. Visit the Eiffel Tower's observation deck for this view.

GateKeeper at Cedar Point

Sandusky, Ohio

OPENING DATE	April 18, 2014
MAKE	Bolliger & Mabillard
MAX HEIGHT	167 feet (150-foot drop)
LENGTH	4,124 feet
MAX SPEED	68 mph
DURATION	2:40
INVERSIONS	7

When Cedar Point finally decided to build a wing coaster, the company was determined to go big or go home. This also involved redesigning the park entrance, which features a flyover of Gatekeeper as it slips through its signature keyhole moves.

The wing-over drop that begins the ride is the tallest inversion in the world. Gatekeeper also sets records for height, length, and speed for wing coasters. These records add up to another world-class experience at Cedar Point.

Gatekeeper is 1,000 feet longer than Wild Eagle and features X-Flight's keyhole elements and acrobatics. The result is a long, graceful ride filled with exciting inversions. Ride in the front to get the best view as the train rolls through the two keyholes.

The train emerges from the keyhole element in the second tower.

Riders immediately experience a wing-over drop as soon as the train clears the lift hill.

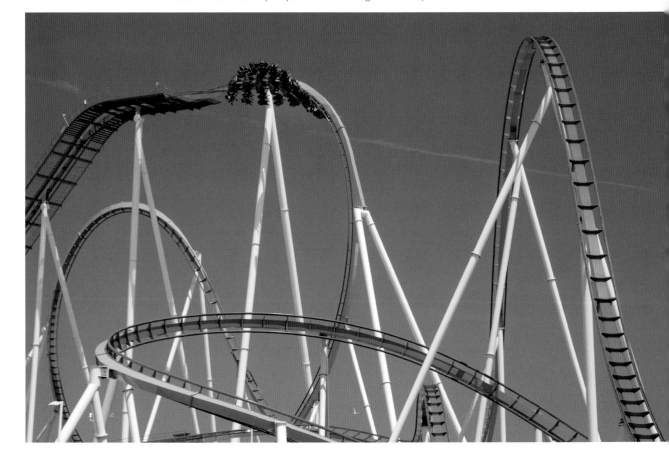

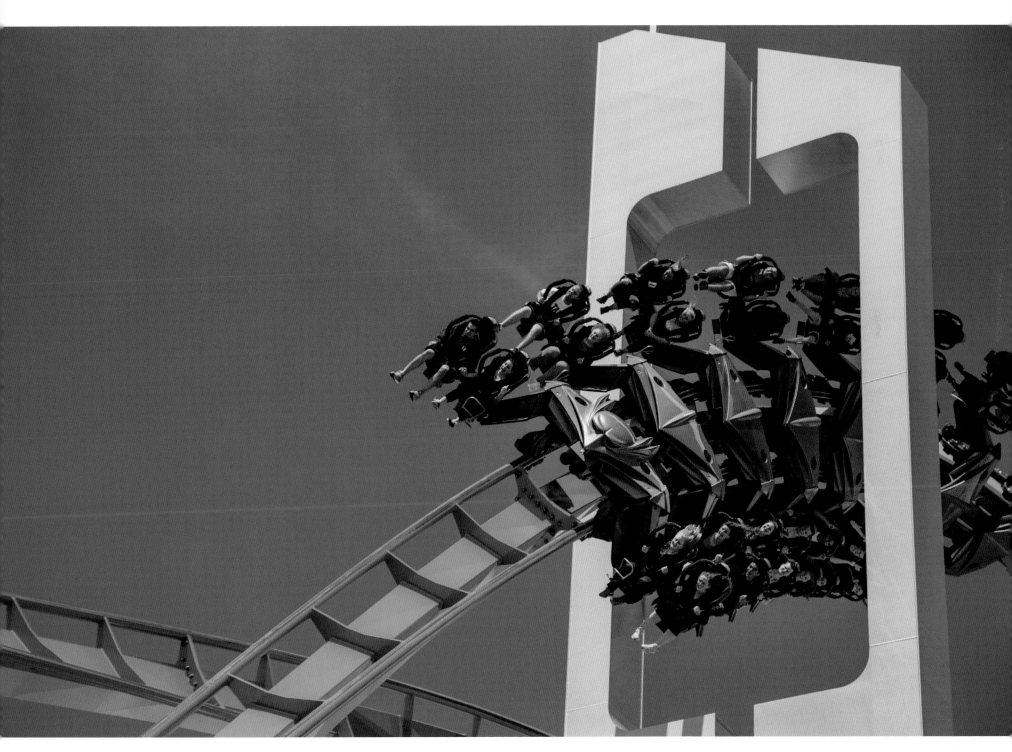

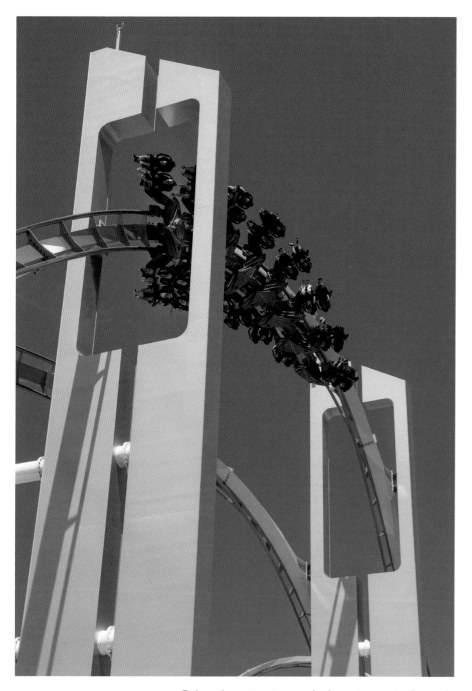

Below these two towers is the entrance to the park.

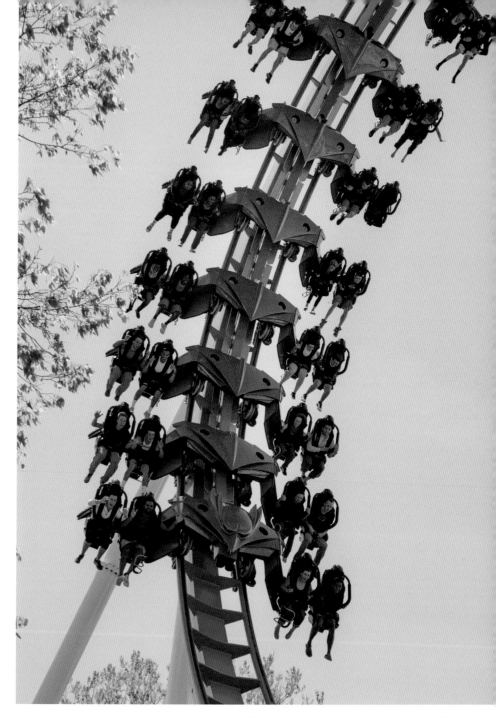

The train turns around at the mid-point.

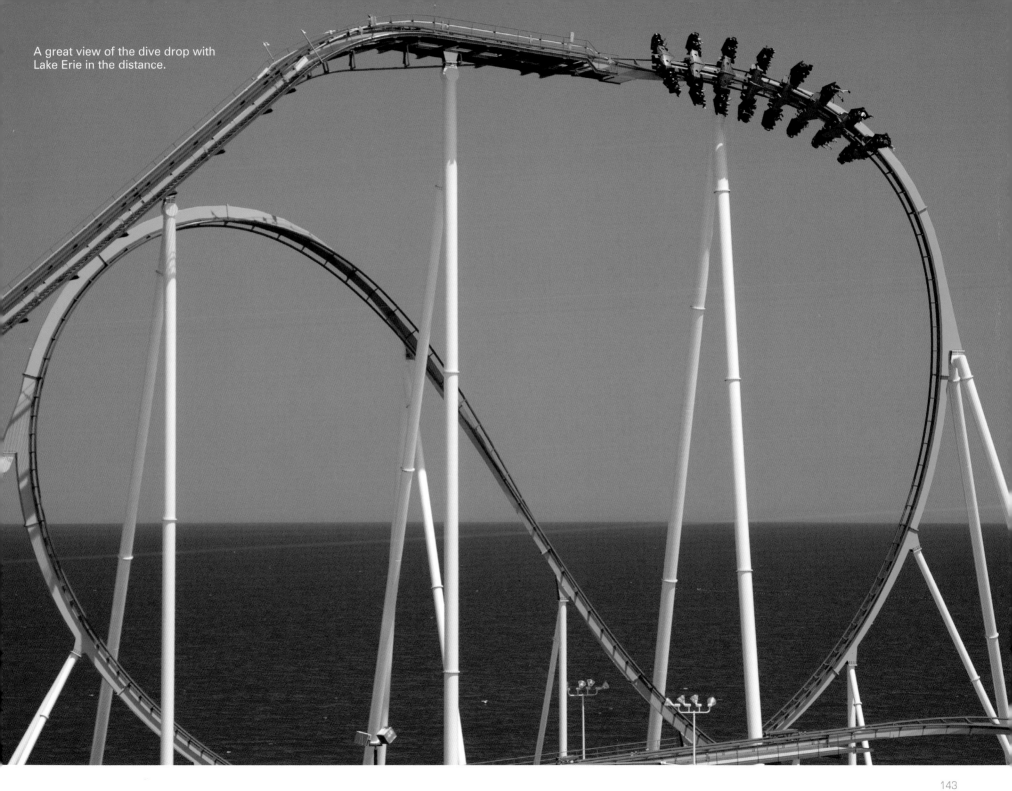

A great view of the dive drop with Lake Erie in the distance.

Hair time: This ride has an abundance of ejector air (airtime that would throw you from the train if not for the restraints).

The entrance is framed by track and trains zooming past.

Wicked Cyclone
at Six Flags New England
Agawam, Massachusetts

OPENING DATE	May 24, 2015
MAKE	Rocky Mountain Construction
DESIGNER	Alan Schilke
MAX HEIGHT	109 feet
LENGTH	3,320 feet
MAX SPEED	55 mph
INVERSIONS	3

This is RMC's first foray into the Northeast and another example of an aging wooden coaster that has been transformed into a state-of-the-art steel hybrid coaster.

The original ride debuted in 1983 as the Riverside Cyclone, which was inspired by the original Coney Island Cyclone. It was an intense ride that appealed to the hard core, but few others. Riverside Park spent many years trying to tame the ride, with varying degrees of success. When Six Flags purchased the park in the late 1990s, the company renamed the ride Cyclone and took some of the sting out of the first drop by shortening it. This made the coaster more rideable but neutered the experience overall.

Six Flags continued to work on the ride, and as late as 2011 installed RMC's Topper Track (thick steel plating that replaced the upper layers of the original wooden track), but even that wasn't enough. In 2014, Six Flags decided to do a full RMC conversion.

While a far cry from the original Riverside Cyclone, this new RMC does a good job of restoring the ride's intensity. In the three inversions, riders experience the world's first double-reversing bank airtime hill, a 200-degree stall, and two zero-g rolls.

The first half of Wicked Cyclone is wonderful, but after the wall climb that follows the stall element, the ride loses some of its grace and starts throwing the kitchen sink at you. It's fine for a ride or two, but after a half-dozen rides you may feel tired out. During the heat of summer when the water park is in full swing, you'll be able to get your fill of rides in the afternoon.

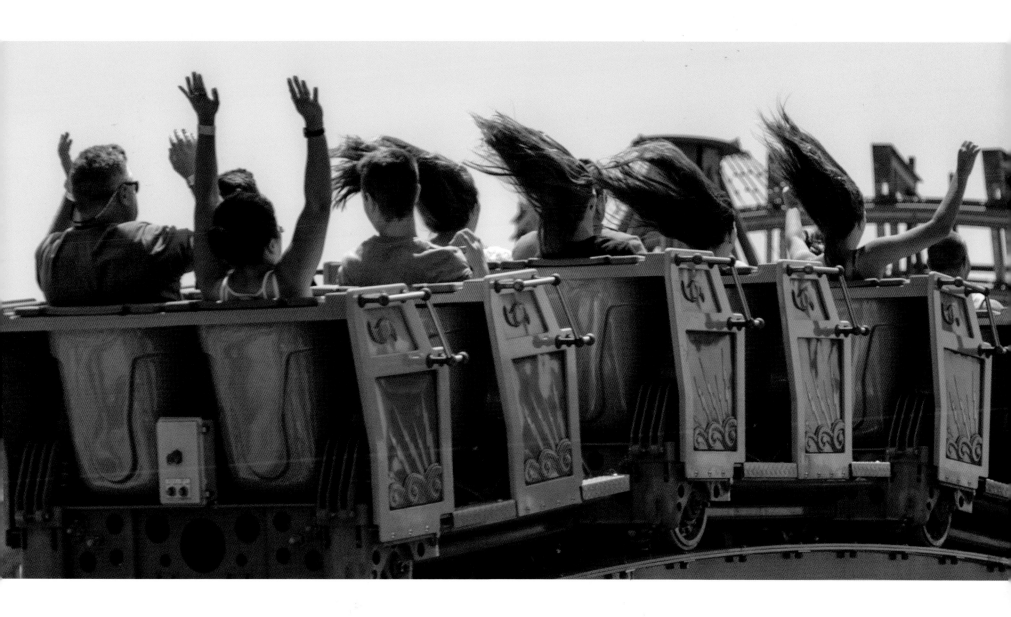

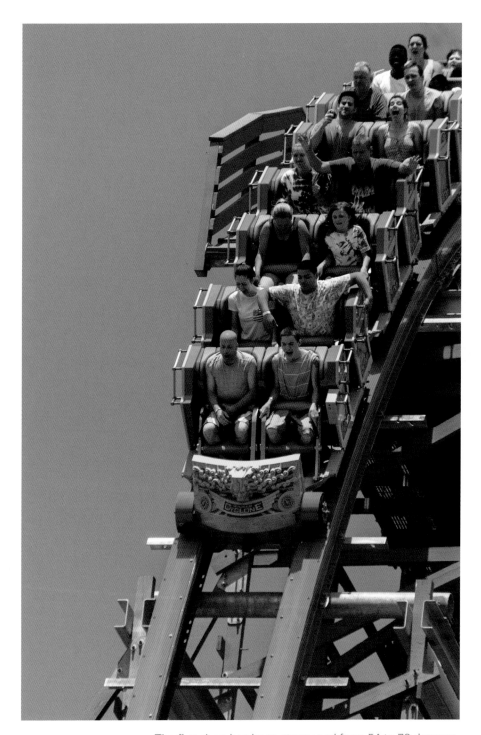

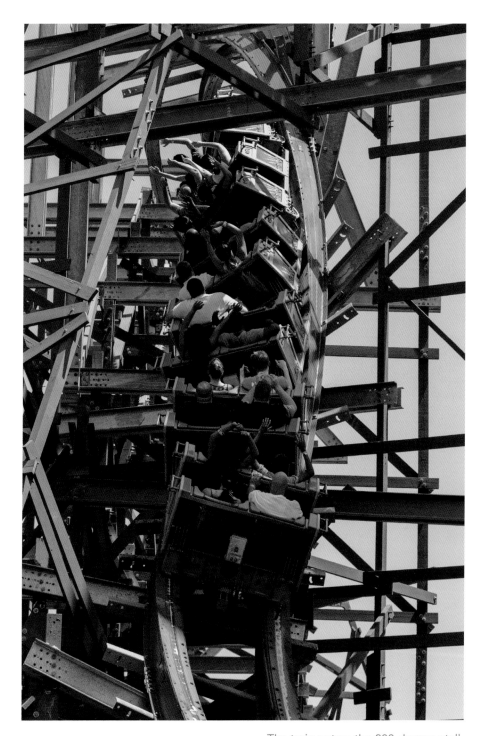

The first drop has been steepened from 54 to 78 degrees.

The train enters the 200-degree stall.

The train navigates the first high banked turn after the initial drop.

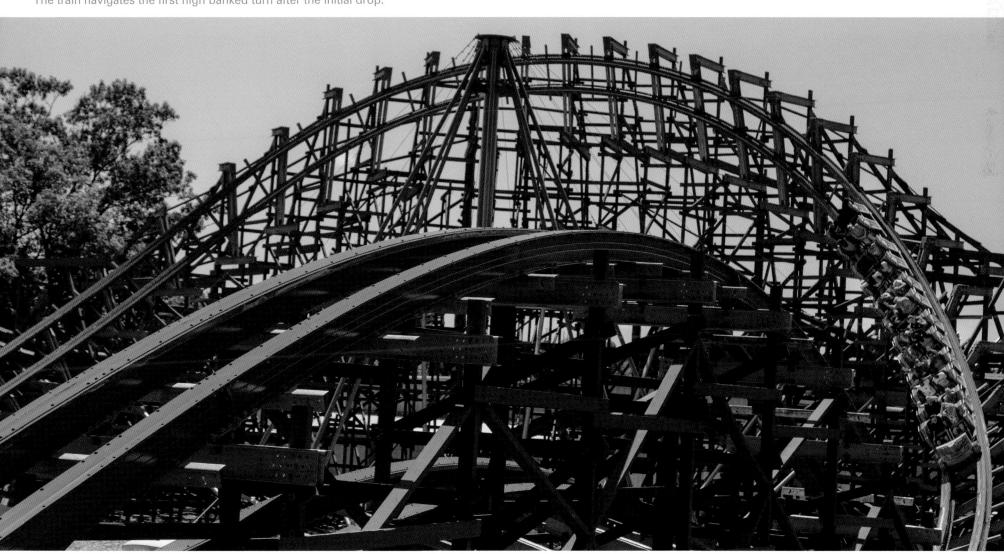

Fury 325 at Carowinds

Charlotte, North Carolina

OPENING DATE	March 27, 2015
MAKE	Bolliger & Mabillard
MAX HEIGHT	325 feet (320-foot drop)
LENGTH	6,602 feet
MAX SPEED	95 mph
INVERSIONS	0

Carowinds was a nice, nondescript park in the Southeast for many years. It satisfied its patrons but wasn't really a player on the national level. All of that changed with Fury 325, to date the tallest conventional full-circuit roller coaster in the world.

At 95 miles per hour, it eats the 6,600 feet of track for breakfast and asks for seconds. It's forceful. It's graceful. It's full of tight turns and has a copious amount of airtime. Like Gatekeeper at Cedar Point, Carowinds totally redesigned its front entrance to show off this monster coaster.

Fury 325 is a perfect balance of force and finesse. Ride it in the front to experience the first drop at its visual best and to experience great airtime as the train rockets over the hills. Ride it in the back for the whip effect on the hills and to feel the power of the train pulling you through the turns. This coaster will find its way to the top of many a list.

One of the many airtime hills on this steel beauty.

The near-vertical 325-foot drop is impressive even when viewed from afar.

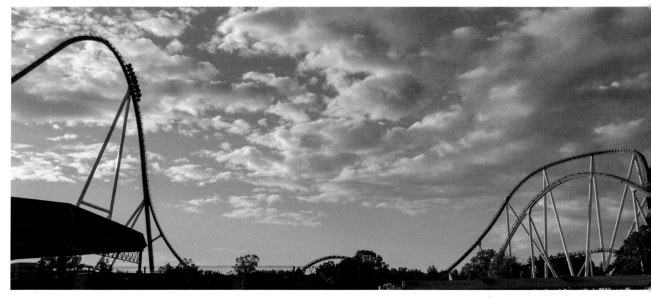

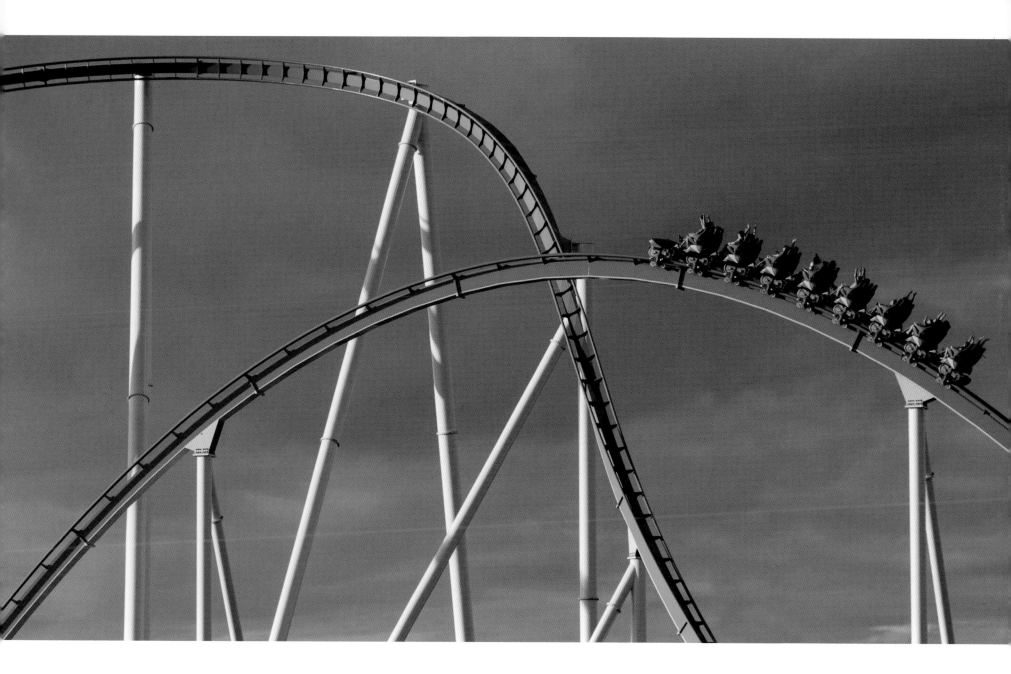

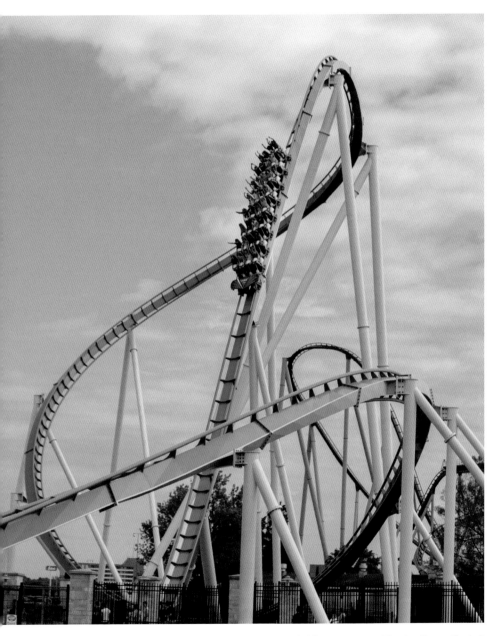

Catch it at the right angle and this turnaround looks like a G-clef.

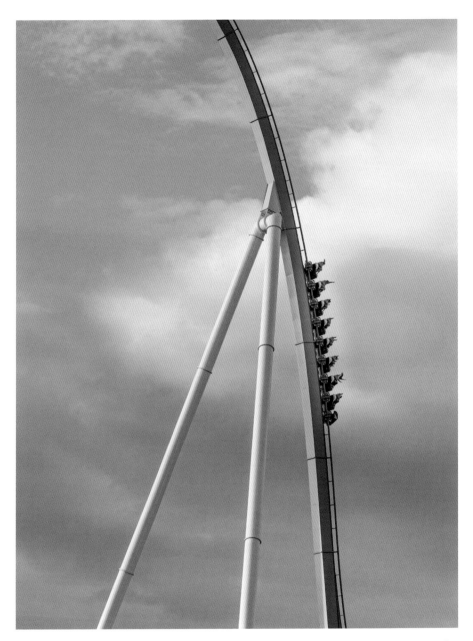

Near-vertical, my foot. Tell that to those people on the train.

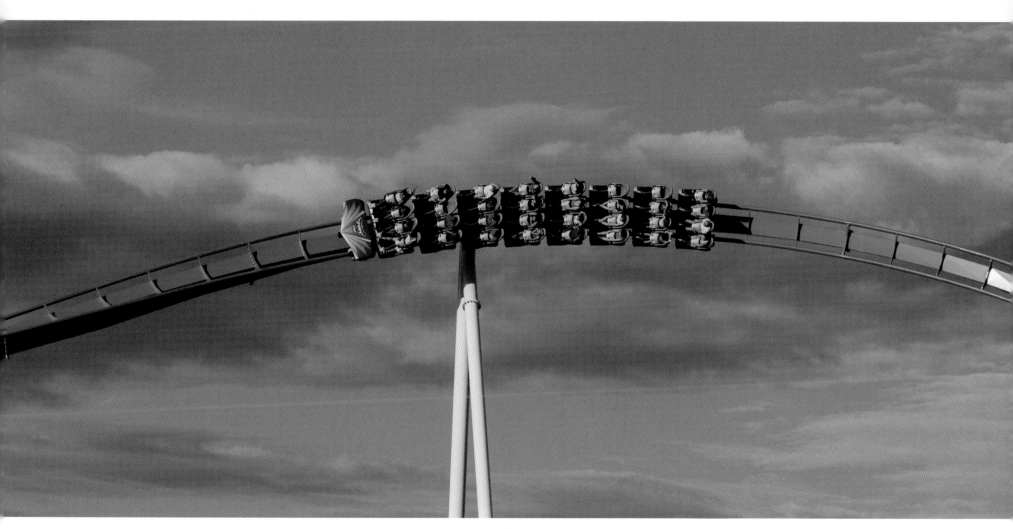

I don't know what it is about the Carolinas, but every time I go, I find the most amazing skies.

Best of the Rest

The next few chapters showcase a regional compilation of parks that were either too small or too big to include, or didn't have enough photographable roller coasters to warrant a dedicated chapter.

The following pictures were shot at parks ranging from Erie, Pennsylvania, to Saco, Maine. This region features the oldest and most iconic coasters in the world.

Lakemont Park

Altoona, Pennsylvania

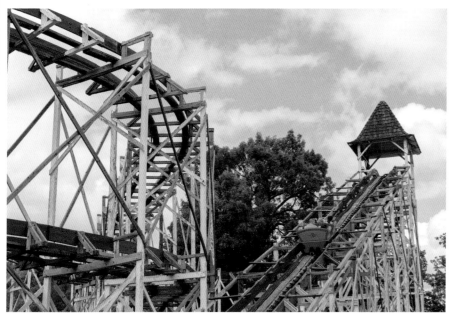

Opened in 1902, Leap the Dips is the world's oldest operating roller coaster.

Leap the Dips is the last side friction roller coaster in the United States.

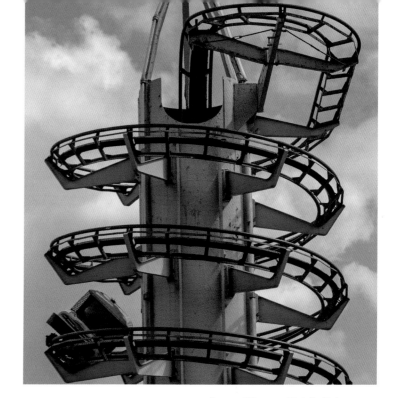

A rare Chance Ride's Toboggan

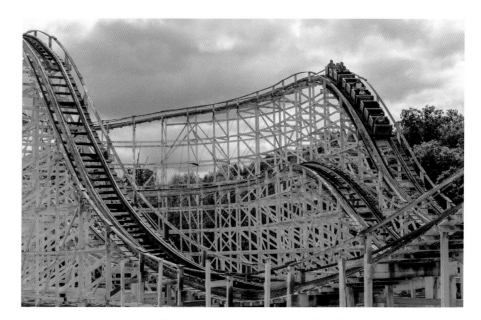

Skyliner was John C. Allen's first full-size coaster design.

Lake Compounce

Bristol, Connecticut

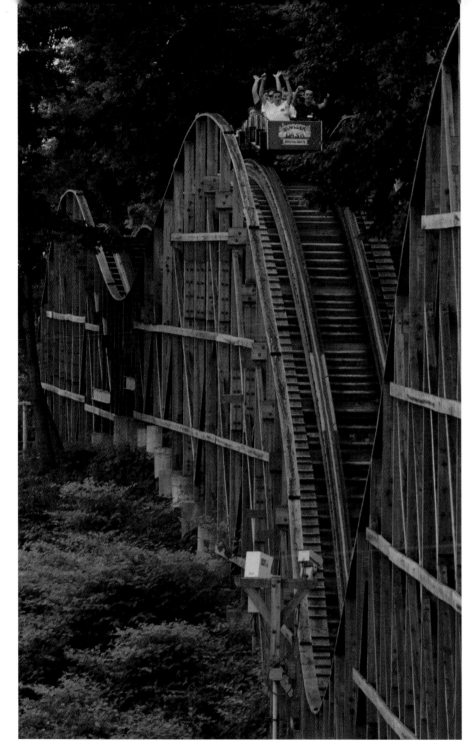

Boulder Dash is a terrific terrain coaster built on a hillside.

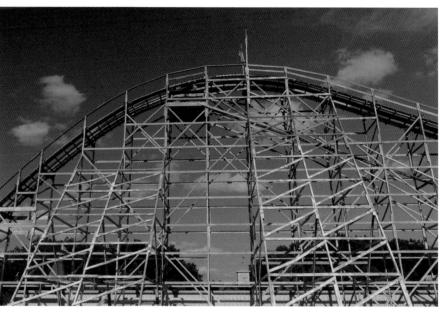

Wildcat opened in 1927. Some of the original wood remains in the station.

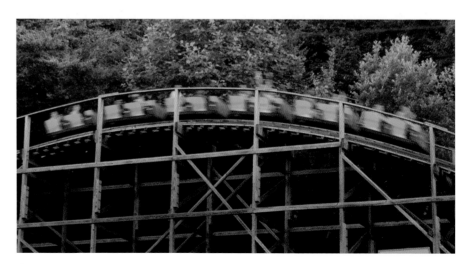

Boulder Dash streaks toward the station.

Conneaut Lake Park

Conneaut Lake, Pennsylvania

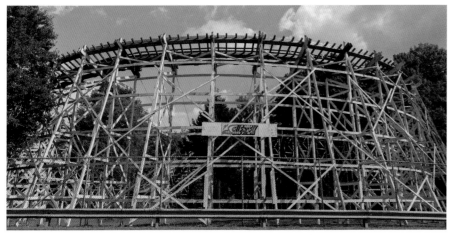

Blue Streak opened in 1938.

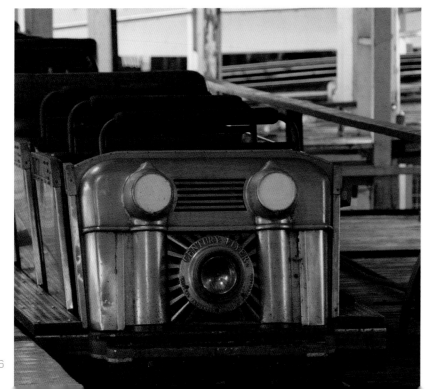

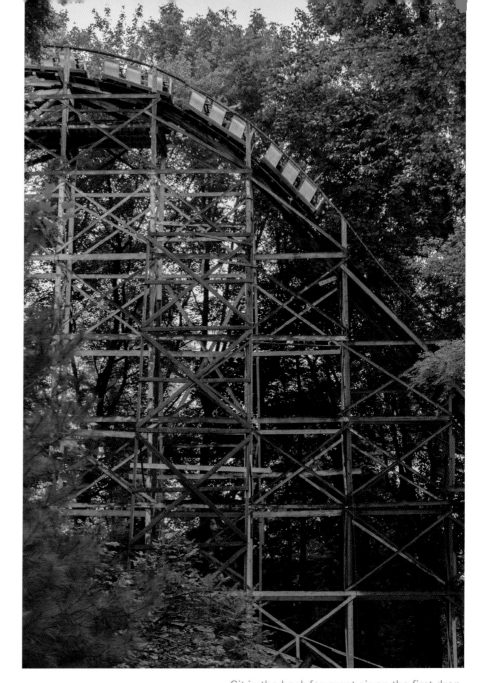

Sit in the back for great air on the first drop.

It currently operates with a National Amusement Devices train.

Idlewild & SoakZone

Ligonier, Pennsylvania

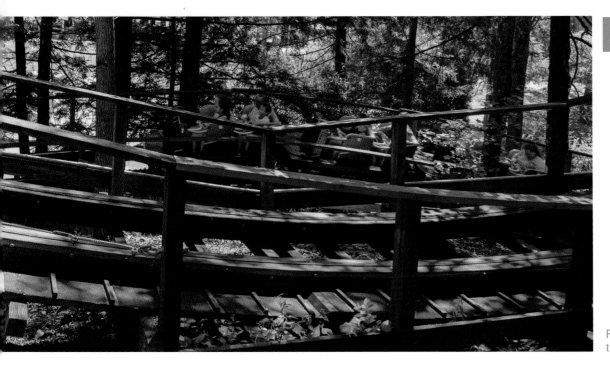

Rollo Coaster is a terrain coaster that opened in 1938.

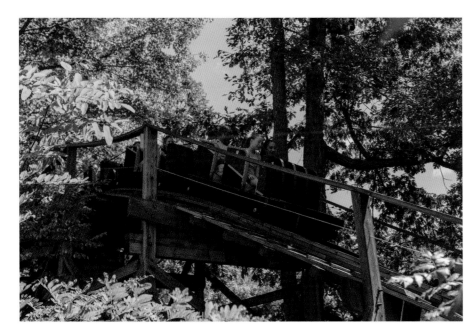

Rollo Coaster is the best junior woodie anywhere.

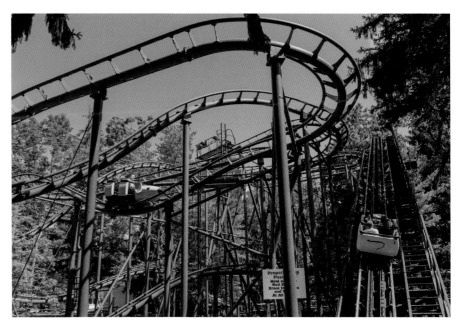

Wild Mouse was originally from Vienna, Austria.

Canobie Lake Park

Salem, New Hampshire

NORTHEAST

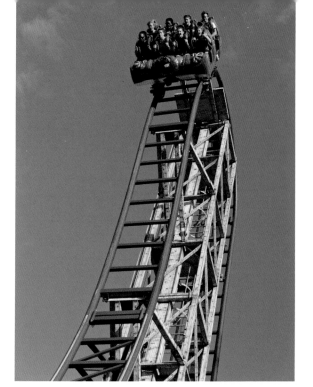

Untamed's 97-degree drop is the steepest in the Northeast.

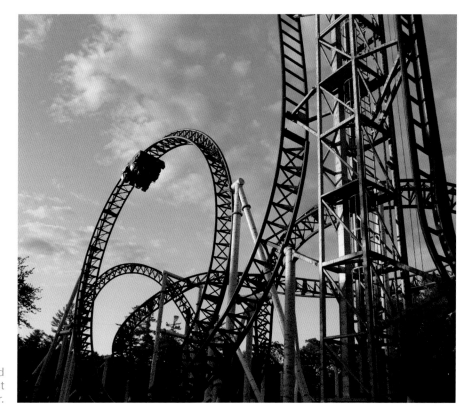

Opening in 2011, Untamed is the park's newest coaster.

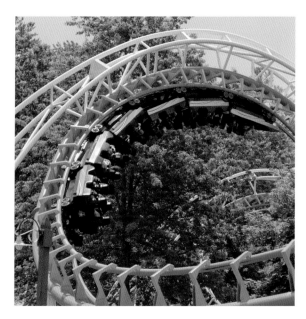

Canobie Corkscrew is a classic Arrow Dynamics coaster featuring back-to-back corkscrews.

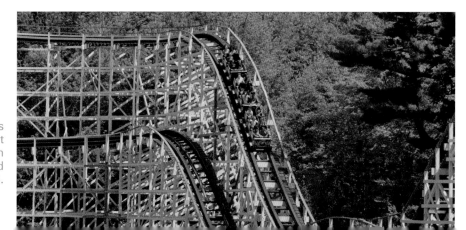

Yankee Cannonball was designed by Herbert Schmeck and opened in 1930 before being moved here in 1936.

Playland Park

Rye, New York

NORTHEAST

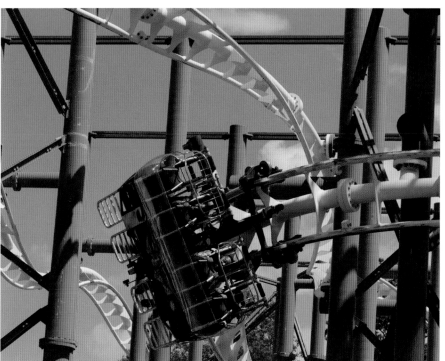

Super Flight is one of three coasters of its kind in North America.

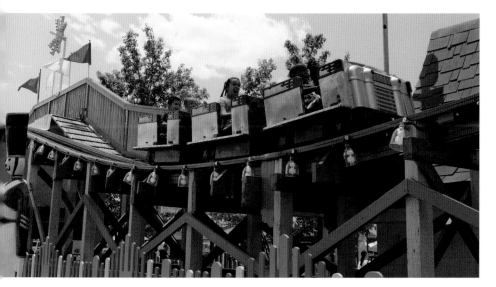

Dragon Coaster features this unique tunnel and dates back to 1929.

Kiddie Coaster opened in 1928 and is a rare wooden kiddie coaster.

Quassy Amusement Park
Middlebury, Connecticut

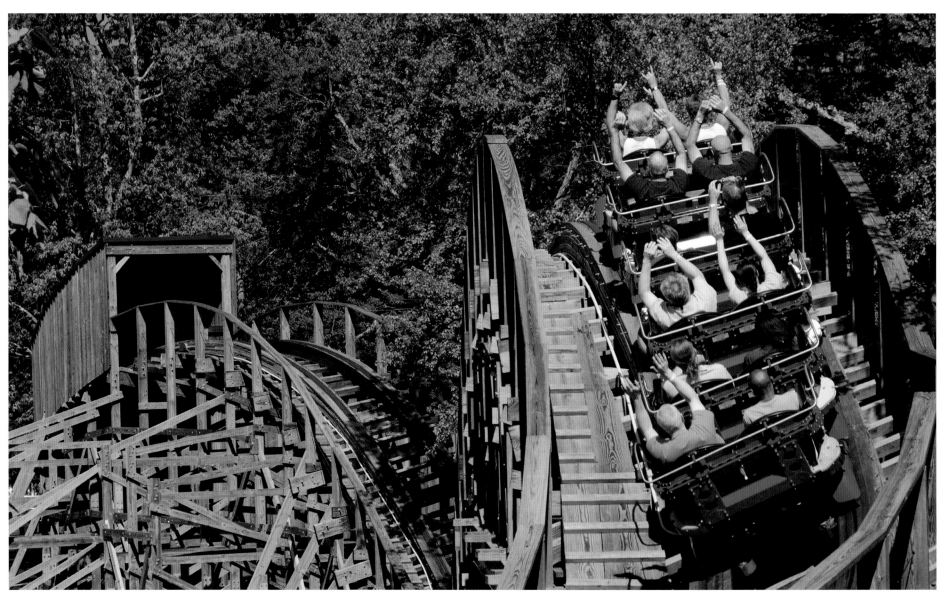

Wooden Warrior may be small, but it delivers the excitement.

Luna Park

Brooklyn (Coney Island), New York

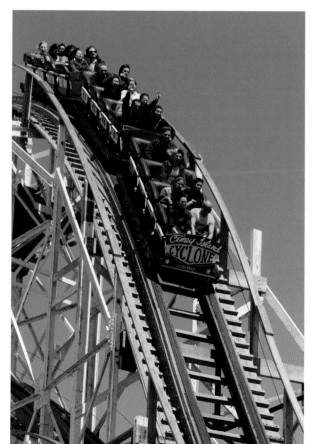

The Coney Island Cyclone opened in 1927.

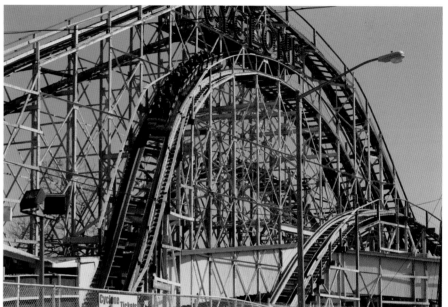

The Cyclone's design influenced countless coasters.

It is arguably the most famous roller coaster in the world.

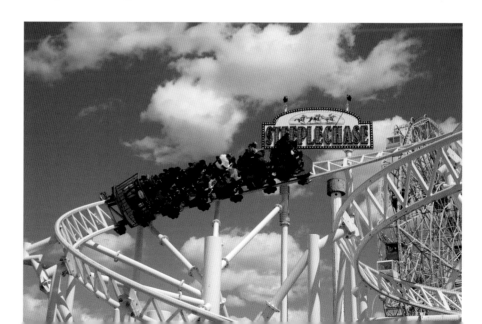

Riders sit as if riding a horse on Steeplechase.

Thunderbolt at Luna Park

OPENING DATE	June 14, 2014
MAKE	Zamperia
MAX HEIGHT	115 feet
LENGTH	2,223 feet
MAX SPEED	55 mph
DURATION	2:00
INVERSIONS	4

FACING PAGE

TOP LEFT: The turnaround is a picturesque dive.
TOP RIGHT: The car has an unusually high center of gravity.
BOTTOM LEFT: The train dives toward the turnaround.
BOTTOM RIGHT: The track is packed in tight but loops and curls in imaginative ways.

The original Thunderbolt was a wooden coaster that operated from 1925 to 1982 and was demolished in 2000. In 2013 it was announced that the Thunderbolt would be born again, this time as a steel coaster.

The vertical lift hill, 90-degree drop, and four inversions couldn't be more diametrically opposed to the classic steel-framed woodie it was named for. Because of how the land is partitioned, and the expensive real estate, the ride is limited to a small rectangle of land like its predecessor and also like the famous Coney Island Cyclone.

This steel coaster seems ideally suited for the location. The lift hill takes up mostly vertical space and the steel track allows the train to maximize the usable space.

The ride itself is quite entertaining. Riders will find themselves straining the loose and needless shoulder straps with each airtime hill. The inversions seem effortless and well placed. At $10 a ride, don't plan on marathoning this one without deep pockets.

Thunderbolt is a vibrant part of the boardwalk.

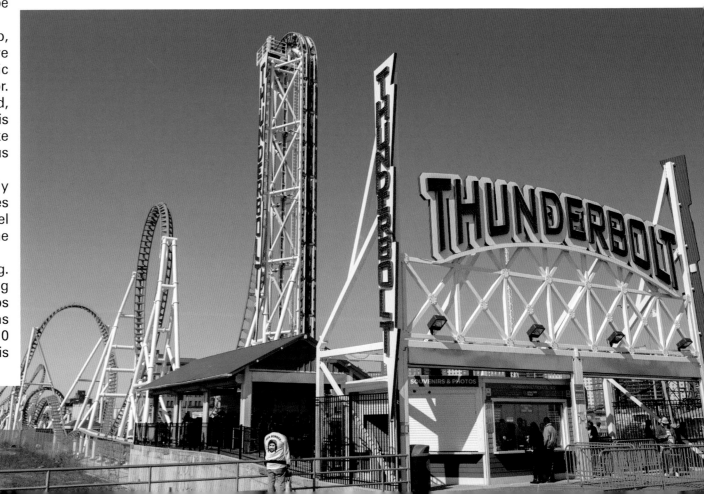

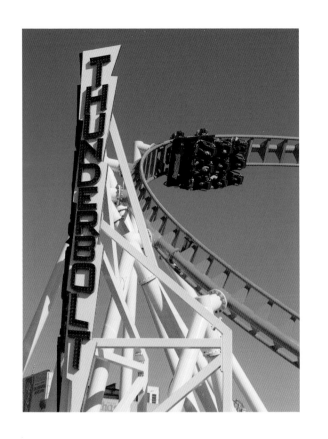
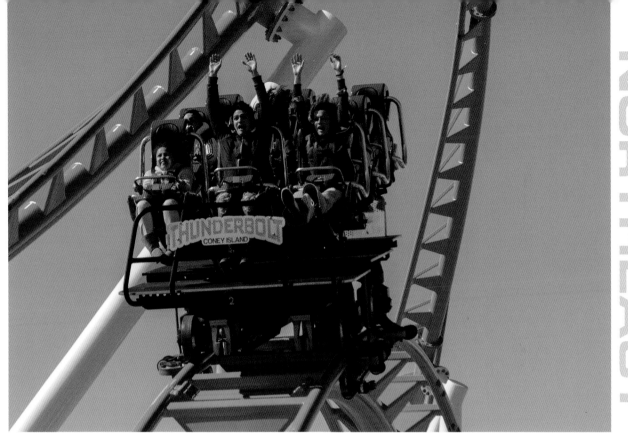

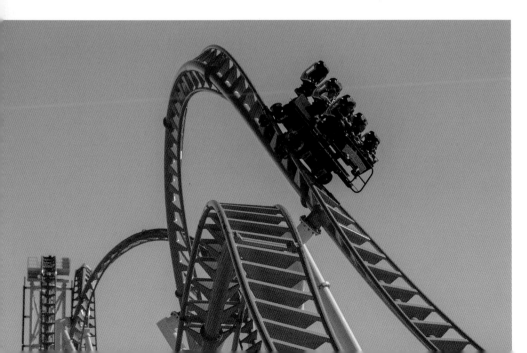
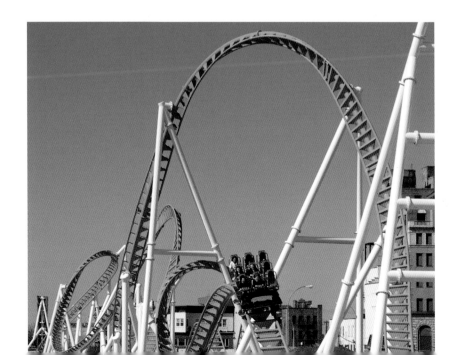

Ravine Flyer II
at Waldameer Park
& Water World

Erie, Pennsylvania

OPENING DATE	May 17, 2008
MAKE	The Gravity Group
MAX HEIGHT	80 feet (115-foot drop)
LENGTH	2,900 feet
MAX SPEED	57 mph
DURATION	1:30
INVERSIONS	0

Tucked away in western Pennsylvania is a little park with a world-class coaster. The original Ravine Flyer was removed way back in 1938 after a tragic accident. Seventy years is a long time to wait for a sequel, but when the park decided it was time to build a new one they enlisted some of the best minds in the business.

The coaster was originally developed by Custom Coasters International in the early 1990s and eventually finished by the Gravity Group in 2008. The resulting coaster is a force of nature, a raucous ride through the woods.

The ride is best experienced at night after the train has spent the day warming up. Early rides are solid but unspectacular. When the lights start to dim, this coaster comes alive, hurling riders through the course at a furious pace. It's no mistake that Ravine Flyer II is rated among the top ten wood coasters in the world.

FACING PAGE

LEFT: The high, banked turns are a thing of beauty.

TOP RIGHT: There are great vantage points for viewing the coaster if you do some exploring.

BOTTOM RIGHT: Front rides are fantastic, especially when you can anticipate the tight turns.

The coaster's flags fly proudly against the setting sun.

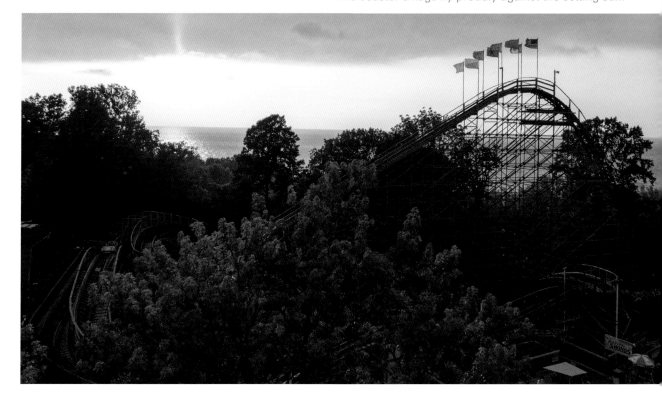

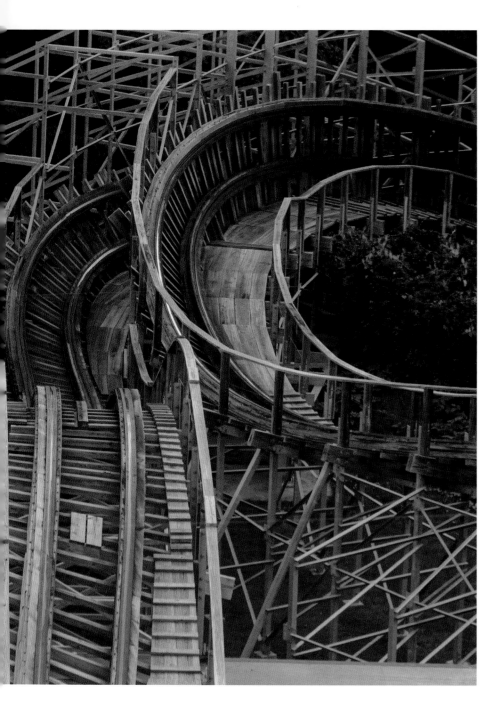

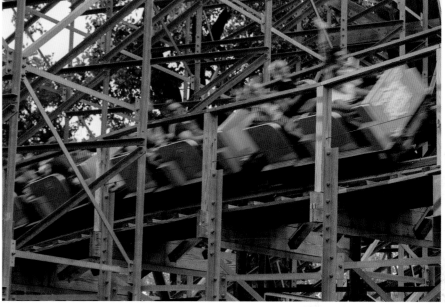

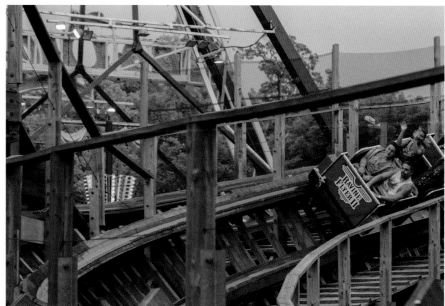

SOUTHEAST

The coasters represented here are mostly from the Orlando area with a couple of parks from Kentucky added for good measure. While the Disney parks are by no means small, they aren't filled with coasters, and their most famous one is indoors, away from prying cameras.

Kentucky Kingdom
Louisville, Kentucky

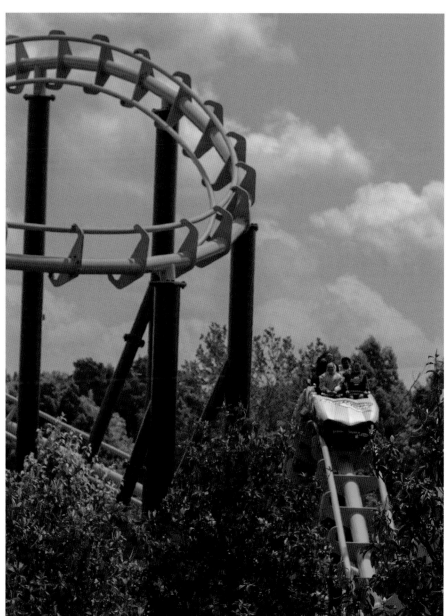

Lightning Run is the first and only operating Hyper GT-X style coaster in the world.

It's a pretty one to photograph as well.

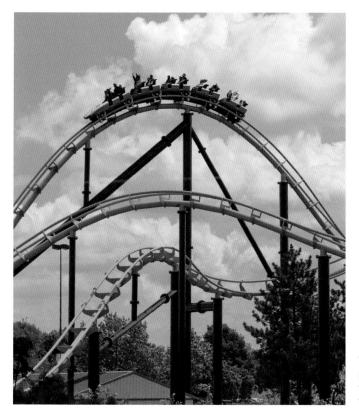

The small train and nimble track make for turbulent rides.

Animal Kingdom

Lake Buena Vista, Florida

SOUTHEAST

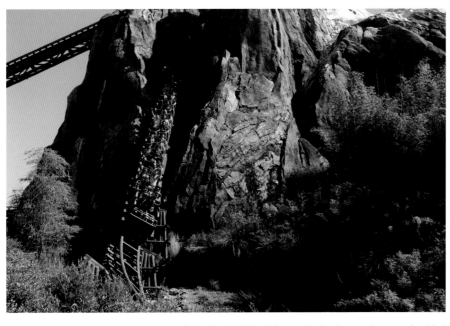

Expedition Everest: Legend of the Forbidden Mountain is themed around a Yeti lurking in Mt. Everest.

It's the tallest artificial mountain in the Disney parks.

It's currently the most expensive roller coaster in the world, costing Disney a reported $100 million.

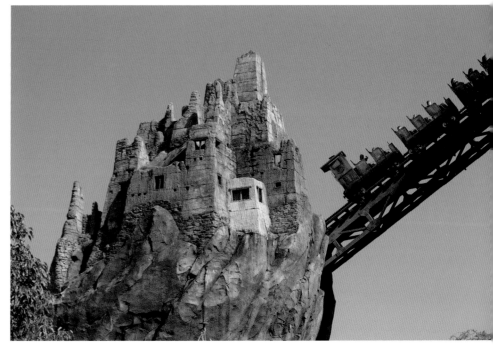

Magic Kingdom

Bay Lake, Florida

Big Thunder Mountain Railroad is themed around the gold rush and a fictional rail line.

The individual cars rock back and forth during the ride.

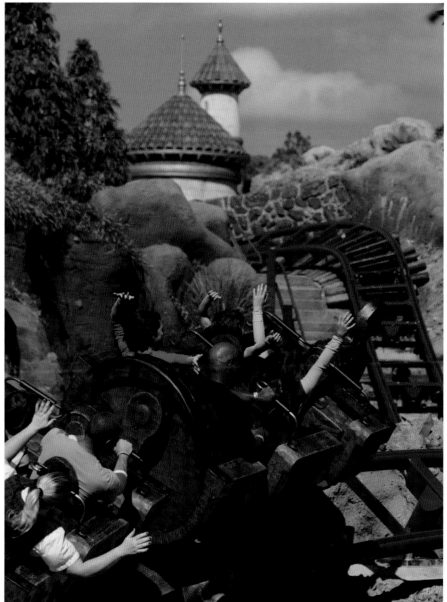

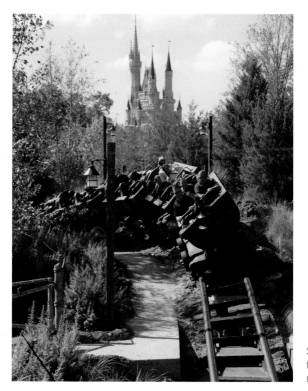

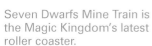

Seven Dwarfs Mine Train is the Magic Kingdom's latest roller coaster.

Sea World Orlando
Orlando, Florida

SOUTHEAST

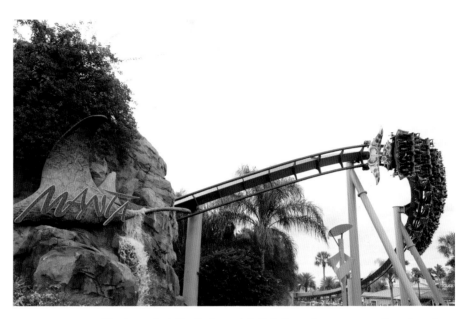

Uncharacteristically forceful, it delivers in ways no other flyer has.

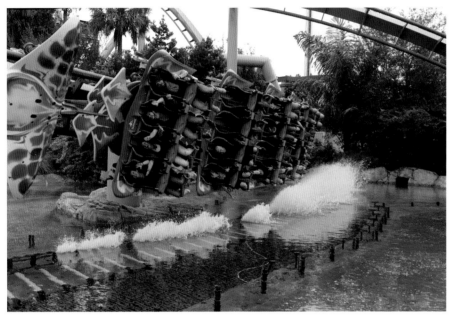

Manta is an outstanding flying coaster.

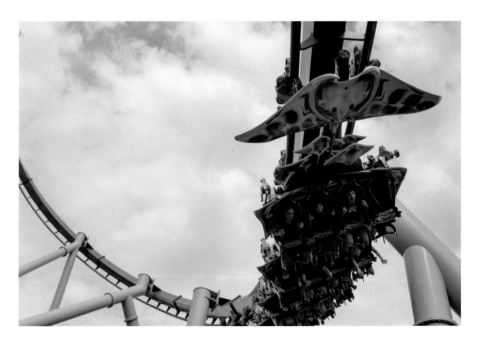

Manta swoops towards the ground.

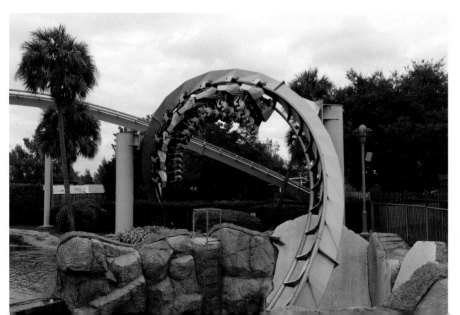

Kraken is a floorless coaster
that opened in 2000.

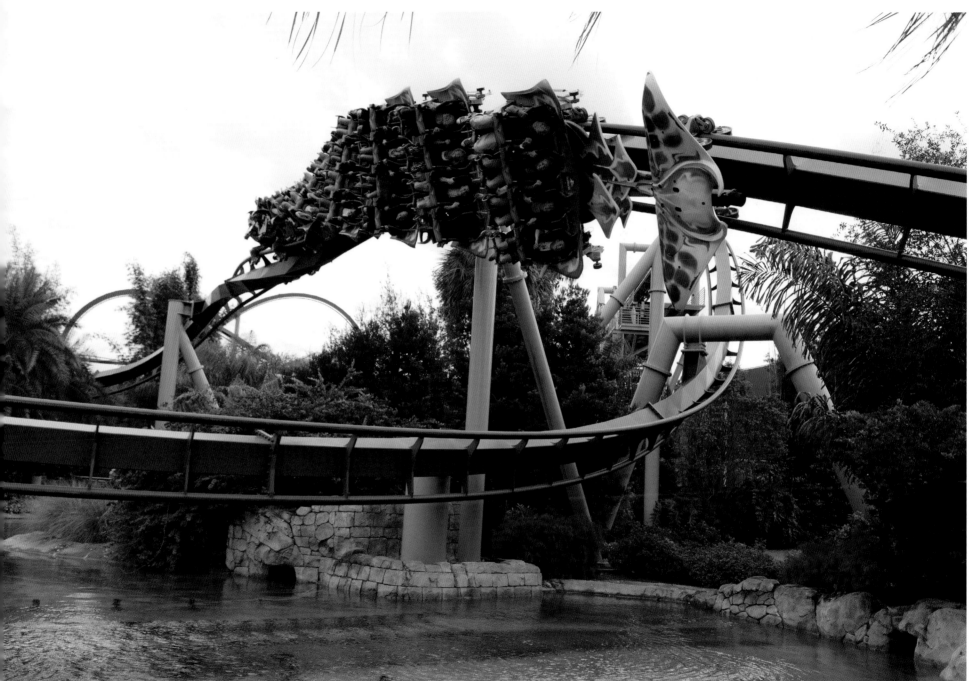

Manta has several vantage points that are great for taking pictures.

White Lightning
at Fun Spot America

Orlando, Florida

OPENING DATE	June 8, 2013
MAKE	Great Coasters International
MAX HEIGHT	69.7 feet (67.2-foot drop)
LENGTH	2,032 feet
MAX SPEED	44.3 mph
DURATION	1:15
INVERSIONS	0

It's Orlando's first and only wooden coaster built by the venerable GCI, but this is no typical GCI. White Lightning is GCI's shortest coaster, and it breaks significantly from GCI's design DNA. Except for a steeply banked turnaround, this coaster has all the hallmarks of a classic out-and-back coaster. It's fair to say that GCI has re-imagined the classic white woodie in a modern context, and it works well.

Even though it harkens to the past, the heart of this ride pulses with GCI blood. The shallow hills, rapid changes in direction, and quick pops of airtime point back to its creator. This small ride surprises at every turn. Eminently re-rideable, your first thought after getting off will be to get back on, and because Fun Spot America isn't a big-time park, it's not hard to find days filled with short wait times. When I visited on a sunny November day, the only trouble was finding enough people to fill a train. If you're in Orlando, take a break from the big parks and spend a few hours at Fun Spot America on this little white dynamo.

FACING PAGE

TOP: The structure frames the outside edge of the park.
BOTTOM LEFT: The train crests the largest hill on the ride after the lift hill.
BOTTOM RIGHT: The small 12-rider train dives down from the lift hill.

Riders blast through a little double down.

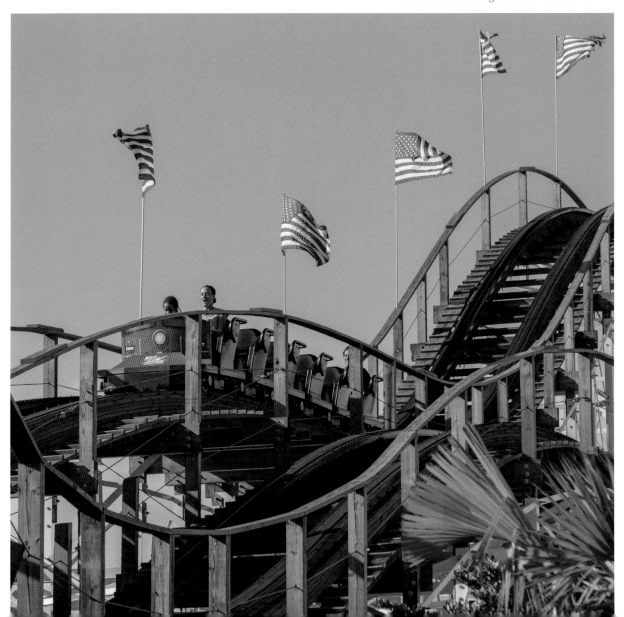

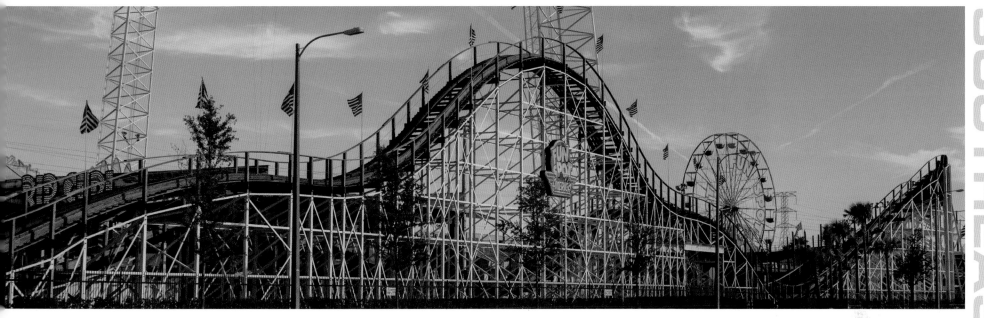

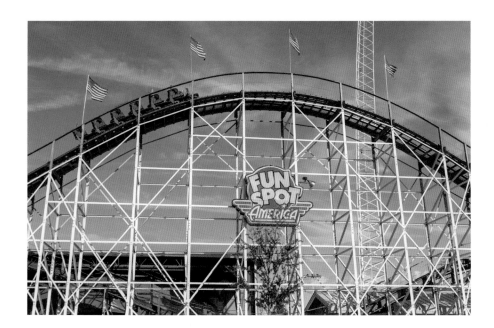

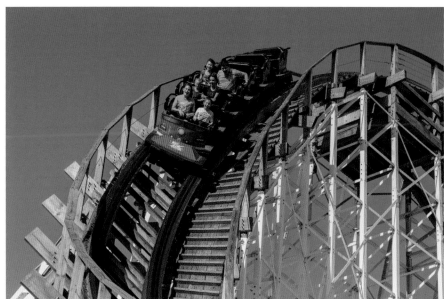

Kentucky Rumbler
at Beech Bend Park

Beech Bend, Kentucky

OPENING DATE	May 6, 2006
MAKE	Great Coasters International
MAX HEIGHT	96 feet (80.2-foot drop)
LENGTH	3,602 feet
MAX SPEED	47.3 mph
INVERSIONS	0

Beech Bend Park is on a small patch of land near a drag strip. It has a quaint, down-home feel and features mostly small, carnival-type rides with one glaring exception: Kentucky Rumbler is a big-time coaster in a small-time park.

GCI does it again with a fresh coaster design that fuses elements of coasters past with a modern design aesthetic. The three station fly-bys during the ride are unique to this coaster.

FACING PAGE

TOP LEFT: The structure is intricate and compact.

TOP RIGHT: The train streaks by on one of its fly-bys.

BOTTOM LEFT: The craftsmanship that went into this ride is apparent when you get up close and personal.

BOTTOM RIGHT: Join a coaster club like ACE, attend an event at Beech Bend Park, and maybe you'll get a chance to see this beauty up close.

The first drop is an homage to the long-defunct Rye Aeroplane coaster.

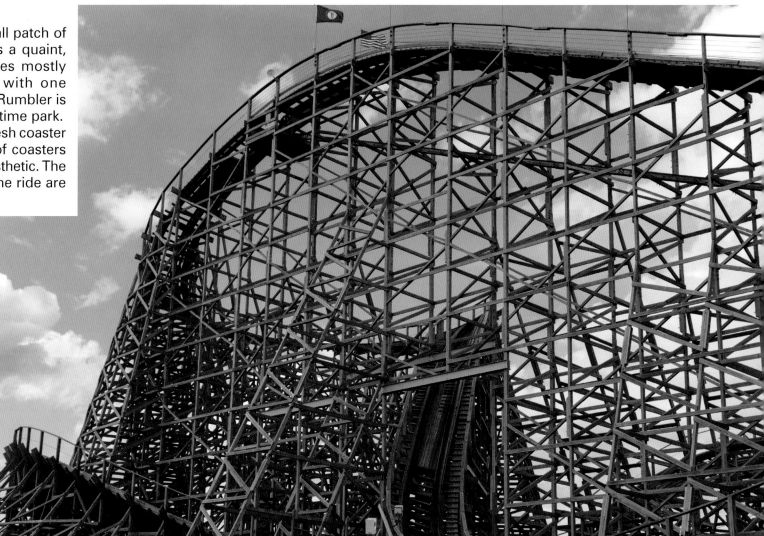

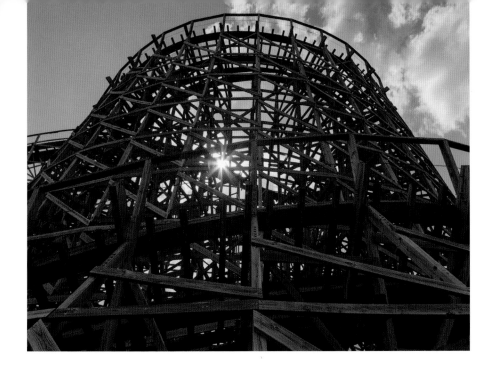

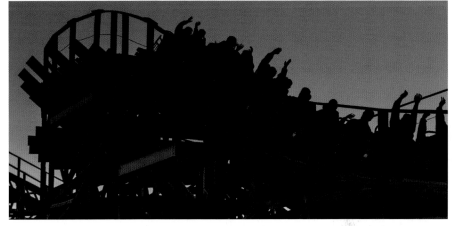

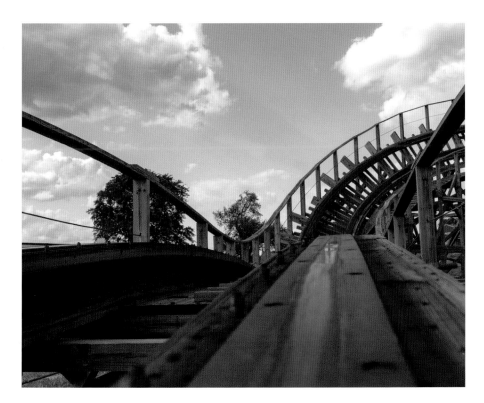

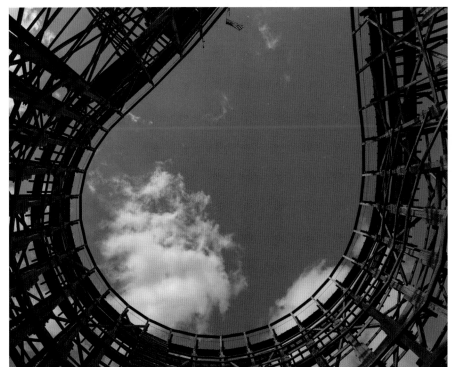

WEST AND SOUTHWEST

While the parks in this chapter aren't necessarily small, their coasters don't offer enough photo opportunities to justify an entire chapter.

Frontier City
Oklahoma City, Oklahoma

Wildcat is a classic woodie that was relocated from Kansas City's Fairyland Park in 1991.

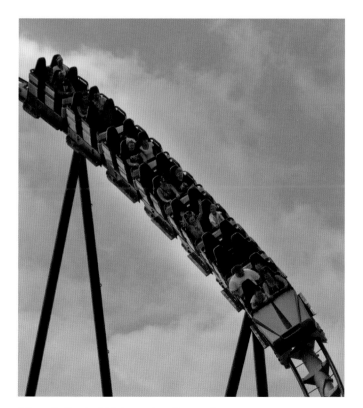

Silver Bullet is Oklahoma's tallest roller coaster.

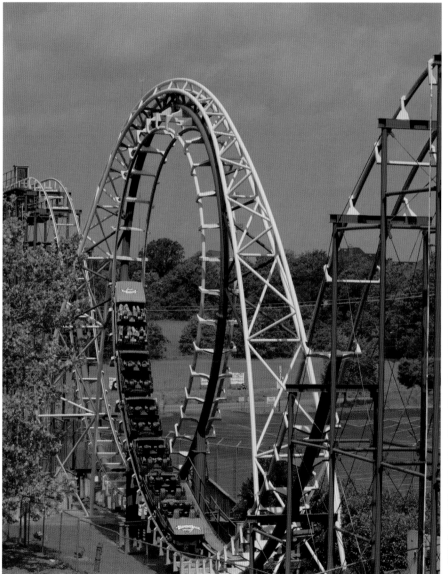

Older readers familiar with Six Flags Great Adventure will be happy to know that Lightning Loops found a new home in Frontier City as Diamondback.

Disneyland
Anaheim, California

Big Thunder Mountain Railroad has wonderfully themed surroundings.

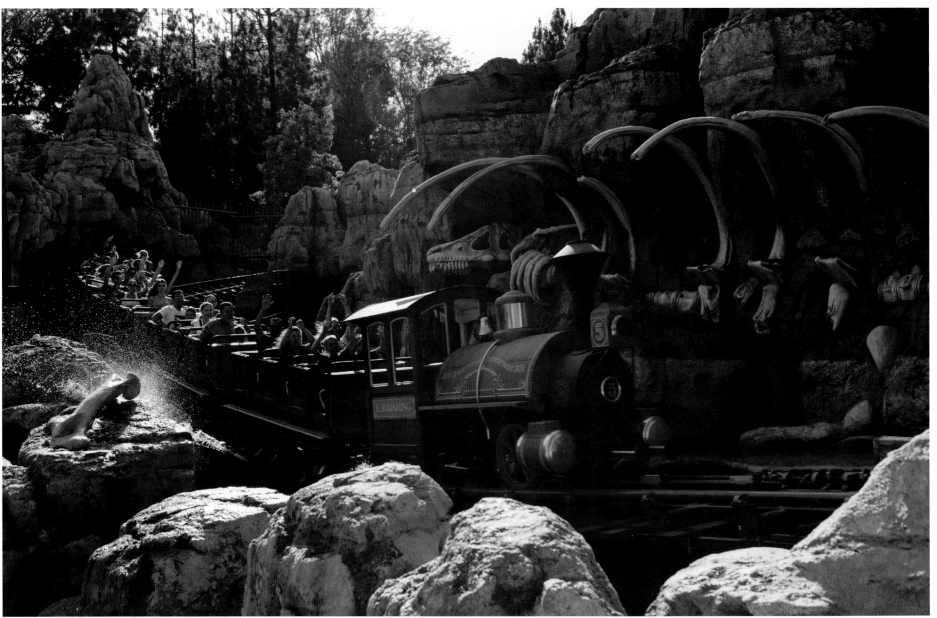

California's Great America

Santa Clara, California

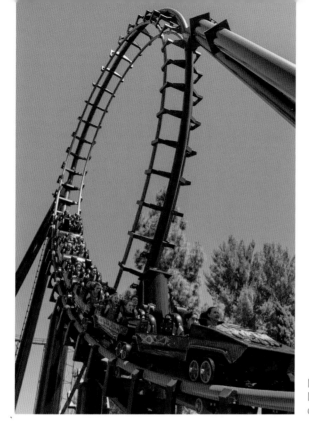

Demon is an Arrow Dynamics looping steel coaster.

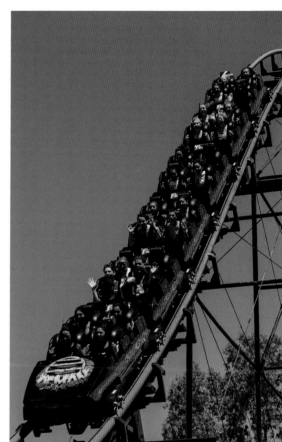

It has a sister coaster of the same name in Six Flags Great America.

The train traverses a double corkscrew.

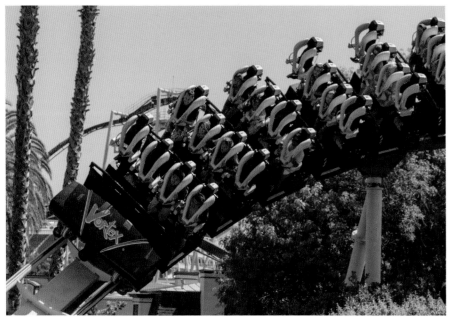

Vortex was B&M's second standup coaster.

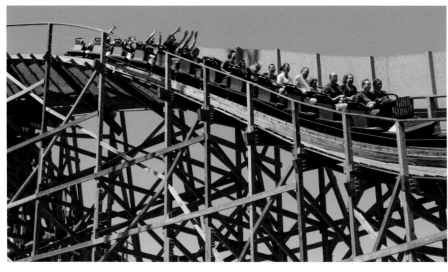

Gold Striker is another GCI masterpiece.

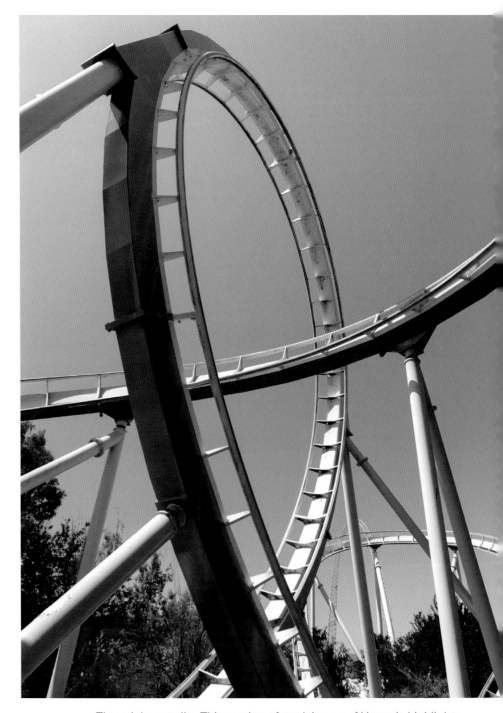

Thread the needle: This section of track is one of Vortex's highlights.

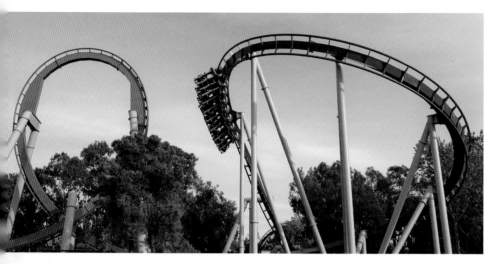

Flight Deck is a fast, thrill-a-second inverted coaster.

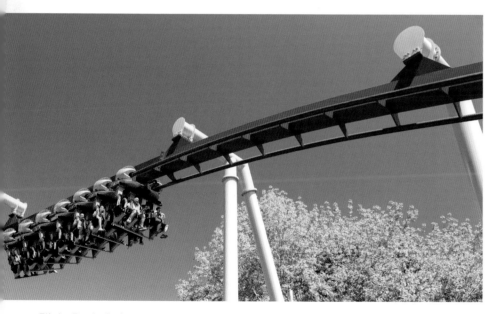

Flight Deck dashes toward a zero-g roll.

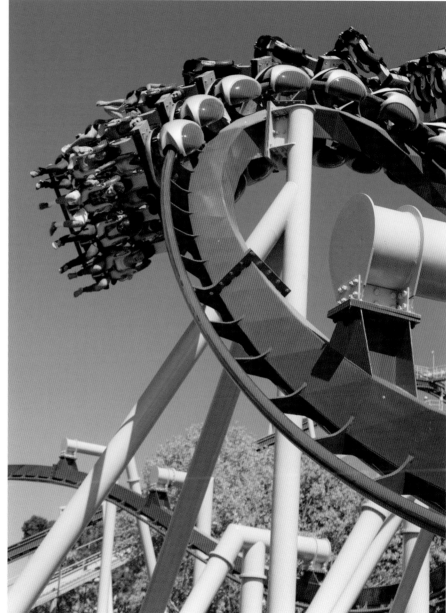

It was also B&M's second inverted coaster.

Six Flags Discovery Kingdom

Vallejo, California

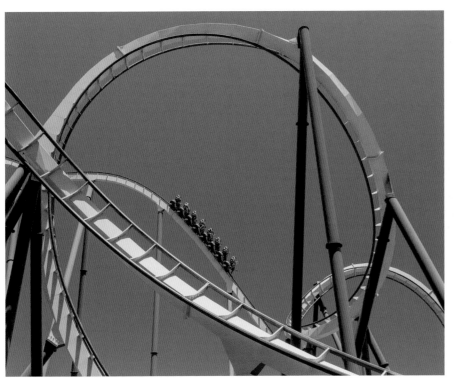

Medusa has the first sea serpent roller ever incorporated into a ride built by B&M.

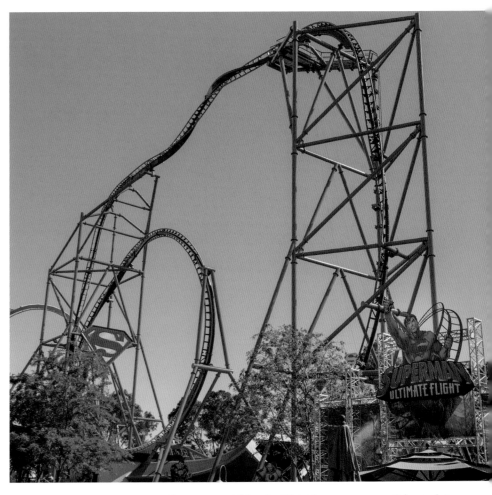

Superman: Ultimate Flight has a very small footprint.

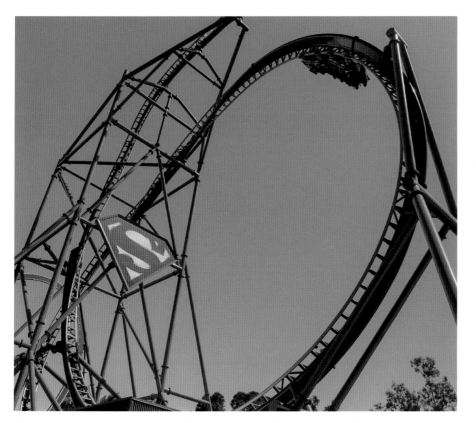

Trains are launched forward and backward to gain momentum for the loops.

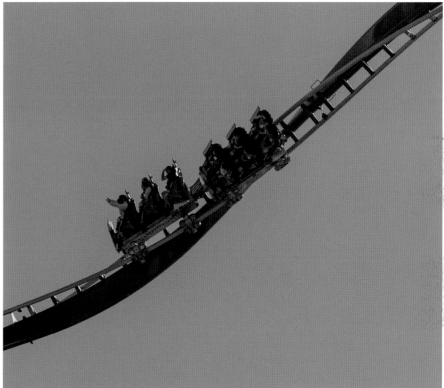

Only a small train can maneuver in such tight spaces.

V2 Vertical Velocity is normally pointed straight up, but local height ordinances forced the park to tilt the tower forty-five degrees.

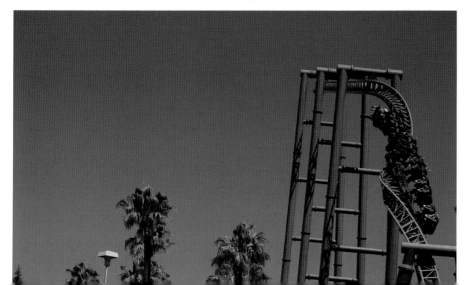

Two words describe Superman: Ultimate Flight: concentrated joy. The ride looks crazy and unlike anything you've ever ridden. Riders are launched forward and backward and forward again to gain enough speed to crest the big outer loop. After a roll, riders are whipped around the inner loop and back to the station.

The ride is short and sweet, and it needs to be to move the lines. Until 2014, this type of coaster was available only on the West Coast, but in 2015 Busch Gardens Williamsburg received one, and Lake Compounce will join the club in 2016.

WEST AND SOUTHWEST

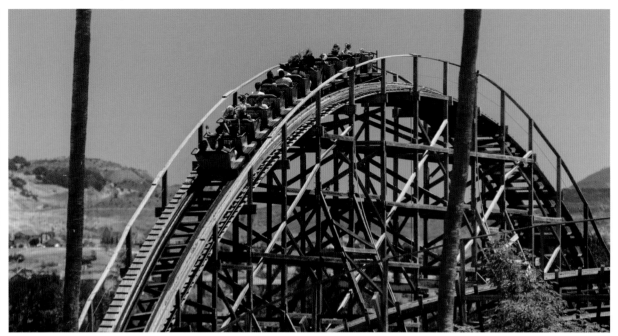

Roar was an early GCI creation. It was fun, but could be rough.

Kong is an inverted coaster built by Vekoma. Beware. It hurts.

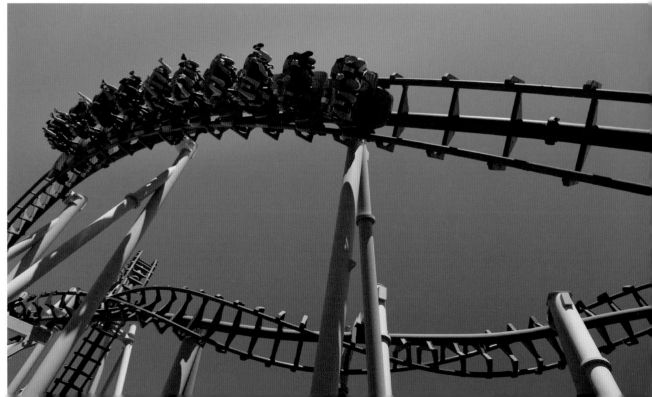

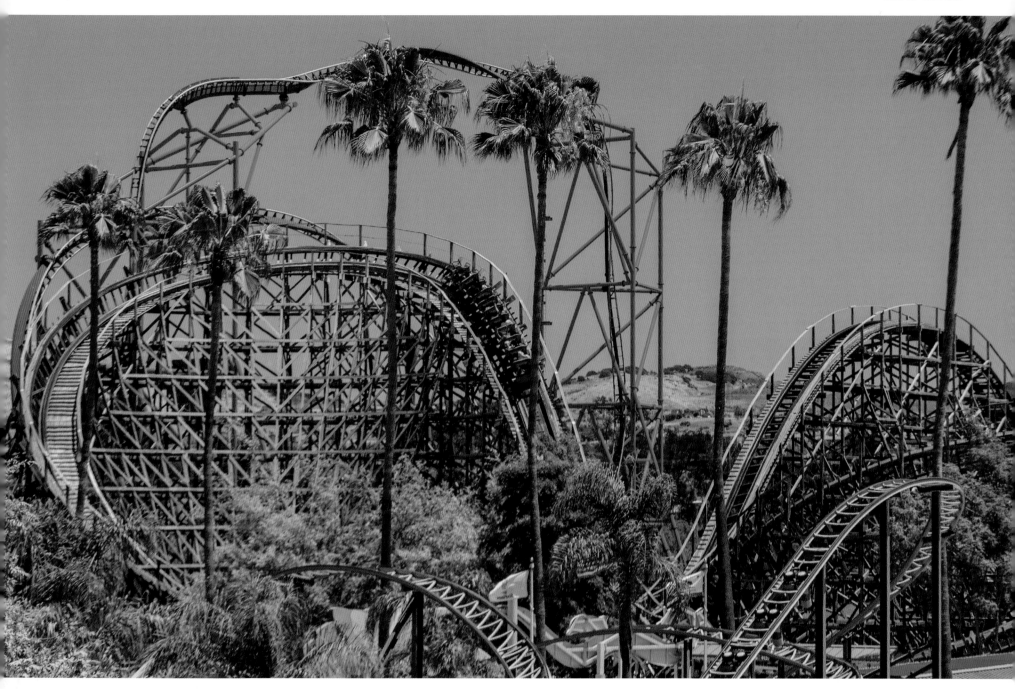

RMC will convert Roar to a steel coaster hybrid for the 2016 season. It'll be interesting to see what they do to this GCI creation.

Giant Dipper at Santa Cruz Beach Boardwalk

Santa Cruz, California

OPENING DATE	May 17, 1924
MAKE	Arthur Loof
MAX HEIGHT	70 feet (65-foot drop)
LENGTH	2,640 feet
MAX SPEED	55 mph
DURATION	1:52
INVERSIONS	0

Believe it or not, this coaster took only forty-seven days to construct in 1924 at a cost of around $50,000. That's less than $700,000 in 2015 money, so it was likely a bargain even then considering it would cost millions today.

As an historic landmark that has delivered over 60 million rides since opening, it seems fair to call it the Coney Island Cyclone of the West. Some would argue, however, that since Giant Dipper opened three years before the Cyclone, perhaps the Cyclone should be called the Giant Dipper of the East.

Personally, I'd choose a ride on the Giant Dipper over the Cyclone any day, but I'm sure there are many Cyclone fans who disagree. Either way, both rides are classics.

FACING PAGE

TOP: You can get a great view of the entire ride from the beach.

BOTTOM LEFT: Sit in the back for a nice trip down the first hill.

BOTTOM RIGHT: Admire your surroundings as you glide around the turn above the station.

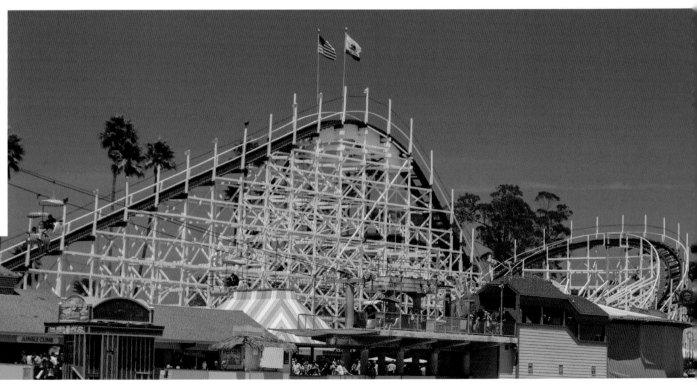

The lift hill creates an iconic profile for the Santa Cruz Beach Boardwalk.

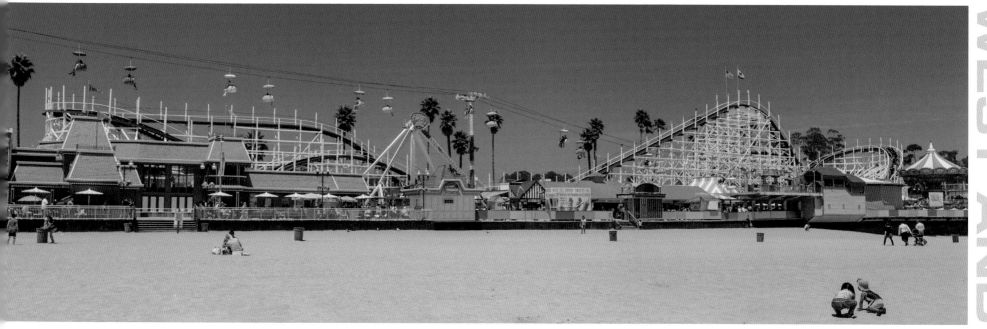

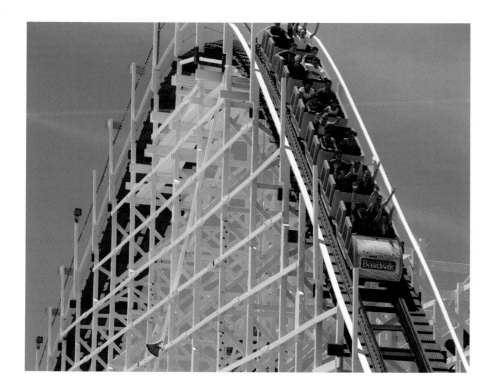

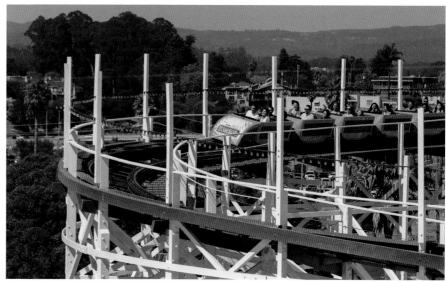

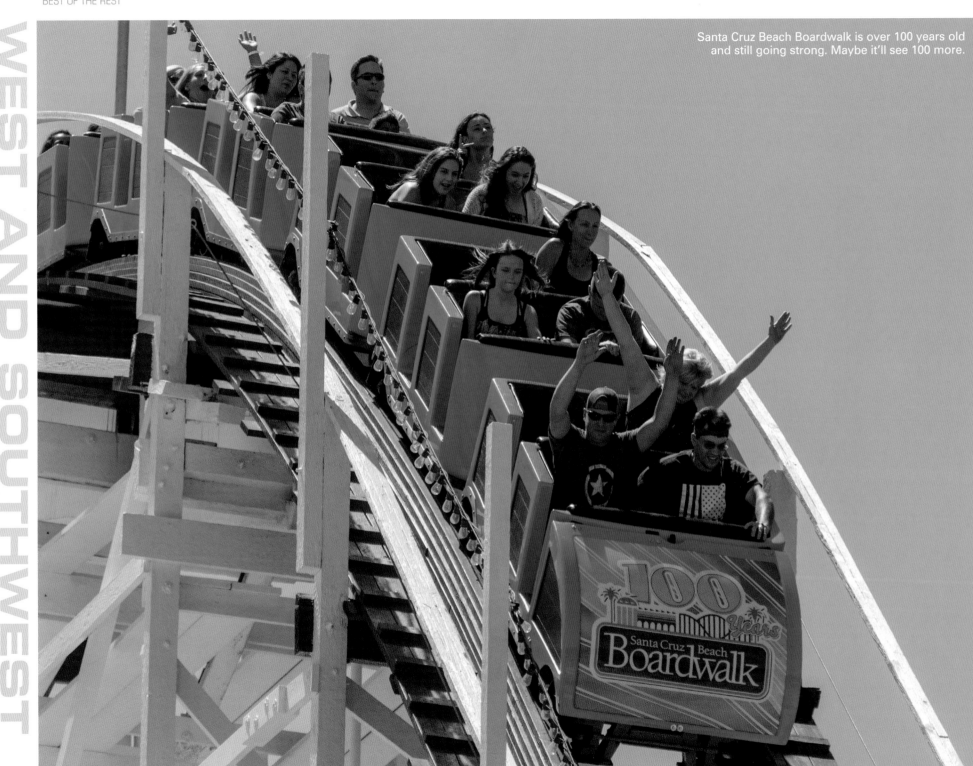

Santa Cruz Beach Boardwalk is over 100 years old and still going strong. Maybe it'll see 100 more.

Bibliography

Beech Bend Park. Beech Bend, July 27, 2015. http://www.beechbend.com/.

Busch Gardens. SeaWorld Parks & Entertainment, July 25, 2015. http://buschgardens.com/.

Canobie Lake Park . Canobie Lake Park, July 27, 2015.http://www.canobie.com/.

Cedar Fair. Cedar Fair LP, July 30, 2015. http://www.cedarfair.com/.

Conneaut Lake Park. Conneaut Lake Park. July 27, 2015. http://www.newconneautlakepark.com/.

Dollywood. Dollywood Company, July 26, 2015. http://www.dollywood.com/.

Frontier City. Frontier City, July 27, 2015. https://www.frontiercity.com/.

Funtown Splashtown USA. Funtown Splashtown USA, Inc., July 27, 2015. http://funtownsplashtownusa.com/.

Fun Spot America—Orlando. Fun Spot America Theme Parks, July 25, 2015. http://fun-spot.com/.

Holiday World & Splashin' Safari. Holiday World & Splashin' Safari, July 7, 2015. http://www.holidayworld.com/.

Idlewild. Palace Entertainment, July 27, 2015. https://www.idlewild.com/.

Kentucky Kingdom. Kentucky Kingdom, July 27, 2015. http://www.kentuckykingdom.com/.

Lake Compounce. Lake Compounce, July 27, 2015. https://www.lakecompounce.com/.

Lakemont Park. Lakemont Park & Island WaterPark., July 27, 2015.
 http://www.lakemontparkfun.com/.

Luna Park. Central Amusement International LLC, July 27, 2015. http://lunaparknyc.com/.

Playland. Westchester County Department of Parks, Recreation and Conservation, July 27,
 2015. http://ryeplayland.org/.

Quassy. Quassy Amusement Park, July 27, 2015. http://www.quassy.com/.

Roller Coaster Database. Duane Marden, July 30, 2015. http://www.rcdb.com/.

Santa Cruz Beach Boardwalk. Santa Cruz Beach Boardwalk, July 27, 2015.
 http://beachboardwalk.com/.

Sea World Orlando. SeaWorld Parks & Entertainment, July 30, 2015.
 http://seaworldparks.com/en/seaworld-orlando.

Six Flags. Six Flags Theme Parks, Inc., July 30, 2015. http://www.sixflags.com.

Universal Studios Islands of Adventure. Universal Orlando Resort, July 30, 2015.
 http://www.universalorlando.com/Theme-Parks/Islands-of-Adventure.aspx.

Waldameer. Waldameer & Water World, July 27, 2015. http://www.waldameer.com/.

Index

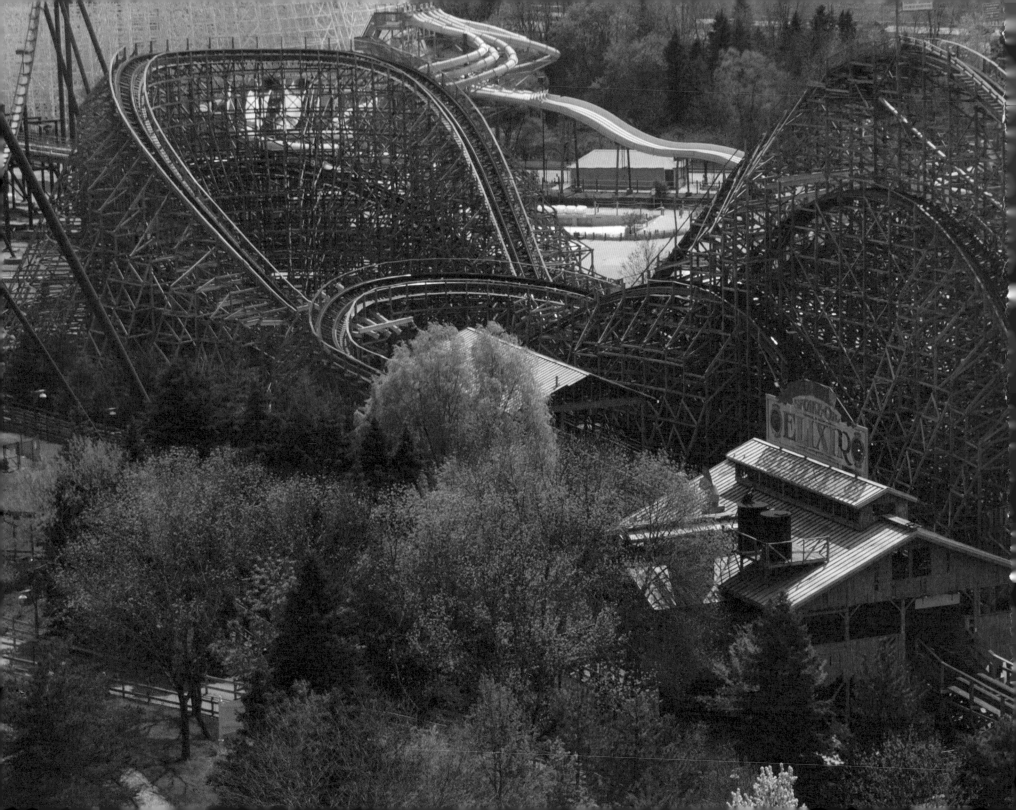